THE MOMENT *of* SEEING
Minor White at the California School of Fine Arts

THE MOMENT *of* SEEING

Minor White at the California School of Fine Arts

By Stephanie Comer & Deborah Klochko · Essay by Jeff Gunderson

CHRONICLE BOOKS
SAN FRANCISCO

Library of Congress Cataloging-in-Publication Data available.

ISBN-10: 0-8118-5468-X
ISBN-13: 978-0-8118-5468-9

Manufactured in China.

Designed by Michael Read and Irene Rietschel.

Distributed in Canada by Raincoast Books
9050 Shaughnessy Street
Vancouver, British Columbia V6P 6E5

10 9 8 7 6 5 4 3 2 1

Chronicle Books LLC
85 Second Street
San Francisco, California 94105

Pages 4–5: photographs by
Frederick W. Quandt

CONTENTS

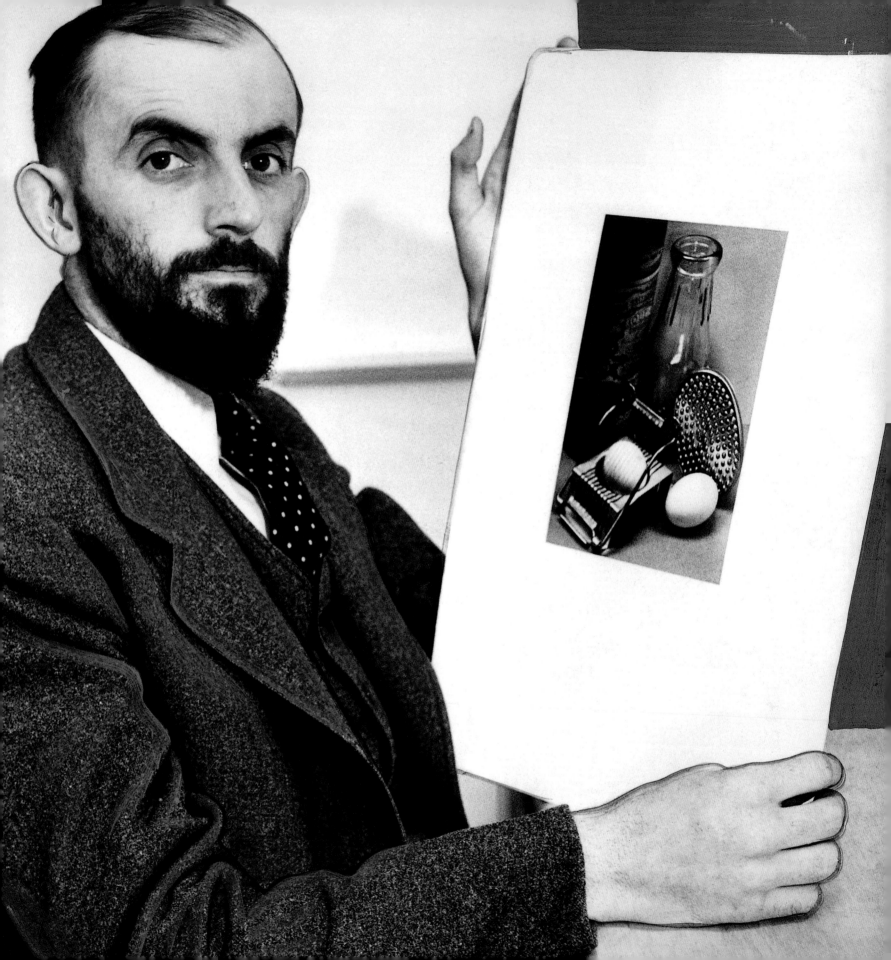

INTRODUCTION

The founding of an innovative art photography program at the California School of Fine Arts in 1945 did not happen by accident. During the previous two decades, a rich and diverse approach to art began to establish itself in California. An independent spirit dominated the work being created, often without the need to compete with the East Coast and European art trends of the day.

The war in Europe had a major impact on California. The state became a major industrial center in the nation's war economy, and it also saw an influx of artists escaping the upheaval overseas. This rapid growth, followed by the postwar enthusiasm for new ideas, defined San Francisco and the Bay Area in the 1940s. The intermingling of poets, painters, filmmakers, and photographers created an environment that allowed Ansel Adams's vision for a photography department to flourish at the California School of Fine Arts. In the early years of the program, most of the students were former soldiers who had returned from the war eager to continue their education. Supported by the G.I. Bill, these students brought maturity and an intense desire for learning to their study of photography.

Sixty years later, the sense of excitement and innovation that was part of this unique program has been brought to life, undimmed, through the voices of a number of the original students and through the amazing archive of the California School of Fine Arts and the Minor White Archive at Princeton. *Moment of Seeing: Minor White at the California School of Fine Arts* is about this special time and place when history came alive and creativity flourished.

Stephanie Comer
Deborah Klochko

Opposite page: *Ansel Adams, 1938.*

THE MOMENT OF SEEING

PHOTOGRAPHY AT THE CALIFORNIA SCHOOL OF FINE ARTS

BY JEFF GUNDERSON

In the summer of 1949, Allan Arbus, who had been "doing fashion pictures" with his wife, Diane, for Conde Nast and other advertisers, wrote to Minor White at the California School of Fine Arts that he was "deeply interested in what [Ansel] Adams calls 'expressive photography' and very dissatisfied with fashion photography." The photography department that White had written about for the July 1949 issue of *U.S. Camera* had impressed Arbus, who wrote, "creatively I am locked or blocked . . . After reading your article I thought your school might free me to work."[1] The program about which Arbus inquired began with the 1945 organizational efforts of Ansel Adams, CSFA director Douglas MacAgy, and San Francisco Art Association Board president Eldridge "Ted" Spencer, but the school's first recognition of photography and filmmaking can be traced to 1880, when Eadweard Muybridge "projected his pictures on a screen" at the school.[2]

The nineteenth-century beginnings of the San Francisco Art Association (SFAA) and its accompanying California School of Design (CSD) materialized with the gold, silver, shipping, and railroad fortunes that accumulated in Northern California after the completion of the transcontinental railroad in 1869. The wealth of "the big four"—Charles Crocker, Collis P. Huntington, Mark Hopkins, and Leland Stanford—underwrote artists, photographers, and art organizations in Gilded Age California. Photographers Muybridge and Carleton Watkins; painters Thomas Hill, Albert Bierstadt, and William Keith; and the SFAA and CSD all claimed the patronage of these robber barons. By 1893, SFAA and CSD were housed in the Mark Hopkins mansion atop Nob Hill, offering classes in painting and sculpture, holding exhibitions for San Francisco society, and maintaining a library that included books on photography among its art titles. The school expanded from its early limited curriculum of life classes and plein air painting to include crafts, applied arts, and illustration mimicking the popular style of the time. By the 1920s, when the Hopkins land was sold to the Mark Hopkins Hotel in exchange for property at 800 Chestnut Street on the northeastern slope of Russian Hill, the school had a full program of fine arts, design, and crafts, but it had not yet embraced photography as a medium worthy of instruction.

The long gestation of photography at the California School of Design, which became known as the California School of Fine Arts (CSFA) in 1916, began soon after the November 15, 1932, opening of the Group f.64 exhibition at the M. H. deYoung Memorial Museum. Three of the eleven

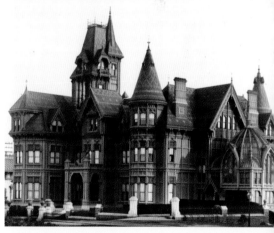

This page: California School of Fine Arts, 1930; Mark Hopkins Mansion, Nob Hill, c. 1906.

Opposite page: Two students drawing outside at the California School of Fine Arts, 1928; Students in a painting class, 1928; Students in a sculpture class, 1938.

9

participants—Ansel Adams, Edward Weston, and Imogen Cunningham—would go on to become influential teachers in the CSFA photography department.

Adams's introduction to the world of fine art was in 1926, through Albert Bender, an extraordinary San Francisco philanthropist who was the first outside of Adams's musical and hiking groups to show a serious interest in his photographs. Bender financed Adams's first portfolio, *Parmelian Prints of the High Sierras,* and made sure that major art collectors and museums took notice.[3] Through Bender, Adams met members of the San Francisco Art Association's Board of Directors as well as future board members like Spencer. The f.64 show, Bender's support, and the model of Alfred Stieglitz's An American Place gallery encouraged Adams to open his own exhibition space for art and photography in San Francisco at 166 Geary Street in 1933. By 1934, the San Francisco Art Association's School Committee suggested a course in photography, complete with "$200 to furnish a darkroom," with Adams as the instructor.[4] While arguing for the course, board member Sydney Joseph "discussed photography as an art" and considered the camera "a working tool in the hands of artists," but the recommendation proved to be no more than a false start.[5]

Yet throughout this period, future photographers enrolled at the school to study art, then applied these creative skills to their chosen medium. John Collier, Jr., encouraged by Dorothea Lange and Maynard Dixon, as well as Leo Holub and Russell Lee, studied painting at the school in the 1930s, much like Louise Dahl-Wolfe, who had studied color composition and the fine arts at CSFA from 1916 to 1919. In 1935, T. H. Palache donated a full run of Stieglitz's *Camera Work* magazine to the school's library, demonstrating the importance of photography and of Stieglitz's exhibitions, at his New York 291 gallery, to the school's art and design curriculum.[6]

Ansel Adams remained connected to CSFA throughout the 1930s, poised for the opportunity to teach. During that time he had a major solo exhibition at the San Francisco Museum of Art and helped establish the New York Museum of Modern Art's Department of Photography.[7] He produced photographs for the 1940–41 CSFA college catalog and organized the Golden Gate International Exposition's Pageant of Photography at Treasure Island.[8] He then ventured to southern California, where he taught sporadically at the Art Center School in 1941 and 1942 but left in 1943, as he said, "disgruntled with the school's politics and bickering . . . particularly . . . with its director, Edward 'Tink' Adams."[9]

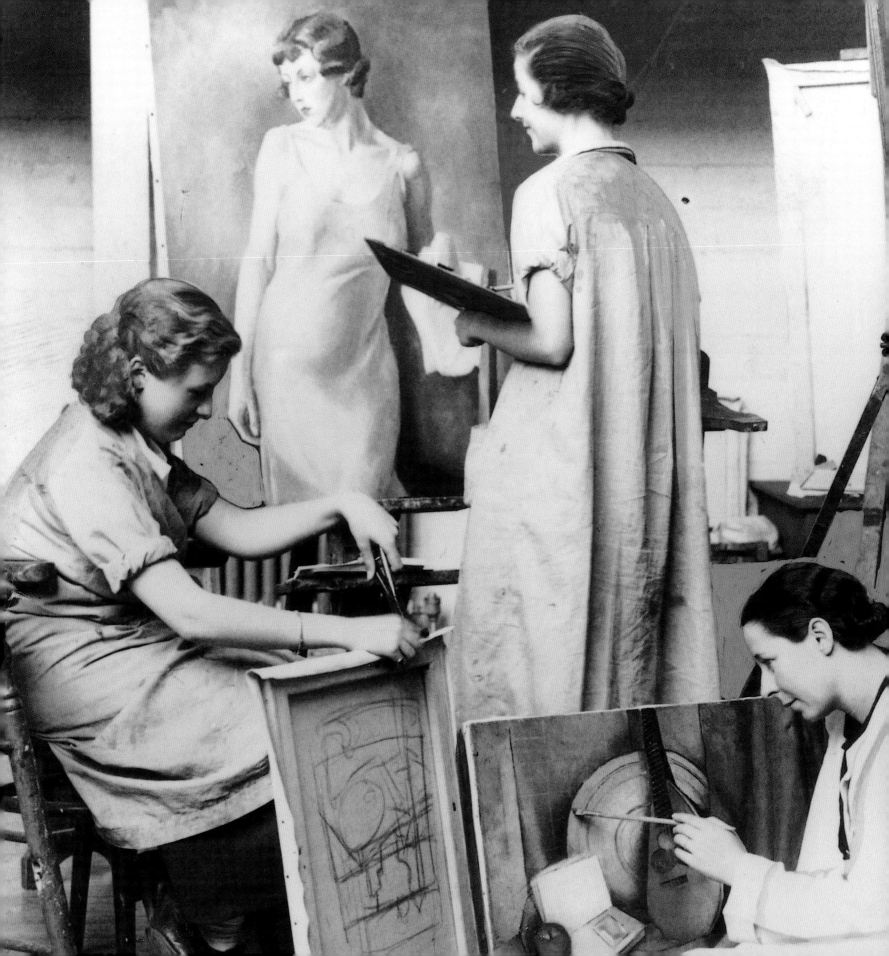

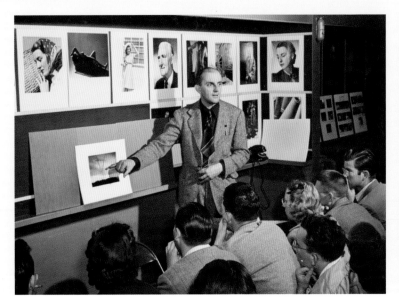

In August 1944, Adams proposed a series of lectures at the California School of Fine Arts to his longtime friend Ted Spencer. Adams's lectures were based on a series he gave at the New York Museum of Modern Art in May 1944. His purpose was "two-fold: 1) to encourage the layman to think of photography as a creative medium [and] 2) to encourage the photographer to have faith in the expressive potentials of straight photography."[10] Though Adams was anxious that the lecture series succeed, he understood the dynamics of CSFA and the San Francisco Art Association community, and he solicited ideas from Spencer, who knew "the tempers of the situation" and could offer insight into how to "put this over 100% . . . for the School."[11] The publicity material announced "Six Lectures on Photography by Ansel Adams" to be held on consecutive Mondays, Wednesdays, and Fridays in December 1944. Forty people attended some combination of the series of six lectures, including Homer Page, Cedric Wright, Paul Taylor, Mrs. Paul Taylor [Dorothea Lange], and Ellen Bransten, and, as Adams later wrote, "some were just salon pictorialists." Nancy Newhall sent a number of prints—"examples of resonant creative work"—from the New York Museum of Modern Art's collection that included one of Stieglitz's "Equivalents" photographs, which Adams said made such an impression on one participant that there were "tears in her eyes" as she declared, "Now I know what you are talking about!"[12]

Obviously encouraged by this success, Spencer and Adams thought it the right moment to add photography to the school's curriculum. In May 1945, Adams submitted his eighteen-page "Report on the Proposed Department of Photography" to Spencer. The school would soon awake from its wartime hibernation. There were studios that needed to be filled, and there were four or five years' worth of college-age students who had deferred their schooling to fight in World War II and were eligible for G.I. Bill educational benefits. Adams's report stressed that San Francisco was ideally situated and that "this new department could not come at a better time . . . Everything points to an intense cultural development on the West Coast following the war." He warned that "competition in professional photography will be severe . . . and only those . . . with an inclusive technique, imagination and understanding of the medium will survive." Adams felt that with the combined resources of the California School of Fine Arts, its new Department of Photography, and

This page: Ansel Adams teaching at the Art Center School, Los Angeles, 1941.

Opposite page: Edward Weston, *Ansel Adams, Wildcat Hill,* 1943; CSFA catalogue, 1940–41.

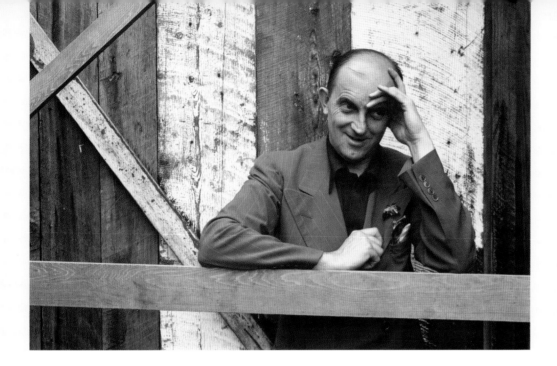

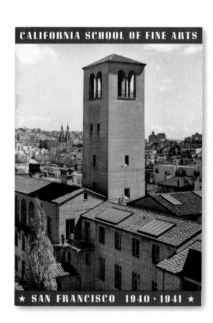

the San Francisco Museum of Art, "a magnificent photographic center will develop . . . that would unquestionably lead the field in this country, if not the world."[13] Adams's enthusiasm for the CSFA photography project and his personal stake in its success nevertheless did not prevent him from applying for a Guggenheim grant to photograph the American landscape.

Adams did not want to repeat the mistakes he had witnessed while teaching at the Art Center in Los Angeles in his plan for a CSFA photography program. He stressed "personal contact with the instructor," which he thought "more effective and stimulating than continuous, routine, group instruction." Consequently, he strongly recommended that the department "be based . . . on a music conservatory plan . . . [with] lectures, demonstrations and exhibits, . . . required reading, and personal instruction and assignments." These lectures would serve to "orient the entire school," not just the photography students, "toward understanding . . . good photography as an important element of contemporary life." Adams stressed that the history of photography needed to be incorporated into the "general course of art history offered to all students" and that the photography faculty would be "prepared to contribute the necessary lectures and illustrations." To increase income and publicize the department, he proposed "evening classes for amateurs" that could be offered "as an interesting inducement to the general public." Although Adams thought the school had an excellent library, it would need to "acquire a working collection of photographic texts . . . Beaumont Newhall will make a list of books and periodicals as a basic selection." Adams advocated "specific relationships between the photography department and other departments of the school . . . fashion, design, advertising, reproduction of works of art (painting, sculpture, etc.), industrial design, textiles, interior decoration (photo-murals and screens, etc.) should be developed to the fullest extent"—the photography students would be "prepared to handle the photographic requirements of the school." Finally, Adams strayed from the practical aspects of the department's organization and emphasized that "the significance of photography and its close relationship to industrial culture and modern thought" placed a great responsibility on those "entrusted with the educational aspects of the art."[14] As he wrote some months later, "It's GOT to be the best photo school in the U.S.A.!"[15]

The proposal for the new Department of Photography coincided with the hiring of Douglas MacAgy as the director of the California School of Fine Arts. MacAgy was brought on to make the

school innovative, and the board of directors gave him "a free hand to revise the curriculum and hire faculty as he saw fit."[16] In addition to the embryonic photography program, MacAgy developed a faculty that included painters David Park, Clay Spohn, Hassel Smith, Dorr Bothwell, Claire Falkenstein, Elmer Bischoff, Ed Corbett, and Clyfford Still; he eventually added Richard Diebenkorn, who had studied at the school for a year. He also invited Mark Rothko, Ad Reinhardt, Stanley William Hayter, Evsa Model, and Edward Weston to teach summer classes, and he initiated Workshop 20, an experimental filmmaking course under the direction of Sidney Peterson. MacAgy's choice of faculty "emphasize[d] vision over craft, and spirit over method."[17]

According to the thirty-two-year-old MacAgy, art education was out of date, as art schools "in a dreamy inertia . . . keep preparing students as if they were turning out artists for an ideal Paris of the year 1910." He claimed "the day of the eccentric lone wolf in art—the Bohemian living on air" was over. MacAgy's new curriculum would get students to learn "the whole relation among art, artists and the community"[18] and would deal with "the problem of inducing the student from the start to adopt a creative attitude which permits independent discovery." MacAgy faulted not only the rigidity of high schools but also the "art school tendency to direct the student to emulate standard forms."[19] He moved to give the place a freer, more vital atmosphere, "opening studios around the clock, and brought musicians, poetry readings, and other events" to the school.[20] MacAgy believed that there should be a balance of student "participation in collective concerns with the cultivation of individual personality," and that "cultural studies which give perspective to the relationship of the individual artist and society" should be part of the curriculum.[21] As Minor White would later write, the California School of Fine Arts "went uncomfortably modern practically overnight" with MacAgy's arrival, which "generat[ed] a high creative excitement in both students and staff."[22]

Many logistical details had to be worked out before the birth of a CSFA photography department. There was support from the board president, the new director of the school, and from Adams, but there was no money for the construction of a photography lab or for the purchase of equipment. Adams "saw no reason why we can't prime all possible barrels at one time,"[23] and he encouraged MacAgy to contact San Francisco's Columbia Foundation while he wrote immediately for a possible Rockefeller Fund grant. Adams, in feeling out his Rockefeller Fund contact, Lindley Bynum,

Opposite page: Ellen Bransten,
Douglas MacAgy, CSFA Director, 1945.

expressed particular concern that a similar program would be funded at another institution competing for the same limited pool of qualified faculty. He asserted that CSFA's photography department would be "the absolute tops of its kind, and the only one wherein a serious study of photography can be undertaken with the dignity and effectiveness which the medium deserves." Though it did not pan out, Adams initially thought there was "no reason why the University of California and its Southern branch, and other universities as well" could not affiliate with CSFA "for advanced study in photography with complete credit for degrees and scholastic accomplishment."[24]

Adams's wholehearted support of the CSFA program did not stop at soliciting funds. He again took promotional pictures to be used in CSFA's 1945–46 catalog, but because of time restraints and "strange equipment" he had to do a "rush job" and consequently preferred not to have his name appear as photographer—he wrote to MacAgy, "Just consider it one of those cooperative gestures, with brighter hopes for the future."[25] Beaumont Newhall, curator of photography at the New York Museum of Modern Art, came through with a list of thirty titles necessary for the school's Anne Bremer Memorial Library, including Walker Evans's *American Photographs,* Dorothea Lange's *An American Exodus,* Paul Strand's *Photographs of Mexico,* Edward Weston's *California and the West,* Barbara Morgan's *Martha Graham*, Newhall's own *Photography: A Short Critical History,* and of course three of Ansel Adams's books, *Making a Photograph, Born Free & Equal* (with Lange), and *Sierra Nevada*.[26] Adams must have been reassured when he received correspondence from MacAgy stating that there was a "pretty good chance" for funding in his inquiries with the Columbia Foundation. MacAgy went on to write that an "advisor who is on the inside" suggested that Adams get a letter of recommendation from Newhall.[27] By the end of August, MacAgy had a strongly worded recommendation letter from Newhall, commending CSFA for "planning to include in its curriculum a professional course in the technique, esthetics and application of photography . . . I congratulate you upon your desire to pioneer in this field." Newhall concluded with great praise for Adams, who "has shown that, in addition to being one of the foremost photographers of the day . . . [he] is a gifted and inspiring teacher."[28] With all of these seeds planted by Adams, Spencer, and MacAgy, and with Newhall's letter attached, a formal request for "$15,000 to be used for the establishment of the proposed Department of Photography" was sent to the Columbia Foundation on September 6, 1945. The request delineated $6,000 for permanent equipment, $4,000 for the installation of the photo lab, and $5,000 for operating expenses for the first eighteen months.

Space was certainly not a problem. Of the school's twenty-one studios, the six in the East Wing had "been allocated temporarily to the Red Cross as a blood procurement center."[29] During the war, one-sixteenth of all blood collected throughout the nation had been gathered at the school.[30] The evacuation of the Red Cross would mean there would be plenty of room for the new department. While CSFA awaited word on funding for the department through the fall of 1945, Adams and MacAgy continued to work on how the school would handle the expected flood of students who would arrive in the next couple of years with "all tuition costs, fees, and equipment as well as an allowance of $50 per month" paid by the G.I. Bill.[31]

Although Adams wanted to begin as quickly as possible, he deferred to Spencer, who had concerns about starting a new department without the support in place. While waiting to hear from the Columbia Foundation, Adams suggested an eight-week basic photography course for the fall of 1945. Adams would provide the equipment, while the school would install a basic darkroom. His suggestions for this course included all sorts of minutia, described in a four-page single-spaced

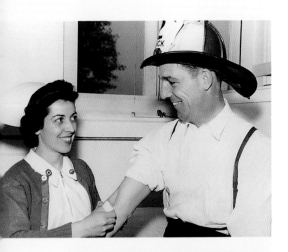

This page: *Miss Mary Grant, RN and six-time donor Mr. Frank Blackburn, Chairman of the Blood Donor Day for Firemen,* 1944; article from *San Francisco Chronicle,* 1944.

Opposite page: Letter from Beaumont Newhall to Douglas MacAgy, dated 24 August 1945.

8-24-1945

The Museum of Modern Art
New York, 24 August 1945

Mr Douglas MacAgy
California School of Fine Arts
Chestnut & Jones Streets
San Francisco 11, Calif.

Dear Mr MacAgy,

I am very glad indeed to learn, from my friend Mr Ansel Adams, that the California School of Fine Arts is planning to include in its curriculum a professional course in the technique, esthetics and application of photography. Such a course of instruction is badly needed. The present trade schools are, in my estimation, inadequate to meet the needs of the present day, when photography has become a most important form of documentation, illustration and, above all, both editorial and personal expression. The teaching of photography belongs in the curriculum of an art school, and I congratulate you upon your desire to pioneer in this field.

Mr Adams has shown that, in addition to being one of the foremost photographers of the day, he is a gifted and inspiring teacher. During the season 1943-44 and 1944-45 he conducted highly successful courses in photography at the Museum of Modern Art. The attendance reached the maximum which the Museum lecture room could accomodate, and the courses were financial successes. But more than this, it was the privilege of the staff of the Department of Photography to observe the benefit which Mr Adams' teaching gave to his audience. Many younger workers and some professionals not only learned tricks of the trade, but found an orientation and a new and quickened appreciation of the possibilities of the medium of photography.

Together with my colleagues on the staff of the Museum's Department of Photography I very much hope that your School will find it possible to realize your project. If I can be of any service to you, please do not hesitate to call upon me.

Yours sincerely,

Beaumont Newhall
Beaumont Newhall
Curator of Photography

WESTERN UNION

A. N. WILLIAMS
PRESIDENT

TELEPHONED TELEGRAM

The filing time shown in the date line on telegrams and day letters is STANDARD TIME at point of origin. Time of receipt is STANDARD TIME at point of destination

10-24-1945

BZA106 DL PD=PLACERVILLE CALIF 24 1130A

DOUGLAS MACAGY DIRECTOR=

CALIFORNIA SCHOOL OF FINE ARTS CHESTNUT AND JONES

STS SFRAN=

FIVE THOUSAND REFERRED TO OPERATING EXPENSES SALARIES
PUBLICITY AND ADVERTISING FOR FIRST YEAR AS BUFFER
FUND AGAINST POSSIBLE LOW REGISTRATION. DOUBT IF IT
WILL BE REQUIRED IN FULL BUT I INCLUDED SAME AS
PRECAUTIONARY MEASURE HOWEVER SOME SALARY DURING
ESTABLISHMENT OF DEPARTMENT AND COSTS OF ADVERTISING AND
PUBLICITY SAY TWO THOUSAND MAXIMUM, SHOULD BE CONSIDERED.
WILL PHONE THURSDAY=

ANSEL ADAMS.

800 Chestnut St.
Or. 2640 N.S.
3p. 1:17p Mailed

COLUMBIA FOUNDATION

RUSS BUILDING

SAN FRANCISCO

DOUGLAS 5491

Copy to Mr. Spencer

MARJORIE ELKUS
EXECUTIVE DIRECTOR

November 1, 1945

Mr. Eldridge T. Spencer, President
Board of Directors
San Francisco Art Association
Chestnut and Jones Streets
San Francisco 11, California

My dear Mr. Spencer:

I am happy to inform you that the Board of Directors
of the Columbia Foundation has approved a grant of
$10,000.00 to the San Francisco Art Association for
the establishment of a Department of Photography at
the California School of Fine Arts.

These funds are intended for the purchase of the
equipment necessary in the establishment of the
Department. Our check for the above amount will be
forwarded you shortly.

Assuring you of our interest in the splendid work
of the Art Association, I remain

Very truly yours,

Marjorie Elkus

(Mrs.) Charles deY. Elkus, Jr.
Executive Director

ME:ma

This page: Telegram from Ansel Adams
to Douglas MacAgy, 1945; letter
from Mrs. Charles deYoung Elkus, Jr.
to Eldridge "Ted" Spencer, 1945.

typed letter to MacAgy. Publicity, tuition fees, equipment and plumbing requirements, as well as precise descriptions of sink and table specifications, were all detailed for this initial class at CSFA. Adams was eager to begin teaching and planning for the future of the department. He recognized that the venture would consume much of his time, and he was driven to complete other extracurricular projects, including a "series of 6 books on technique for Morgan & Lester" that would eventually include *Camera and Lens, The Negative,* and *The Print.*[32]

The beginning of the 1945 fall semester brought the first of the G.I. Bill students, and the school's precarious financial situation began to ease. The improved fiscal picture made it possible for the board to risk Adams's course without fear of going over budget if grant money failed to materialize. On October 18, the School Committee of the board recommended "two four-week sessions on photography by Ansel Adams."[33] Realizing that the delay in grant funding would prohibit the department's inauguration and the subsequent publicity, Adams worried about low attendance in the class, which was to begin on November 19, so he quickly identified "enthusiasts" from his previous year's lecture series as well as others who would enroll, including "a young sailor" stationed in San Francisco, "Mrs. Simon Bolivar Buckner [and] Patsy Farbman . . . three out of fifteen as a start!" Adams promoted the course, conducting a radio interview with station KQW on November 12 and hurriedly notifying Bay Area camera clubs.[34] The November issue of the SFAA *Bulletin* announced the sessions "for advanced amateurs and professionals." The classes "will be devoted to the fundamental techniques and esthetics of photography, including visualization, exposure, development, printing, and presentation." The course was to be limited to twenty students, who would attend "group instruction" on Mondays combined with "exclusive, individual instruction" through the rest of the week while working on specifically tailored photographic assignments.[35] By this time, Adams had no doubts about the future of the skeletal photography program, even without instructors, a facility, or funding. He wrote to prospective student Sgt. Phil Hyde on November 1: "This is confidential but . . . we are hoping to establish the most advanced and effective photographic School in the country . . . We are awaiting a grant . . . Please keep this hush-hush until it materializes." In soliciting him for the program, Adams warned Hyde that he should not "be taken with the idea that technique is the only requirement, or that photography can be mastered in a year! It is just as tough as music, architecture, or painting—if it's going to be good."[36]

On the day that Adams wrote to Hyde, Mrs. Charles deYoung Elkus, Jr., executive director of the Columbia Foundation, sent a letter to Spencer informing him that the school's grant had been approved for $10,000 "for the establishment of a Department of Photography at the California School of Fine Arts."[37] MacAgy and Adams moved quickly to promote the now official new program. By November 9, there was already a typed list of museums, colleges, schools, businesses, and organizations that would receive the nearly one hundred posters publicizing the upcoming "special course in photography." Adams wrote again to "Friend Hyde" that "O.K.—your name heads the waiting list" for the opening of the official department by fall 1946.[38] The press release announcing the new department was a combined effort by MacAgy and Adams. MacAgy wrote that "the new department . . . will be based on a unique pattern, a pattern not only related to the program of the School as a whole, but to the requirements and promise of the postwar creative and vocational world." Adams stressed that it would be "similar to the program of a musical conservatory," with "thorough esthetic and practical training and not superficial exposure to vocational fields."[39]

As always, Adams found himself busy with a number of projects—reworking his plans for the department, continuing his book series, and worrying about his friend Edward Weston, who

1946

International Events

Europe and Japan begin rebuilding after WWII.

British leader Winston Churchill gives "Iron Curtain" speech.

The Nuremberg Trials condemn twelve Nazis to death.

National Events

Republicans win a majority in both the Senate and the House of Representatives.

The US conducts atomic tests on Bikini Atoll.

As WWII veterans return home, the birth rate increases by about 20 percent.

Under the G.I. Bill of Rights, WWII veterans head to college in record numbers.

Labor unrest and strikes develop across the country as wartime economy ends; women, African Americans, and Hispanic Americans must give up their jobs to men returning home from war.

Science & Technology

First mobile telephone call; Kodak Ektachrome invented; first digital computer (ENIAC) invented.

Culture

Art: *The Pit* by George Grosz, *Brothers* by Ben Shahn, Alfred Stieglitz dies.

Architecture: Ranch-style houses are popular.

Literature: *The Common Sense Book of Baby and Child Care* by Benjamin Spock, *The Member of the Wedding* by Carson McCullers.

Film: *The Best Years of Our Lives, It's a Wonderful Life, Notorious.*

Theater: *The Iceman Cometh, Annie Get Your Gun.*

Music: "There's No Business Like Show Business," "Shoo Fly Pie," "On the Atchison, Topeka and the Santa Fe."

Television: First musical variety show, *Hour Glass;* first soap opera, *Faraway Hills.*

Radio: *The Bickersons.*

‹It was learning in the Grove of Akademus.›
—IRA H. LATOUR, 1996

This page: Ansel Adams, *Ira H. Latour, San Francisco,* 1945.

Opposite page: Ira H. Latour's exposure record, 1946.

was separating from his wife, Charis. At the same time he immersed himself in the first four-week course. That class enrolled fifteen students, including Lee Blodget, Ensign Arnold M. Wheelock, Ellen Bransten, and Hinsdale Ira Latour, who later wrote that students were with Adams constantly throughout both of the four-week sessions and even "unofficially, throughout most of the holiday period," making for a nearly "three-month continuum earning ten units of academic credit." Latour wrote that "almost every day we were with Ansel, and since he made his home darkroom available, we were with him many evenings and weekends." The "Special Course" was "intensely stimulating, rather freewheeling, and a bit chaotic . . . It was learning in the Grove of Akademus."[40] Adams used class time to make photographs for the Morgan & Lester book series—four portraits he made of Blodget, for instance, were later used to illustrate artificial light in *Ansel Adams: The Negative.*[41]

To fulfill his new administrative duties for the school, Adams outlined an eighteen-week Basic Plan of Curricula for the first semester of the program, which was to begin in the fall of 1946. Course titles included History and Esthetics, a Technical Lecture, Class Demonstration, and Print Criticism. Students were also to participate in Photo X . . . Personal Instruction and Photo Z . . . Field or Studio Work. Adams formulated many of these ideas with students over lunches and dinners in San Francisco, as well as in class and in what Latour called their "makeshift darkroom, The Cubicle."[42]

The anticipated 1946 summer session would be a special case, Adams wrote, to allow the school "to clear up various 'bugs' in the studio, lab and general operation." It would also serve as a "screening course" for the first entering class and should be "very intensive and . . . reveal with its 6 weeks' span the abilities—or lack of them of the students." Future summer sessions, beginning in 1947, would serve as a "buffer course to enable regular day students to perfect their work and to round out missing or weak aspects of their knowledge." Adams envisioned the summer program as an integral part of the main fall and spring day school, but if it were decided to make the summer a "separate entity," he suggested the photography course be a "specialist class either for advanced professionals . . . or for students of landscape and outdoor portraiture."[43]

Although Adams recommended establishing a night school auxiliary to the photography department, he thought it "should not be addressed to the casual amateur or the hobbyist" but rather to the "serious amateur" and "professionals." By the end of 1945, interest in the program had grown so much that Adams was receiving many inquiries about the school and felt it was "time we prepare a short preliminary description of the course" so that potential applicants could receive information directly from the school.[44]

The second session of the initial Special Course regrouped on January 7, 1946, now with twenty students, six continuing from the first session—Anna Elges, Bransten, Latour, Walter Treadwell, Fritz Kaeser, and Wheelock. Adams was once again thrilled to be teaching and obviously impressed with the students. Required materials for the second special session included Adams's recently published "Exposure Record," along with *The Photo-Lab Index.* He wrote to Nancy Newhall, "The class opened today. . . more than full! About ten people want it continued as is until the main department opens for the summer session. Ouch! How am I going to do my work and keep my promises is a question that is beginning to trouble me."[45] Adams did not want to abandon these cherished students, but at the same time, even before the initiation of the formal opening of the department, he questioned his ability to pursue all of his projects as well as run CSFA's photography program. He continued to elaborate on the plans for the department, now armed with the experience from teaching the two special courses. He reported to the School Committee that there should be "three types

EXPOSURE RECORD
Designed and Copyright 1945 by
ANSEL ADAMS
131 24th Avenue, San Francisco 21, California

SHEET NO. ②
FILM ISOPAN
SIZE 4-5
DATE LOADED JAN 46
DATE EXPOSED JAN 46

PLACEMENT OF SUBJECT INTENSITIES ON EXPOSURE SCALE

	64	45	32	22	16	11	8	5.6	4	2.8
REL. LENS STOP F/	64	45	32	22	16	11	8	5.6	4	2.8
REL. EXP. FOR V	1/32	1/16	1/8	1/4	1/2	1	2	4	8	16
REL. EXP. FOR I	1/2	1	2	4	8	16	32	64	128	256
WESTON SCALE	–	U	–	–	A	↓	C	–	O	–
ZONES	0	I	II	III	IV	V	VI	VII	VIII	IX

NO.	SUBJECT	0	I	II	III	IV	V	VI	VII	VIII	IX	FILM TYPE OR SPEED	F.L.	EXT.	X	NO.	X	STOP	EXP.	DEVELOPMENT
1	TOMBSTONE, BLANCHE, FRANCE			13		50			500			50						25	1/10	30 MIN. D23
2	STONE AND TREE			13					500			50						36	1/5	AT 68°
3	GERMAN STONE, SHATTERED			13			150		800			50						36	1/5	"
4	HANNAH KIRK - STONE				25				800			50						36	1/5	"
5	SKY LINE & ROW OF HOUSES				50				800			50						22	1/25	" X
6	WM. BLACK . STONE				6.5				400			50						36	1/2	"
7	GERMAN STONE (RETAKE)			25			400					50						36	1/10	"
8	WM BLACK (RETAKE)		13				400					50						36	1/10	"
9	JAMES REYNOLDS			15			300					50						25	1/10	"
10	BRIDGIT McCARTY NO ①			25								50						36	1/10	"
11	BRIDGIT McCARTY NO ②			13			200					50				•		36	1/5	"
12	ALLEY WAY & LAUNDRY				13				200	400		50						36	1/2	30 MIN. WATER BATH

PHOTOGRAPHER: X REDUCED IN FARMERS PLACE: CATHOLIC SEMITARY JOB: REMARKS OVERLEAF

REMARKS:

EXP. NO.	REMARKS	NEG. FILE NO.
1	DEEP SHAD. ON GRASS 13 . STONE 50 - LIGHT 500	
2	SHAD. ON WALL 13 . LIGHT ON STONE 500	
3	DEEP SHAD. ON GREY STONE 13 - LIGHT ON GREY STONE 150 - ON MARBLE 800	
4	SHAD. 25 - LIGHT ON MARBLE 800	
5	SHAD. IN FORE GROUND 50 AVERAGE	
6	SHAD. IN GRASS 6.5 LIGHT ON MARBLE 400	
7	SHAD ON GRASS 25 - LIGHT ON STONE 400	
8	SHAD. ON GRASS 13 - LIGHT ON MARBLE 400	
9	SHAD ON GRASS 13 - LIGHT ON MARBLE 300	
10	SHAD ON GRASS 25	
11	SHAD ON GRASS 13 - LIGHT ON MARBLE 200	
12	SHAD. 13 - LIGHT ON BUILDINGS 400 - SKY 200 - 30 MIN. WATER BATH	

of courses," with the "day course aimed at students who intend to become creative photographers of
professional standing." This group should be limited to thirty students "who enroll for the full course
of three academic years." The day students would be required to enroll in MacAgy's The Arts in
Contemporary Life class as well as enroll in elective courses in other departments.

Although Adams was less sure about the summer session, he still considered it a "screening"
course that might lend itself to thematic projects. He was more specific about the night course—it
would meet for three evenings a week [and] would consist of lectures, criticisms, and demonstra-
tions with no use of the lab facilities. Adams had also secured $150 to begin purchasing the photog-
raphy titles that had been suggested by Beaumont Newhall the previous summer. By March 1946,
Adams had laid out his plans for spending the $10,000 Columbia Foundation money to equip the
CSFA photography lab—$5,300 would be for photographic equipment for studios and darkrooms
and $4,700 would be spent for installation. In a letter to MacAgy, he listed an assortment of lighting
equipment, cameras, timers, densitometers, enlargers, tripods, lenses, and so on to be purchased,
as well as a schedule for their acquisition in four stages, beginning prior to the summer of 1946 and
lasting until the spring of 1948.[46]

In the midst of establishing the CSFA photography department, Adams was embroiled in the
New York Museum of Modern Art's squabbles concerning Edward Steichen's appointment as the
museum's director of the Department of Photography. Adams thought Steichen "the anti-Christ of
Photography," and by April he resigned his membership on the museum's Advisory Committee
on Photography.[47] This was particularly ironic given Adams's close friendship with Edward Weston,
whose 250-print retrospective curated by Nancy Newhall had just opened at the museum on
February 11, 1946.[48] By March, Beaumont Newhall resigned his position at the MOMA because
of differences with Steichen. Accordingly, Adams hoped to arrange for both Nancy and Beaumont
Newhall to participate in some way at the beginnings of the CSFA's photography department during
the summer of 1946. Beaumont Newhall wrote to Adams that he and Nancy may "take advantage" of
Ansel's "hospitality . . . that we can work in the school this summer."[49]

Adams's staffing plan for the summer course included himself and Beaumont Newhall as instruc-
tors and Elliot Finkels as the "technical assistant and lab superintendent." Adams would handle the

This page: Pirkle Jones, *Nancy and
Beaumont Newhall in Ansel Adams'
garden,* 1947.

technical side while Newhall would concentrate on the aesthetics, with "interchange and coopera-tion wherever possible."[50] Although Adams had made a sincere offer to Newhall for a teaching appointment, MacAgy could not commit to his proposal until the uncertainty about the department was resolved by the CSFA School Committee. The lab still needed to be built and the budget was still in limbo. Newhall understood the situation and did not want to force MacAgy into rushing his decision about a summer 1946 faculty appointment. In May and June, Newhall would be teaching at the Institute of Design in Chicago as well as Black Mountain College, and he would arrive in San Francisco with "lantern slides . . . happy to give" lectures to both day and night school sessions. Newhall's prepared lectures included "The Tradition: Photography in the 19th Century," "Present Trends: Photography in the 20th Century," "Photographic Vision: An Introduction to the Esthetics of the Camera," "The Challenge of the Medium," and "Expression in Photography." These were talks that Newhall felt he could give at CSFA that "might ease Ansel's load somewhat . . . complement Ansel's instruction and prove of benefit to my fellow students." He wrote to MacAgy, "Both Nancy and I, for our personal benefit, want to take Ansel's summer course. Ansel has written me that he has already enrolled us." Newhall asked MacAgy, "Is it possible for me to take your summer course as a veteran? . . . To take the course without paying for tuition and to receive a subsistence allowance would be a real financial assistance to me just now."[51]

It must have seemed odd to MacAgy that the person whose recommendation was instrumental in securing the Columbia Foundation Grant to establish the photography department was inquir-ing how to become one of the program's first students as well as poised to be its first visiting faculty member. Because of MacAgy's reluctance to commit to Newhall, Adams reiterated his plan to have him as his fellow summer instructor, emphasizing that "it is quite probable that he will be signed up with a large Western Institution in the Fall, and I feel it would be advantageous" to have Newhall on the CSFA faculty. Adams had already titled Newhall's segment of the class "The Interpretative Basis of Photography" and reworked his proposed lecture series to include "The History of Creative Pho-tography, Contemporary Trends, . . . Criticism of Photography, and a final period devoted to a criti-cal analysis of the student's work. I know of none better suited for this." While Adams would split time with Newhall during the first summer session's day school, he would share the night school teaching responsibilities "with Philip Fein and guests who would teach individual classes in portrait and architectural photography as well as Newhall, who would teach 'Problems of Interpretation.'"[52]

By late spring, Adams had a comprehensive syllabus for the six-week summer session, with him-self teaching class periods devoted to "Functions of the Camera and Lens," "Demonstration," "Photo-graphic Visualization," "Printing," "Toning," and other technique classes, while Newhall would teach "Basic Photographic Esthetics," "Criticism of Problem Assignments," "Composition," "Photographic History," and "Contemporary Directions in Photography."[53] MacAgy and Adams agreed that Adams and Fein would teach the initial summer photo classes in 1946, but the deal to hire Beaumont Newhall fell through.[54] In his place, Nancy and Beaumont Newhall recommended Minor White, a photographer who worked with them at the museum.

While wrestling with MacAgy over the appointment of Newhall, Adams planned for building the much-needed photography lab. The $10,000 grant—initially fairly evenly divided between facilities and equipment—was quickly spent on remodeling a studio vacated by the Red Cross for the lab. By May 1946, $7,589 was committed to Beaumont Furnace and Sheet Metal Works to construct six small darkrooms and a large group darkroom complete with sheet iron partitions, stainless steel sinks, and appropriate electrical work. And this did not anticipate an additional

International

The U.S. Truman Doctrine establishes the American policy of "containment."

The U.S. Marshall Plan directs massive funds to assist European economic recovery.

National

The term "Cold War" is coined.

The National Security Act creates the Defense Department and the Central Intelligence Agency.

U.S. Gross National Product begins its historic postwar surge.

Jackie Robinson joins the Brooklyn Dodgers, becoming the first African American to play in baseball's major leagues since the nineteenth century.

Americans own approximately 40,000,000 radios and 44,000 television sets.

UFOs (unidentified flying objects) are reported throughout the summer in various parts of the U.S.

U.S. House Un-American Activities Committee assembles the "Holly-wood Black List."

Science & Technology

Holography invented; Bell transistor and microwave technology demon-strated; Chuck Yeager breaks the sound barrier.

Culture

Art: *Full Fathom Five* by Jackson Pollack, *Betrothal II* and *Agony* by Arshile Gorky, *Ulysses and the Sirens* by Pablo Picasso.

Architecture: Developers build Levittown, a middle-class suburb in Long Island, New York.

Literature: *Tales of the South Pacific* by James Michener, *Diary of Anne Frank*.

Film: *Crossfire, Miracle on 34th Street, Great Expectations, A Gentleman's Agreement*.

Theater: *A Streetcar Named Desire*.

Music: "For You, For Me, For Ever-more," "I'll Dance at Your Wedding."

Television: *Meet the Press, Howdy Doody, Kraft Television Theatre*.

$1,000 in electrical work, wooden tops for worktables, viewing boxes, window shades, and a ceiling for the large darkroom. "Thus," the School Committee concluded, the total for just the facility "will exceed the $10,000 solicited from the Columbia Foundation." Adams then had to request an added $1,500 for equipment to get the department up and running by the summer. Although concerned, the School Committee felt that changes in estimated costs for construction were to blame, and the Columbia Foundation was still positive in their choice of projects for 1945–46.[55]

There was also the matter of determining which students to admit to the summer program. Adams and MacAgy were optimistic that there would be plenty of postwar students from whom to choose. Consequently, applicants were asked to communicate with Adams as early as possible so that he would be "satisfied that their qualifications meet the standards of the program." Students were required to have their own equipment, consisting of "a 4×5 view camera of some good make, a good lens, . . . a Reis tripod, . . . a focusing cloth, at least six cut film holders, a Weston Master meter, and a carrying case." In addition, "students . . . are selected on the basis of their answers to a questionnaire and . . . by means of personal interview."[56] While orchestrating the facility construction and the hiring of faculty, Ansel learned that he had received a prestigious Guggenheim Fellowship. He wrote to Weston, "Yep! At last! Generous project—interpretation of the Natural Scene—National Parks and Monuments! Two years—perhaps three."[57] While Adams's plans were to change, he was still motivated to get the CSFA project off the ground.

Between May and June, the faculty for the summer photography program finally took shape. It included two established Bay Area photographers, both members of the f.64 group, Imogen Cunningham and Alma Lavenson. Cunningham was appointed to teach portraiture in the night classes alongside Lavenson, who would lecture on architectural photography. Listed among new instructors was "Minor White. . . Photography, 6 periods weekly, to replace Fein."[58] The summer day class was taught in Studio 18 beginning June 24, meeting six hours per day, five days a week for six weeks— a total of 180 hours for four units of credit. Twenty-six students were enrolled in the class, including class monitor Eliot Finkels, Muriel Green, Oliver Gagliani, Philip Hyde, Rose Mandelbaum, Richard Muffley, Raymond Piercy, Clifford Freehe, and Minor White, who first checked into the class on July 5.[59]

White arrived in July, and Ansel Adams met him at the train. Before White knew it, he later wrote, "the whole muddled business of exposure and development fell into place" the next morning, during a lecture by Adams on the Zone System. "[A]nd sitting up in class, my problems . . . cleared up, pronto! . . . The theory was crystalline clear . . . and I was out in the afternoon helping kids trying to do it. I think they probably knew more about it than I did; but some of them knew less, so I talked to those." This was the week of Minor White's thirty-eighth birthday, and although Ansel did not know it, by explaining the Zone System he had given White the "gift of photographic craftsmanship" as a present.[60] White wrote to Alfred Stieglitz on July 7 that he was "getting a few days of teaching in to help Ansel when he is busy with other things . . . My first class the other night was a delicious experience." He thought it particularly "interesting to watch and listen to the questions of the ex-servicemen" when they would ask about Stieglitz: "I am pretty darned happy to be able to give them first-hand knowledge of your kind of photography."[61] Within the first week, White was busy teaching "equivalents" as well as the Zone System. So began his "fabulous experiment" of "teaching camera work" at the California School of Fine Arts.[62]

This page: Imogen Cunningham, portrait of Alma Lavenson, 1942; Students working in the darkroom, c.1948.

Opposite page: Lisette Model, *Imogen Cunningham*, 1946.

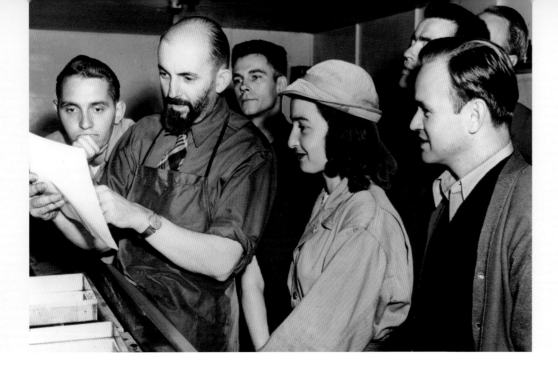

This page: Ansel Adams demonstrates darkroom technique to students (clockwise from upper left: Philip Hyde, John Bertolino, Pirkle Jones, and Muriel Green), 1946.

Opposite page: Al Richter, Minor White teaching, 1949.

According to the autobiographical sketch that Minor White provided to the school in 1948, he attended the University of Minnesota, where he majored in botany and minored in English, learning the "rudiments of photography . . . making photomicrographs of algae." White's desire to travel took him and his "faintly grim smile" to Portland, Oregon, where he "learned photography thru camera clubs," started teaching photography at the YMCA, and began work documenting iron front buildings for the Works Project Administration (WPA). White continued to work for the WPA in LaGrande, Oregon, where he produced a set of fifty prints of rural Oregon that were exhibited at the Portland Art Museum in 1941 or 1942. "Upon escape from the service . . . the less said about it the better," White spent a year studying "Art History, Modern Art and Sculpture, Philosophy of Art, etc." at Columbia, where he "gathered . . . the foundation of the courses now taught at the CSFA Photo Department."[63]

Nancy Newhall wrote to Adams in July to express her happiness that White had made it to San Francisco; "Glad Minor's there at the School. Give him our love." Adams replied, "Me I'm OK. Minor is OK School fine. Much to say . . . Minor is a perfectly swell egg."[64] By the third Thursday in the six-week course, Adams took a long weekend to Yosemite—"Doc here thinks I may have neuritis. Hope it is that simple!" He wrote to MacAgy that he was "pleased with White's approach and enthusiasm," and he obviously felt comfortable enough to leave the class in White's hands for a few days after knowing him for less than a week. Adams was "greatly pleased" at the results of the day class "in spite of the delay in the labs." He was disappointed, however, with the 1946 summer session's night school. It had enrolled forty students, but "quite a few rank beginners signed up." Adams emphasized: "We are not conducting a beginners School." He thought it imperative to "have a better preliminary organization," so he suggested that White take the responsibility for the night school and "arrange for the various instructors," while for the next semester Adams and White would teach only the "basic technical and esthetic ideas—say two weeks each out of the 18." For the day class, Adams thought it could be evenly split between himself and White, with the other teaching period per week going to MacAgy's class in aesthetics.[65] However, as early as the third week of the summer session, while up in Yosemite thinking about his upcoming Guggenheim fellowship to document the national parks, Adams was tapering back his teaching commitment in the department he had worked so hard to develop.

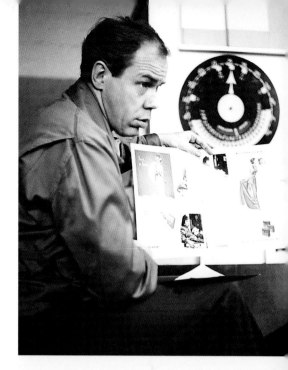

Adams recognized the difference between himself and Minor White and how this distinction would affect the students and the program at the CSFA. "Minor was a very different person and teacher from me," Adams wrote in his autobiography. "It was the inner message of the photograph that most concerned him; he always wanted to know the thoughts, feeling, and reactions of the artist to his subject and his image." Adams realized that after observing White's teaching "over the space of a few weeks . . . that Minor was a remarkable photographer and a potentially great teacher."[66] For his part, White thought Adams "brought to the department his famous discipline of technique," while he "brought . . . academic teaching methods."[67] As Latour would write, White was "the intellectual and academic component Ansel had felt essential for a program of excellence."[68] His teaching skills were exemplary. White understood that "the zone system is a means of linking the science of sensitometry to the art of picture content,"[69] and he could demystify the complications of the system for students. Adams described White's teaching method as one of "intense 'verbalization'—the talking out of creative intentions, concepts, and directions."[70] Indeed, according to students, "it was not uncommon for him to spend an hour on one photograph probing always for deeper, more personal responses." Both Adams and White were "deeply committed to an objective approach to photography," and "at parties and around the School" they "dealt with their differences . . . by baiting one another affectionately to the students' delight."[71]

Between 1946 and 1956, over two million veterans attended colleges across the country on the G.I. Bill. As a group, these students were inquisitive and motivated. "They had a degree of acuteness and sophistication of interest which was quite unlike what had been before."[72] At CSFA, nearly half of the school's total fall 1946 enrollment used G.I. benefits.[73] The postwar students embarking on the new photography program were, in White's words, "full of plans after the long futility of no planning; older, most of them experienced in photography" and "in school because they chose to be."[74] According to MacAgy, nearly five hundred students applied to the photography program, but the "capacity of the laboratory facilities limited" the number of students to thirty-six, of which thirty-one were "veterans, including one of the five women." Two of the students had no experience, while one "had interrupted a professional career to attend school." The majority of their photography training seemed to have been "provided by the armed services," while the entering group's education ran the gamut from high school graduates to some students with college experience and BA degrees, to one who had a "Master's degree from a mid-western college." The class included one African American student and one Japanese American student.[75]

White thought that "the caliber of the students was exceptionally high." Averaging twenty-seven years of age, "their war experiences gave them a maturity not ordinarily found in first year classes." According to White, the two aims of the first year were "mechanical competence" and to "introduce the student to esthetics and to the expressive phases of photography."[76] First-year student Pirkle Jones recalled, "There was great emphasis on the 'western school' of photography . . . the f.64 approach."[77] The first semester was certainly a lesson in both technique and "expressive" photography with the team teaching of Adams and White. As Adams wrote, "the students do reflect my 'influence' and—joking aside—maybe I should stop fussing around and just be an 'influence.'" He informed Spencer that "most of the students could command basic mechanical problems" after only twelve weeks. "They were much more advanced than I had dared to hope—mechanically and aesthetically." Adams declared the first-year students "outstanding and advanced in relation to

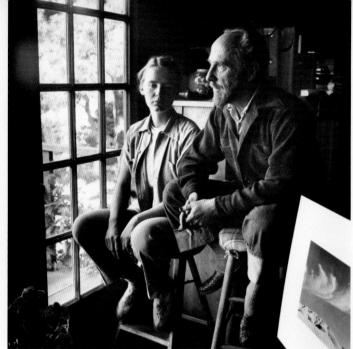

any other . . . I mean it in a very objective, impersonal way." Then he commented to his friend, "you know me well enough to discount personal conceit."[78]

In December, Minor White made his way south from his residence at Adams's home near Baker Beach in San Francisco to Carmel and Point Lobos, where he met Edward Weston for the first time. This proved to be not only a personal, creative, and photographically significant milestone in his life, but it would also be of immense importance to the future of the school's photography program and its students. Over the next couple of years, White and his students took numerous field trips to Lobos, where they met with Weston.

There were serious concerns about the sustainability of the night photography classes, which had begun with an enrollment of thirty-six students in the fall but had dwindled to eight by the end of the semester. This prompted the board to allocate "$36 for three lectures to local photography societies" to recruit the advanced amateurs necessary to fill the night school class.[79] In revamped plans for the spring night class, Adams and White divided the eighteen-week semester into three sections: "Mechanics," which included "Visualization" and the "Zone System"; "Space Analysis," which included the "demarcation between 'psychological' analysis and 'esthetic'"; and "Creative Approach to Subject," which included "The Creative Condition and Theory of Equivalents." Of the fifty-one class sessions, Adams was scheduled for five; the first two would introduce the "scope of the course, . . . visualization, . . . exposure," and the "nature of light"; he would reappear in week six to do two classes on "filters and orthochromatics" and "flash and syncro-flash"; then he would attend the "print critique" in week seventeen. The rest was left to White. By this point, Adams and White decided to include beginners, as "demonstrations and lectures will treat the basic techniques of photography, with special emphasis on the mechanics of the small camera . . . and view camera."[80]

The spring 1947 enrollment for the school increased to 493 students, up from 463 the previous fall. Veterans represented 270 of the total. There were 106 students in the commercial program of the school, 94 in fine arts, and 34 in photography. After the successful introduction of photography, MacAgy expanded his sights and hired Sidney Peterson to teach filmmaking during the spring term.[81] The semester began on January 6. Adams's Guggenheim grant had "tipped the balance" in his "struggle for enough time" for his own work, and by January 25—after the third week of the

This page: Al Richter, Minor White, c. 1948; Fritz Henle, *Edward Weston and Charis in Their Home,* Carmel, 1941.

Opposite page: Attendance record, summer session, 1946.

Upper ledger (gradebook spread):

Term Began August 19, 1946 Subject Photography TWENTY WEEKS Term Ended Dec 20, 1946 Teacher M. White

SUMMARY Term and Semester Grades

Period	1st WEEK	2nd WEEK	3rd WEEK	4th WEEK	5th WEEK	6th WEEK	7th WEEK	8th WEEK	9th WEEK	10th WEEK

1. Ash, Donald
2. Amigo, Fred
3. Bancroft, Catherine
4. Bram, Denny
5. Benfield, Harold
6. Currie, Dorothea
7. Carpenter, M.F.
8. Chas, F.A.
9. Chen, Hank
10. Collins, M.
11. Collins, Dom
12.
13. Dougherty, Thos.
14. Hall, Kenneth
15. Hale, Julie
16. Hyman, Harry
17. Hulmer, Raymond
18. Heick
19. Harrison
20. Hayamura
21. Hyer, David
22. Lynch, W.
23. Lehman, John
24. Moose, C.A.
25. McClintock
26. Petty, Cliff
27. Polaski, Stanley
28. Presto
29. Rhinlander, F.H.
30. Rogers, John
31. Ramage, Fred — Cancelled
32.

Lower ledger:

Week of:

	6-24 M T W T F	7-1 M T W T F	7-8 M T W T F	7-15 M T W T F	7-22 M T W T F	7-29 M T W T F		Grades
Gagliani, Oliver								
Hyde, Philip								
Kelly, Ralph W.								
Knight, Philip B.								
Levy, Clifford V.								
Loze, Stebler								
Mandelbaum, Rose								
Maesa, M.G.								
Meek, Nail								
Meyer, Richard								
Muffley, Richard								
Gillman, Ruby								
Nickson, Roy								
Piercy, Raymond								

eighteen-week semester—he left San Francisco to photograph in "Death Valley for at least a week —then on through Joshua Tree . . . to Phoenix and Tucson . . . El Paso, Big Bend, Carlsbad and White Sands—then onto Santa Fe, Taos, Shiprock, Grand Canyon, and S.F." At that point he would return to the students, who were expecting the technical training they had been promised.[82]

Adams wrote to White from Joshua Tree to encourage him: "I am a bit worried about you . . . You are doing a grand job in every way . . . just figure out what the kids [at CSFA] are getting in relation to any other photo school! Don't squeeze too hard . . . don't worry . . . take it more easy, please . . . You are too good to waste upon the academic air." Adams needed this separation from the school: "Looking back on the immediate past, I wonder how I avoided blowing up." He complained to White about the "fussiness of Aesthetics, of Modern, of Mode, of Non-objectivity, of the abstract, of the surrealist's pregnancies—it seems remote, actually *outdated!*" The academic jargon and the immersion into MacAgy's avant-garde crucible had taken its toll. He needed to be roughing it in the national parks of the southwest with his camera, "the hint of clear air, and the organic life of clouds." Because White was living in Adams's home, next to Adams's mother and father, he wanted to make sure White would "peek in on his parents," but warned him: "Don't be too good!"[83]

This correspondence must have made White wonder about the status of his own Guggenheim application, which he had submitted the previous year. It wouldn't be until April that he would get the news that his proposal for a grant to support a "writing project to produce . . . an illustrated text" for photo students had been denied by the Guggenheim Foundation.[84] On his sojourn through the national parks, Adams wrote to Spencer of his intentions "to be a photographer—an artist . . . I am afraid that Committees, Executives, Cooperation (such as it was) has now passed into the Age of Determination. (If you have an effective remedy for a black eye, will you tip me off?)" He obviously felt beat up, but he reassured Spencer that despite his abandonment of the department they had started, it was in good hands: "I have every confidence in Minor White. His coming was literally a gift from Heaven! I do not think the Board realizes how few and far between photography instructors are . . . that will support the ideals set forth in your general program."[85] Indeed, Adams wrote in his autobiography that White "swiftly established himself as one of the most important teachers at the school and endeared himself to the art community."[86]

The spring 1947 semester incorporated a term project titled Power and Light in the San Francisco Area. Students photographed "steam plants, hydroplants, distribution, and the use of power by industry, farms, residential, cities and transportation." The class had access to Pacific Gas and Electric resources during the semester, and it produced a portfolio at the end of the eighteenth week. By March, the quality of the photography sparked an interest in PG&E's publicity department, as demonstrated in correspondence from James McCullum, who inquired about the acquisition of photographs for the company.[87] It was to be the first of the class projects that became an integral ingredient in the department's curriculum.

In January 1947, Beaumont Newhall wrote to MacAgy to congratulate him on the fine start of the school's photography department and to inquire about the possibility of teaching the following summer. He had ideas for lectures that would, he said, "trace the development of photography as an art" and would teach students the "critical evaluation of photography in terms of a functional esthetic." MacAgy appeared pleased with Newhall's suggestion and responded that he was proposing two guests for the 1947 summer session, "one painter and yourself," although "Ansel has some notion about Weston, but that hasn't been worked out to any degree yet." Within days, however,

This page: CSFA catalogue, 1947–48.

Opposite page: Beaumont Newhall, *Ansel Adams at Mono Lake, East Side of the Sierra.*

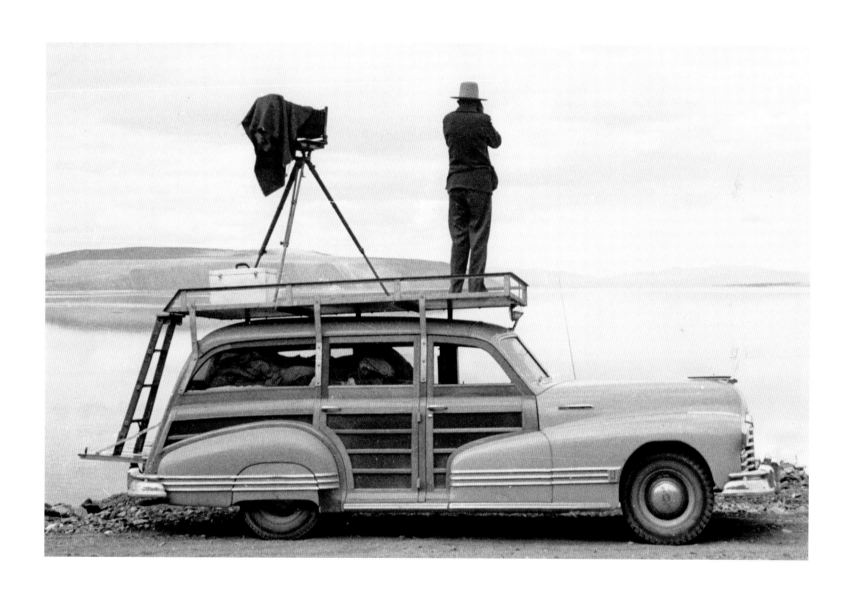

This page: Ruth-Marion Baruch, *Untitled,* from the Power and Light project, 1947; Rose Mandel, *Untitled,* from the Power and Light project, 1947.

Opposite page: Al Gay, *Untitled,* from the Power and Light project, 1947.

MacAgy wrote back to Newhall that the School Committee doubted the need for three photography instructors. Even though Adams and White agreed that "it would be swell" to have Newhall on the summer faculty, "they had had the notion that the summer should be devoted exclusively to field trips." White had proposed a summer session based around a Subjective Photography class that would consist of "field trips to record the forms found in nature, in industry, in cities" with excursions to Carmel, "to an industry . . . to record the designs of forms which a functioning engine creates," and to the streets of San Francisco to observe "transportation, business, living and recreation."[88]

By March 1947, Newhall was impatient with CSFA over its summer plans. He and Nancy were going to be in San Francisco in May to research a history of American daguerreotypes, and he needed to study material in West Coast collections. Although he wanted to stay through the summer to teach, he would leave by June for Black Mountain College, where he had been given a firm offer if nothing surfaced at CSFA. MacAgy responded to Newhall that "a sizable proportion of the photography students . . . have complained that they are not getting adequate technical education, and many of them plan to leave at the end of this term. These students are among the best." Consequently, MacAgy "felt immediate additions . . . must be made in the technical field," resulting in Newhall's "postponed invitation . . . until more spadework has been accomplished in the photography department." MacAgy apologized to Newhall for being "so slow in whipping things into shape . . . It would have been fine to count you in on our summer session this year."[89]

MacAgy's concern about student complaints was real. Many had expressed dissatisfaction, and the blame could certainly be leveled at Adams, who had only appeared for the first three weeks. However, when the students got the chance to volunteer for a Yosemite field trip to work with Adams in March, only eight signed up. Thus, White cancelled the trip, knowing that Adams would now be free to go off as he pleased, notifying MacAgy that "AA will love it!" MacAgy summarized what he thought were the complaints of "several photography students, including Lee Blodget," in a March 11, 1947, memo to the School Committee. The criticisms came "from some of the best students," and they "signified their intention of withdrawing . . . at the end of this term." Listed foremost among the students' criticisms was that "Ansel Adams was not here as advertised," and that "while White is excellent for aesthetic matters, he is deficient in knowledge of techniques."[90]

This page: Lee Blodget, portrait of Rose Mandel, c. 1947; Rose Mandel, *Nata Piaskowski,* c. 1946.

Opposite page: Minor White, *Evil Plants,* 1947.

White, of course, was well aware of the student revolt, and he had already written to Adams about it to deflect any guilt that Adams may have had about the fact that his desertion from the program was causing havoc at the school. White suggested "there are other causes for the general decline and feeling of depression" on the part of students. He thought the students' dissatisfaction stemmed from more than "the overt expression of missing" Adams's presence in the classroom, and he blamed himself for "the real reason . . . troubling some," as his first two assignments were "very hard on everyone—probably too much so. For instance told [Clifford] Freehe that his commercial work was up to professional level and that he ought to concentrate on the expressive. That upset him no end. And so on. So the first cause of depression . . . is the severe criticism of their photos."

White continued, "The second cause is still deeper, and not entirely clear to me." He explained that it began with "a lecture on the creative condition," in which White declared that "the basis of a man's art was his soul, his heart or his genitals . . . (you should have seen Eliot [Finkels] squirm—delightful). This statement was made prior to the Steam Plant pix [part of the Power and Light in the San Francisco Area term project]. Consequently many photos were made (including mine) which were obvious statements of sex symbols. There have been many reactions . . . from prudishness . . . through delight of the more virile or bawdy elements in class . . . to the profound concern of the more expressive elements in class. Rose [Mandel] in this respect has been very helpful, she knows a great deal about psychology, is not afraid of revealing her own thoughts via the photograph, and is a keen diagnostician of other people's photos (I owe much to her sensitivity and information)."

White's challenging lecture made it "possible to separate the sheep from the goats as well as the ones who have something to say from those who will be good commercial men and nothing more. The strong ones are appearing in all their strength."[91] White, in a memo to MacAgy, compiled a list of up to twelve students leaving the photography department, giving specific reasons why they decided to drop the program. Included were Blodget and three others who knew "they would remain no longer than one year"; Mandel, who had accepted a job at the University of California; Dwain Faubion, who "is ready to start a business in a small town . . . and proved to be one of the ablest students"; two students who were "doubtful material" and "seem to be psychologically a bit twisted"; and one student who was "without imagination and not enough intellect."[92]

Even though Adams was busy with his national parks project and not involved in the School on a daily basis, he was always concerned with the program's development and with the students and faculty. By the end of the 1947 spring semester, Adams, White, and MacAgy were ready to go back to the Columbia Foundation for more money to improve the photography department's facilities. Adams listed $7,000 in improvements that he hoped MacAgy would use to justify further funding. Adams thought, "If we ask for $10,000 we *MIGHT* get it!" Included in Adams's proposed $7,000 facility improvements were eight Kodak Precision enlargers, eight lenses, exposure meters, camera back adapters, enlarging easels, Kodachrome adapters, $1,250 worth of lighting equipment, and $3,000 for establishing a color laboratory.[93]

Adams's first-year departmental report advocated facility and equipment improvements. Especially important, as the program got closer to its third year, was the funding for the color laboratory, "complete with air-conditioning and thermal control of water." The color lab would be essential for the school to compete with other photography programs. Adams's report expressed extreme pride, claiming "there is no doubt that the Department . . . is unique . . . It is the first institution that has presented photography both as a practical profession *and* as an expressive art form." He stated that

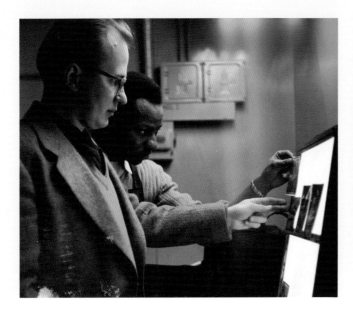

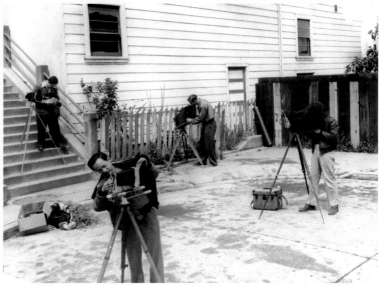

This page: Al Richter, portrait of Bill Quandt and David Johnson, c. 1947; Bill Heick, view camera class (clockwise from upper left: George Wallace, John Bertolino, unknown student, and Benjamen Chinn), 1948; portrait of Al Richter, c. 1948.

Opposite page: Pirkle Jones, *Court of Arches, Stanford University*, 1947; Al Gay, portrait of David Johnson, 1946.

the original plan of "basic training in techniques and esthetics" had been "amplified [as] students accomplished much more than had been conservatively anticipated." Adams left the rest of the report, including the student appraisals, to Minor White, who, he declared, "is the logical person to carry on the activities of the Department."[94] Although White had been dealing with the day-to-day administrative and teaching duties since January, the official torch had been passed. Adams assured MacAgy of his "continual interest and . . . desire to cooperate in every possible way" with the future of the school's photography program.[95]

Twenty-eight students finished the first full year in the new program out of the thirty-six who had enrolled in the fall of 1946 and the thirty who had begun the spring semester. Sadly, White reported "there was one death during the term." He thought the "caliber of students exceptionally high," which he credited to the fact that most were veterans. White, like Adams, was quick to acknowledge how their "maturity and intense interest in photography . . . speeded progress far beyond expectations." He judged that "four students are definitely potential artists, and at least six others probably are." He specifically highlighted the lone African American student, David Johnson, as a "potential documentarist," and Japanese American Geoffrey Shoji Doi as "an advertising photographer." "Five seem . . . heading into commercial work . . . The others are still to come to decisions . . . The second year program will undoubtedly reveal what their direction and expression will be." White was pleasantly impressed with two who "reached high levels of attainment which put them out of the 'student class.' One [Rose Mandel] was a Polish refugee . . . with a fine training and experience in art. Photography proved, to her . . . a liberation of profound creative energy." Equally impressive was Blodget, who had previously studied art at the school and found in photography the "medium which activated . . . his desire to create." White enthusiastically anticipated the development of his students, making sure second-year work would be "devoted to furthering communication to impersonal audiences and to the expansion of the student's personality through photographic experience."[96]

White must have been personally frustrated with the cancellation of his exhibition Amputations, which had been scheduled to open at the California Palace of the Legion of Honor in August. The exhibition was dropped because White refused to show the photographs without his accompanying text, which was "criticized for its length, . . . quality, . . . his emphasis on the private soldier," and

"his feelings regarding America's postwar patriotic stance."[97] Thus White devoted his attention to the 1947 summer session class, which would be limited to only ten new students, eight of whom would continue on into the day program for the fall term. The new students participated in their Subjective Photography field trips, while continuing students executed three commissioned projects, including producing thirty-five photographs for a promotional brochure announcing Pepsi-Co scholarships to high school students, an "imaginative treatment" portraying the campus of Stanford University, and a photography project documenting the work of architect Bernard Maybeck.[98] The Stanford commission undoubtedly was secured through the assistance of Spencer, who was the "supervising architect for all building projects at Stanford from 1946–1960."[99] Students Pirkle Jones, Albert Gay, and Rose Mandel, along with Minor White, worked eight to ten weeks in Palo Alto to produce forty to fifty prints documenting "the architectural, landscape, and environmental subjects" of the university.[100] The proceeds from the assignment were to be divided between the photographers, their expenses, and CSFA. Unfortunately, the cost of the project "was greater than anticipated" for a variety of reasons, not the least of which was the "10–12 hours on location" and "30 exposures" it took the four photographers for an acceptable picture" of the Stanford Post Office. Furthermore, "there existed an emotional tension slowing down the entire crew caused by having to make the photographs have a quality which no one felt to be consistent with the campus itself."[101] The commission illustrated concepts White had stressed in his educational thinking—that students were taught by doing, by experiencing the life of the practicing photographer—and the project utilized the "apprentice-tutorial-conservatory method."[102]

By the summer of 1947, it was necessary to find a replacement for Adams, who had transitioned into an advisor and visiting faculty member, so William Quandt, Jr., was hired to handle the technical aspects of the program. Quandt had been a student in the first year as well as a commercial photographer. He had also done publicity photography for his alma mater, San Francisco Junior College (now City College of San Francisco), photographic mural work at the 1939 Golden Gate International Exposition, and a host of photography-related work for the U.S. Army Air Force during the war.[103] While Quandt would concentrate on the technical, mechanical portion of the curriculum, White would approach the creative side. Homer Page, who had studied at the University of California and

the School of Design in Chicago with Laszlo Moholy-Nagy and Georg Kepes, was hired by MacAgy to teach along with White and Quandt for the fall semester.[104] Page, who first introduced the small-format camera, was particularly popular with some of the best students, like Ruth-Marion Baruch.

By May 1947, a complete questionnaire had been developed to assist in the selection of students. Questions revealed the kinds of students sought: "Are your abilities and preferences more mechanical than intellectual?" "Do you do things with your hands?" "What kind of music do you like?" "Why . . . a photography school rather than . . . college?" More revealing questions included: "Do you intend to aim for the high bracket money *reputed* to be available to the top-flight commercial or journalistic photographer?" "Are you willing to accept a low wage standard for most of your life in order to follow photography as a means of expressing yourself?" "In other words, do you wish most of all to use the camera as an art medium?" To elicit some sense of potential students' understanding of contemporary photographers and photographic history, question ten asked, "What are your impressions of the following photographers? Valentino Sarra, Edward Weston, Paul Strand, Edward Steichen, Lisette Model, Bernice Abbott, D. O. Hill, Alfred Stieglitz, George Hurrell, George Platt Lynes." And finally, prospective students were queried: "What cameras have you worked with?" "What experience have you had with photography?" and "What is your opinion of the present day Salon?"[105] Attached to the questionnaire was a supplemental sheet of requirements for accepted students "who expect to continue photography as a life work." Included was either a 4×5 or 5×7 view camera, a lens "as good . . . as you can afford," a tripod, and other miscellaneous supplies. As students advanced to the second year, they were required to have flash equipment, and by the third year a miniature camera. Also, students were warned that "housing in San Francisco is a problem."[106]

Twenty-two first-year students enrolled for the fall semester in August 1947, while sixteen continuing students started their second year. An additional thirteen students began the night school program. It was now White's department, and changes to the curriculum would reflect his philosophy. The photography curriculum included reading and writing assignments in something called "Creative Condition." Brief written reports on Richard Boleslavsky's *Acting: The First Six Lessons,* H. G. Bailey's *Story of a Face,* and *Tertium Organum* by P. D. Ouspensky were required. "The lessons learned from Boleslavsky . . . the principles of art history . . . converted to use by photographers, the psychological approach learned from [Meyer] Schapiro . . . the idea of the equivalent from Stieglitz" and the technique "learned from Ansel" would all become staples of the photography classes.[107] Students needed to outline their "mental approach while photographing," compose a brief essay on "the relation of Edward Weston to Point Lobos," as well as produce "10 to 15 photographs illustrating the concepts of Stylistic Analysis."[108]

White described how students approached "expressive" photography on three fronts: "subjective," "objective," and "equivalents" (from Stieglitz's term "used to derive a feeling" in his photographs of clouds). White found that "the self-revelation which the students . . . unexpectedly explored" when executing these "expressive" photography assignments "came from the unconscious rather than the conscious. Consequently psychoanalytic implications arose which threatened to lead into therapy rather than esthetics." In order to circumvent this, White put to use the "psychoanalytic approach to photographic expression" that he had learned from art historian Meyer Schapiro at Columbia, coupled with his years of studying Stieglitz's theory of "equivalents."[109] White wrote that "expressive photography" meant "photographing in such a way that the artist revealed himself, chiefly to himself and possibly to a few friends." "Creative" photography would "produce emotions in people generally" and was the goal of the advanced student. White wanted to pursue what he had explored

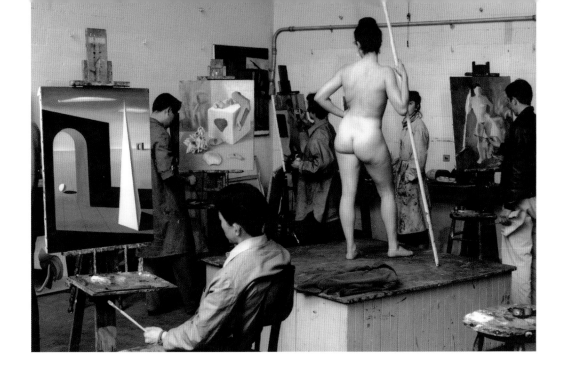

with students in the Power and Light project: "using photographs to reveal the inner workings of the photographer" as a "rapid way" to bring out "creative talent" and "enlarge or liberate that talent."[110] The curriculum would certainly attempt to "balance the expressive with the professional approach to photography," but there was the desire to encourage the student "to see with eyes of a poet."[111] White also needed to mesh his curricular interests for the photography students with MacAgy's overall educational philosophy for the school.

White struggled with integrating specific photography courses with the fine arts classes, as well as with how to get photography students to apply aesthetic issues, including "the expressive," to their photography. This was particularly apparent in his attempts to integrate the "space analysis" beginning class in photography with the introductory Design, Society, Artist class that was required of all students. First-term photography students were resistant. White said they questioned "why they had to study Picasso, Matisse, Dadaism, or abstraction, and all that modern stuff? Expressive photography is fine, but we have to eat someday." White reflected, "Once they could see the spirit in modern art, they could usually find it in photography." A typical schedule for photography students consisted of the schoolwide introductory class in the first semester, Elmer Bischoff's Drawing and Composition in their second term, Clyfford Still's Color Control at the beginning of their second year, and Hassel Smith's Life Sketch during their fourth semester. By the fifteenth week of the semester, White thought his first-year students "suddenly saw the connection" between photography and the issues discussed in the Design, Society, Artist course.[112] Aside from all the intellectual hand wringing over pedagogy, White knew that the "uniqueness of the program may be terminated with a . . . slogan: 'I don't want excuses, I want photographs!'"[113] White constantly adjusted the curriculum to incorporate these ideas.

Classes for the fall 1947 semester included Photography 51 for first-year students, covering the "mechanics of the camera and lens" and the "technical documentation of all work" as well as the "comparison of photography with the other arts." Photography 52, for second-year students, expanded to include the "special fields" of portraiture, landscape, illustration, documentation, and reportage. Listed, although yet to be offered, was Photography 53 for future third- and possibly fourth-year students, which was to include "individual concentration, . . . specialized activities, . . .

CALIFORNIA SCHOOL OF FINE ARTS
800 CHESTNUT STREET
SAN FRANCISCO 11, CAL.

Because of the great number of requests for entrance in the Photography class of Fall 1947, it has become necessary to ask you to answer a few questions. It will aid us greatly in selecting students for the Fall class if you will answer them as carefully as possible.

DATE:

NAME:

ADDRESS:

1. Age?

2. What schooling have you had?

3. Are your abilities and preferences more mechanical than intellectual?
 Do you do things with your hands well or only moderately well?

4. What kind of music do you like best?

5. Why do you want to learn photography?

6. If you have had <u>less</u> than two years of university or college training, why do you seek to enter a photography school rather than go to college or complete your work there? (It is recommended that all potential photographers obtain a college degree before attempting to become professionals, although this is not an essential condition of entrance to this school.)

7. If you have finished college, what was your major and minor and what extra-curricular activities did you have?

8. Do you intend to aim for the high bracket money <u>reputed</u> to be available to the top-flight commercial or journalistic photographer?

9. Are you willing to accept a low wage standard for most of your life in order to follow photography as a means of expressing yourself? In other words, do you wish most of all to use the camera as an art medium?

10. Briefly stated, what are your impressions of the following photographers?
 Valantino Sara, Edward Weston, Paul Strand, Edward Steichen, Lisette Model, Bernice Abbott, D.O. Hill, Alfred Stieglitz, George Hurell, George Platt Lynes.

11. What cameras have you worked with? What experience have you had with photography?

12. What is your opinion of the present day Salon?

(Please use separate sheet of paper for answers.)

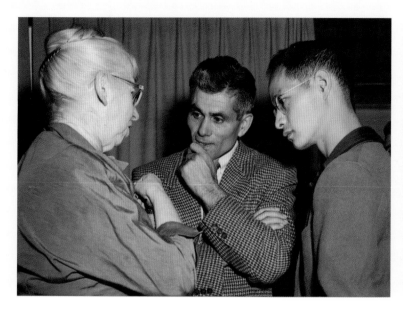

and advanced color photography." Photography 54 was designated as an optional postgraduate course of "advanced study on the professional level."[114] The evening classes were a basic refresher course for professionals and advanced amateurs, but began to serve more as a feeder course for the best students into the day program.

White immersed himself in his teaching at CSFA. He taught five days a week from 9 AM until 5 PM and then returned two to three nights a week to teach from 7 PM until 10 PM. Peter Bunnell suggests that "teaching relieved his loneliness because for him it became a form of parenthood."[115] Private conferences, which were scheduled in three-hour increments, would "extend indefinitely over drinks and dinner."[116] Every fourth Friday, students would gather at Ansel Adams's house, where White lived, and each would print up enough copies of their best image from the previous month to exchange with each other—up to thirty students and faculty. They partied, played music, talked, and drank. William Heick remembers the photojournalist Margaret Bourke-White being at one of the parties when she was in San Francisco visiting White.[117]

Adams wrote MacAgy from New York of his travels in the Midwest and the East in November 1947. He had "seen some good stuff. CSFA really best in many ways; supreme in photography!! THAT'S ego for you! But it is the truth . . . MMA Dept. of Photog. has gone to pot." Although not impressed with the Institute of Design's Department of Photography ("too much emphasis on non-realism"), he did think Arthur Siegel a "swell person. We need him for a month or so, and Chicago needs White for a month or so." Adams reported that "apart from Siegel and the Newhalls I have met no one available for the kind of teaching we believe in. It's sad, but true—there is a great dearth in teaching material."[118] CSFA was lucky to have access to good instructors, and especially good visitors. By 1947, Imogen Cunningham had become a regular visitor in classes, as had Dorothea Lange. White thought Lange's "contribution to the discussion was of the greatest value to the students."[119]

Increasingly, White's time was monopolized by struggles with administrative and curricular issues. New faculty needed to be brought in to accommodate a student body that, by the spring 1948 semester, included a spread of students between their first and fourth semester. Some of them were now poised for the color coursework, facilities needed to keep pace, and equipment purchases were essential. Curricular changes needed to be made to keep the first-year program vital. Looming over

This page: Imogen Cunningham, John Bertolino and Benjamen Chinn, c. 1947; F. W. Quandt, Minor White and Pirkle Jones, 1947; Clyde and Marge Childress, 1945.

Opposite page: California School of Fine Arts admission survey.

Above: Al Richter, class party, 1948;
Al Richter, Minor White, 1948.

Above: CSFA catalogue, 1948–49.

Opposite page: F. W. Quandt, CSFA
students Pirkle Jones, Pauline Pierce,
Al Gay, and Walter Stoy, c. 1948.

the entire school was the shadow of the approaching decline in veteran enrollment. Although
the school was only in the second year of benefiting from the G.I. Bill, there was concern about how
to plan for the future. For spring 1948, it was hoped that Adams would be available to launch the
first color class for the fourth-semester students. Instead, White recommended Clyde Childress, as
Adams continued to concentrate on his national parks and writing projects. Childress had trained
at Art Center in Los Angeles and had just started a commercial photography business in San Fran-
cisco. White considered him to be "a bright lively personality" with "a healthy suspicion of Art
Center methods." Although he recognized that Childress's work was "strictly commercial," he was
comfortable with him teaching the course in color, as Childress was "acquainted with Adams's
teaching technique and his mechanics."[120] There would only be a beginning course offered for the
spring 1948 night class, with Bill Quandt teaching mechanics and second-year student Al Gay teach-
ing composition. White suggested that by the 1948–49 school year, "90 percent of the instruction" in
the night class "be given by student instructors" and that it be coupled with a "well publicized short
lecture course . . . given by Adams, Weston, and White."[121]

Throughout the spring 1948 semester, White juggled administrative troubles while
trying to overhaul the first two years of the curriculum (Photo 51 and Photo 52) plus expanding
the Photo 53 class to accommodate the upcoming third-year students. Nineteen of the twenty-two
first-year students who had started in the fall of 1947 continued into the spring 1948 semester,
including Benjamen Chinn, Bill Heick, Phil Hyde, Helen Howell, Bob Hollingsworth, John Reed,
Al Richter, James Scoggins, George Wallace, Don Whyte, and Arnold Wheelock. Only eleven of the
sixteen second-year students registered for their fourth semester during the spring term, and White
wanted to make sure that their third and final year of the program would entice them all to finish.[122]
During the spring of 1948, Homer Page and Bill Quandt filled in for Clifford Freehe, who resigned
from the evening class in the middle of the semester. There were ongoing problems with scheduling
field trips, particularly White's class project to Benicia, which conflicted with Page's documentary
project class. White expressed his concern to MacAgy that Page had "given the impression" that
the third-year course would not be offered in the 1948–49 school year. He wanted MacAgy's

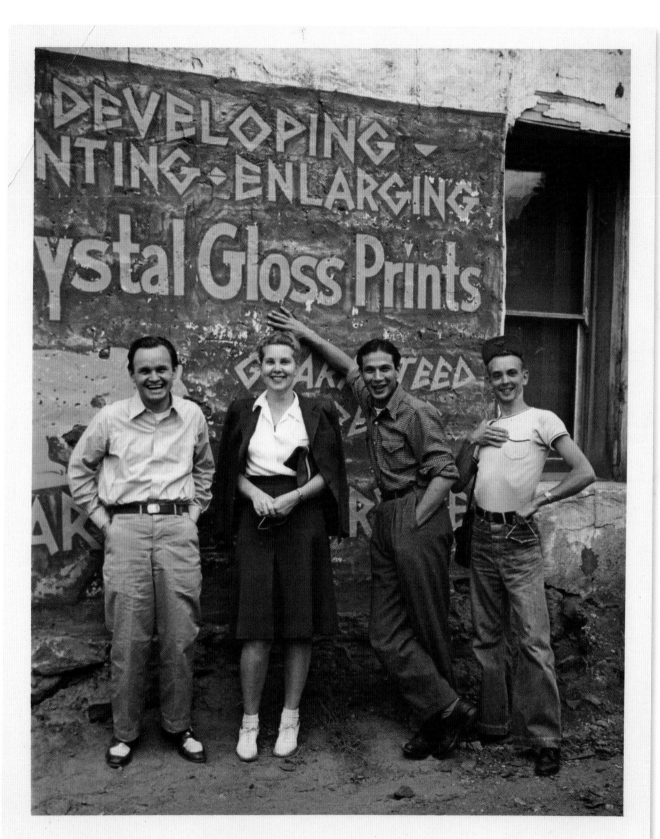

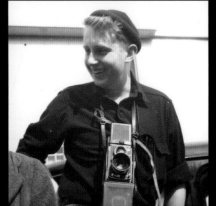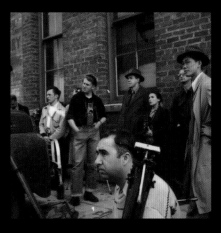

This page: F. W. Quandt, CSFA students, c. 1950; Minor White, from the San Francisco Museum of Art exhibition of photographs interpreting the town of Benicia, 1948.

Opposite page: Richard Rundle, *Edward Weston*, 1948.

assurance that the advanced class would be available to continuing students and yet was reluctant to confront Page.[123] The friction between White and Page must have continued through the rest of the semester. This was the last semester that Page taught at CSFA before relocating to New York, where he would eventually work with Steichen at the NYMOMA on the Family of Man exhibition.[124] White recommended to MacAgy that $3,000 be made available for "transportation, lodging and food" for several students "to make an interpretation of the drought situation." He envisioned that magazines, newspapers, and the Library of Congress "would welcome" the results of this documentary project.[125] MacAgy, although supportive of projects that would publicize the program and the school and possibly produce revenue, would not consider such a pricey venture.

White proposed a 1948 summer curriculum that would include a lecture course with three periods a week by Beaumont Newhall, a weeklong field trip to Carmel with Weston, and a color course taught by Childress.[126] He also worked out a much more detailed curriculum for the 1948–49 year, the third year of the program. The revamped Photo 51, for first-year students, included the basics of Photo Mechanics, Space Analysis, Print Production, as well as projects, field trips, and critiques. First-year field trips were scaled back to day trips to avoid the scheduling conflicts that had become apparent during the spring 1948 term. During the second semester, Photo 51 incorporated artificial light, "synchro-flash and synchro sun," as well as "special developers" and enlarging. The "expressive" portion of the first-year program would include "self-expression," "criticism, its theory and practice," the history of photography, as well as the "organization of space." Longer field trips for first-year students were planned for their second semester—a "4 day trip to Carmel . . . a 3–4 day trip to a nearby town . . . [and] a 3–4 day trip up the coast or inland."[127]

White's elaboration of Photo 52—the second-year curriculum—included portraiture, documentary, field trips, projects, "advanced mechanics," aesthetics, color transparencies, and critiques. His description of the fall classes included work with miniature cameras, documentation of "a street" and of "a group," and field trips. The spring term for the second-year students concentrated on shows and displays of prints, chemistry and physics, color printing, aesthetic concerns of space organization, sequencing photos into shows, and print criticism. Projects for the second-year students were to interpret "Point Lobos in Color," along with "Still Lifes in Color." Critiques would be rigorous

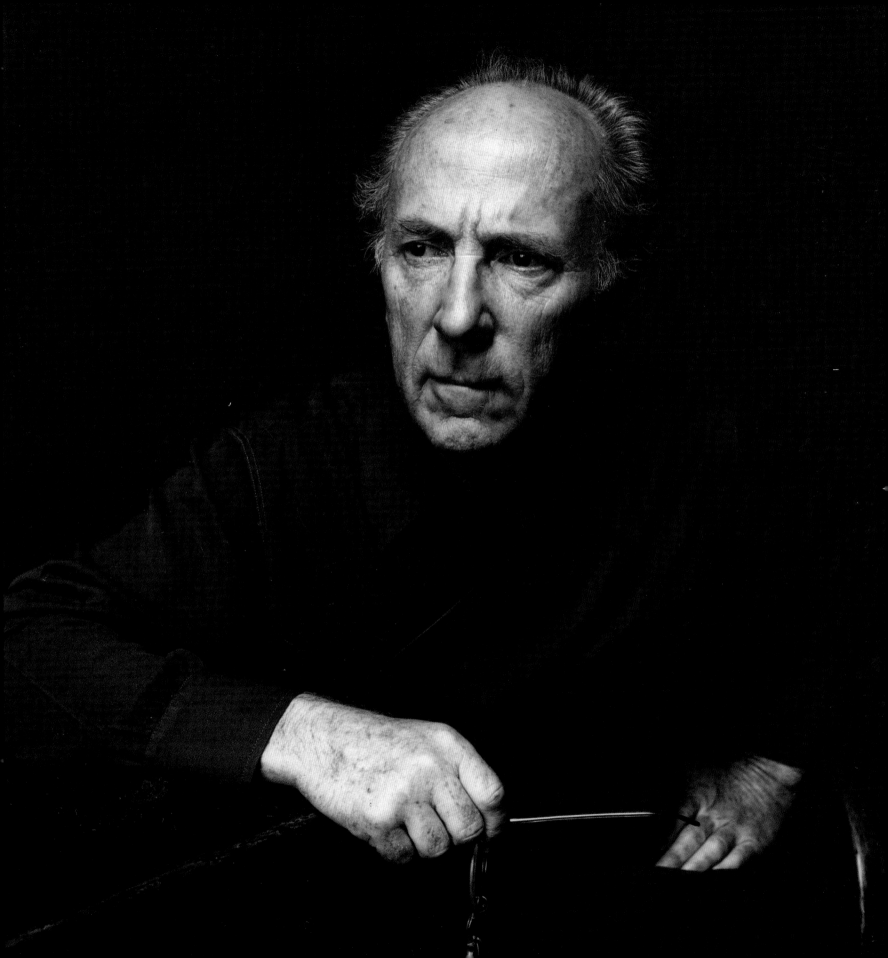

CONTRAST IN SCHOOLS

Examples of Two Ways of Teaching Photography

By JACOB DESCHIN

THE results of two methods of teaching photography are demonstrated in an exhibition of students' work opening Tuesday at the Photo League, 23 East Tenth Street. The show is a joint project of the league's school, which encourages shooting first and learning the techniques afterward, and the California School of Fine Arts, whose photographic curriculum as set up by Ansel Adams stresses mastery of technique. The nearly 100 prints by students of both schools will be shown through Aug. 1.

The show offers an instructive comparison between the results achieved by the two methods which, though having essentially the same goal, reach it by different means. Both urge the personal approach and both agree that expressive picture-making is not possible without a mastery of the technical problems involved.

Visualize Pictures

The California school, of which Minor White is director, starts with Mr. Adams' dictum that a student must learn to visualize a picture in all its technical detail as a print before the exposure is made. The league school, headed by Sid Grossman, gives the student only as much technique as he needs to solve a particular problem.

The teaching at the California school is exact, systematic and formal. Typical of the method is the thorough grounding the student receives in Mr. Adams' detailed code of tone identification. Before shooting a picture, the student measures the brightness of each area of the subject to determine how it will look in the print.

Other phases of photography as a craft are handled in similar fashion. The student is taught an appreciation of design and form and how to use this knowledge in the selection of picture material.

With careful drilling in the handling of equipment and materials, the student learns how to use the various techniques to get the maximum of meaning from his subject-matter, and how each phase of his training may be used to express himself with the greatest technical accuracy about the things he photographs.

Photographer's Function

At the Photo League School the student begins with an attempt to answer the question: "What is my function as a photographer?" The instructors help him by pointing out that his photographic work is not sealed off from the rest of his living, that photography is itself an act of living, a way of increasing his knowledge of the world, of seeing old things in new shapes with new meanings.

"The basic aim of the school," says Mr. Grossman, "is to help the student to understand the limitations and potentialities of the medium, and to learn to make his individual interpretations of his immediate world in terms of a progressively broadening understanding of the medium."

Minimum of Technique

The progressive educational method of the school starts the student off with the barest minimum of technique necessary to manipulate a camera, develop negatives and make contact prints. The student learns technique as he needs it.

As his experiences in photography develop a problem, he learns the technique necessary to solve the particular problem. The instructors try to suggest directions which they feel will lead students to provocative problems.

Mr. Grossman feels that a student gets more out of an explanation of why he failed to obtain a result he wanted in a picture than he does from a lecture before he made the shot.

"Through the progressive solving of problems as they arise," he says, "the student eventually achieves a personal style of photographing, not one dictated by the instructor."

The difference in teaching methods of the two schools is reflected in the type of work shown. That of the League school is characterized by spontaneity of expression and freedom from the restrictions of establishing techniques; that of the California school is deliberate, restrained, studied and subjective.

Despite the perfection achieved by the California students as compared with the work of the League in this respect, both appear to have similar aspirations—to make pictures with understanding and a growing appreciation of the medium.

"UNITY"

This picture by Robert Hollingsworth, a student of the California School of Fine Arts, is an unusual study in design and perspective. From the exhibit opening Tuesday at the Photo League, 23 East Tenth Street.

This page: *The New York Times*, article, 1948.

Opposite page: F. W. Quandt, Sr., darkroom blueprint (detail), 1948.

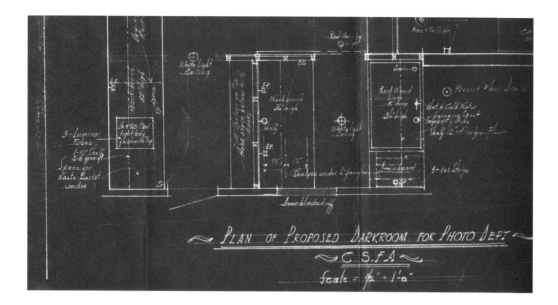

1948

International

U.S. directs reconstruction of Japanese economy and society along capitalist lines.

The United Nations creates the World Health Organization.

The Soviet Union blocks off Allied sections of Berlin; Berlin airlifts begin to supply Berliners.

Mahatma Gandhi is assassinated.

National

International Planned Parenthood Committee is founded.

The Evacuation Claims Act authorizes payment to Japanese Americans who suffered economic loss during imprisonment in U.S. internment camps.

McDonalds opens in San Bernardino, California.

One in ten Americans own a TV and watch an average of 17 hours of the available 42 hours of programming per week.

Science & Technology

Edward Land markets the Polaroid Land Camera; first LPs produced; synthetic penicillin developed.

Culture

Art: *Number 1* by Jackson Pollack, *Untitled, 1948,* by Mark Rothko, *Christina's World* by Andrew Wyeth, *The Kitchen* by Pablo Picasso, Robert Motherwell begins series *Elegy to the Spanish Republic.*

Literature: *Sexual Behavior in the Human Male* by Alfred Charles Kinsey. The phrase "The Beat Generation" is coined by Jack Kerouac.

Film: *Treasure of the Sierra Madre, Hamlet, The Red Shoes.*

Theater: *Kiss Me Kate, Mr. Roberts, The Taming of the Shrew.*

Music: Leo Fender invents the solid-body electric guitar, Miles Davis forms Miles Davis Nonet.

Television: *The Ed Sullivan Show, The Milton Berle Show.*

appraisals, both collective and individual, of the previous two years' worth of work, with discussions of related reading, and, finally, faculty would offer individual help in directions for the student's future.[128]

Photo 53 needed to be ready by the fall in order to give the department a full three-year program. White listed the prerequisites as both Photo 51 and Photo 52 or "two years of previous study in an accredited photography school," "creative work of a high order," "experience in the critical fields of photography and art," "editorial or writing experience in the field," "teaching experience in photography," or "approval of permanent instructor and director of CSFA." The class would be tailored so that advanced students could "bring to creative pitch any technique" that they wanted, and to offer students a type of graduate-level department to learn how to promote their work through research, publication, exhibition, and print production. The third-year seminar would "cover reportage, documentary, fashion, advertising, creative, historical, portraiture, art and photocriticism, teaching outlines, and possible teaching experience with the night class." Students would also be taught the "Theory of Equivalents," which was "the core of our approach to creative work, and incidentally is not confined to photography. The overtones of psychology in art is introduced in this series." Photo 53 would be designed for each student, with applicable projects chosen from first- and second-year classes, an individualized thesis project, seminars, and lectures "which would emphasize esthetics and the interpretation of photographs and photographers."[129] The regular faculty for 1948-49 included White—who would teach Space Analysis, Esthetics, Critiques and Criticism, Portraiture, and Space Organization six periods per week for a total of "216 periods per 36 weeks" of the two eighteen-week semesters—and Quandt, who would teach the Mechanics component of the curriculum along with print production, studio and lab instruction, and assist White with supervision in studio, field, lab, and color lab. The field trips to Carmel were designed as seminars with Weston for work in portraiture and the "natural scene," while Childress would teach the color classes and Bob McCollister would teach a special section, Optics, in the fall of 1948. White and MacAgy had yet to determine the guest instructor for the documentary seminar, although it was hoped to be led "by Dorothea Lange, and aided by Roy Stryker." This course would also include as many Farm Security Administration (FSA) photographers as possible as well as the "view points of Weston and Adams."

White also proposed a Photographic Presentation seminar that could be taught by MacAgy and run the gamut "from the portfolio display to museum installation."[130] The hope that Adams might appear was dashed when he received his second Guggenheim and consequently would be traveling through the end of the year. Adams wrote, "Perhaps then I can do a little teaching . . . but for this year [1948] it is out."[131] The expanded color curriculum prompted Childress to recommend an additional $944 worth of lighting equipment, which prodded both White and MacAgy to reconsider Ansel's idea from the previous year to go back to the Columbia Foundation for additional money to bring the facilities up to standard. MacAgy positioned the school for more funds by sending the foundation a three-page report on the status of the department, highlighting the achievements of the past two years, describing the disbursements on facilities, stressing the success of the "three important community projects" and how "the results to date have exceeded the expectations of the faculty."[132] At the same time, he and White instructed Quandt to work up proposals and plans for the expansion of the photography lab. Quandt and his architect father provided blueprints for a proposed new darkroom, anticipating the needs for third-year students doing enlargements, processing, and color printing. The sixteen-by-nine-foot darkroom would utilize the space in the "Red Cross" room, and "by judicious use of building materials" could be outfitted "for under $4,000."[133]

In May 1948, a set of prints produced by the second-year photography students was displayed at the San Francisco Museum of Art (SFMA) "interpreting the town of Benicia." A second exhibit of these photographs was held the following month at the Benicia Library. Students in the show included Ruth-Marion Baruch, Al Gay, Muriel Green, Pirkle Jones, David Johnson, Bernard McKernon, Richard Muffley, Ray Piercy, Ross Rodgers, George Sale, and Walter Stoy, as well as Minor White. The first-year students also exhibited at SFMA in the summer of 1948, with work they had produced on a four-day excursion with White to Mendocino. This collaborative project was also exhibited at the Albright Art School in Buffalo the following winter.[134]

In June 1948, the *New York Times* reviewed an exhibit of a hundred prints that contrasted the photography program at CSFA with the Photo League of New York City. The article said both schools "urge the personal approach and both agree that expressive picture-making" necessitates "a mastery of the technical problems," but the CSFA program emphasized that the "student must learn to

This page: F. W. Quandt, Edward Weston, c. 1947.

Opposite page: F. W. Quandt, Edward Weston demonstrating camera technique with Ruth-Marion Baruch as sitter, c. 1947.

visualize" the finished print prior to exposure while the Photo League student "learns technique as he needs it." The Ansel Adams–Minor White methods at CSFA were described as "exact, systematic, and formal," with "thorough grounding . . . in Mr. Adams' detailed code of tone identification." CSFA students receive "careful drilling in the handling of equipment and materials, . . . various techniques," and how to "get the maximum of meaning from . . . subject matter." The work shown by CSFA "is deliberate, restrained, studied and subjective," and "despite the perfection achieved by the California students as compared" to the Photo League students, "both appear to have similar aspirations—to make pictures with understanding and a growing appreciation of the medium."[135]

Minor White must have been worn out after the spring 1948 semester of teaching five days a week, fretting over crucial curricular issues, producing exhibitions of collaborative student work, squabbling about day-to-day administrative issues, and working on his own one-person show at SFMA. He wrote to Nancy Newhall that he was "looking better than the picture in the *U.S. Camera* article. At least feel better—the two weeks between sessions was worth it. We see Edward [Weston] starting on the 25th of July."[136]

White considered the pilgrimage to Point Lobos "the climax of every year," so important that at one point he made the "generous proposal" to "forego his own salary in favor of Mr. Weston." He waxed that "on this trip the intensity rose like a thermometer held over a match flame." He wanted to make sure that students had the opportunity "to study the working methods of artists" on the week-long trip with Weston "in his home territory." Weston and the students roamed "over Point Lobos for an afternoon without cameras." Only then would they photograph, while Weston would "climb around to each student and discuss what is on the ground glass." They would sit on the rocks at Point Lobos, gathered around Weston, "all trying to figure out what makes an artist tick." After hiking and taking pictures, the students would drive to Carmel for dinner, then regroup at "Weston's cottage to see the man and his photographs." Weston "selected carefully, put them one at a time, on a spot-lighted easel. He talked quietly or not at all, . . . purred to his cats and kittens . . . He never belittled his work, never boasted, but let each picture speak for itself . . . And we looked. With the sound of the sea, . . . the smell of a log fire around, many of the seeds, planted during the year, sprouted."[137]

CALIFORNIA SCHOOL OF FINE ARTS
800 Chestnut Street, San Francisco 11

[July 1948]

P E R S O N N E L D A T A

Term *Fall '48 – Spring '49*
Dates *9-12-48 - 1-29-49*
 2-7-49 , 6-18-49

Name *Edward Weston* Position *Instructor*

Subjects taught *Photography* Salary *$ 4.00 per hour*

Education:

	From	To	Majors	Degrees	Date
High School	*1st year only*				*1903*
College or University					
Specialized Training					

Teaching Experience:

Institutions	From	To	Subjects
Personal instructions for 30 years			*Photography*

Trade or Business Experience:

Firms	Address	From	To	Occupations
Professional Photographer since about 1910				

In this school since (date): _____

Subjects or courses taught : _____ Full-time _____ No. hrs. _____
 Part-time _____ No. hrs. _____

(signed) *Edward Weston*

(date) *6-23-48*

Additional information on other side.

[July 1948]

Term Fall-Spring 1948-49
Dates 9-13-48 to 1/29/49
 2/7/49 to 6/18/49
Position Guest Instructor
Salary $4.00 an hour

	Degrees	Date
	A.B.	1907
Sweden 1909- 1910		

	Subjects
	...l of photography

	To	Occupations
	1909	Printer

Full-time _____ No. hrs. _____
Part-time ___X___ No. hrs. Guest Instructor

(signed) *Imogen Cunningham*

(date) July 28th, 1948

Additional information on other side.

This page: CSFA Personnel Data Sheets, 1948–49.

White, as well as the students, benefited from the trek to Carmel. He was effusive about what he learned at Point Lobos in correspondence to Weston.[138] The students were familiar with Weston by the time of the field trip to Carmel. His books were in the school library, his work talked about in classes, and one student, Ruth-Marion Baruch, had written *Edward Weston: The Man, The Artist, and the Photograph* as her master's thesis while a student at Ohio University.[139] MacAgy was particularly pleased with the arrangement with Weston. He knew that the cachet of Weston's name on the roster of instructors would increase the school's profile. Indeed, the school brochures advertised the special summer guests for 1948 in bold letters: STANLEY WILLIAM HAYTER, HELEN PHILLIPS, EDWARD WESTON.[140]

By midsummer 1948, MacAgy was again poised to approach the Columbia Foundation for additional funds to expand the photography lab to accommodate the first third-year class, which had entered in 1946 and would need space to produce color work. The department had received magnificent publicity beginning with Minor White's article "Photography Is an Art," published in the December 1947 issue of *Design*. Next came the two student shows at the San Francisco Museum of Art, then the exhibition at the Photo League and the accompanying story in the *New York Times*. Furthermore, Edward Steichen, the director of the New York Museum of Modern Art's photography department, had recently recommended CSFA "as one of three" U.S. schools to European students who wanted to study photography.[141] The need, along with the hopes for a better facility, moved the board to submit a request for another $10,000 to the Columbia Foundation "to carry this project for the next two years."[142]

The fall 1948 semester began on September 13 with fifteen new students enrolled in the first-year class, eleven continuing for their second year, and ten registered for the third and final year of the program. Visiting faculty included Imogen Cunningham, who, on her personnel data sheet, listed her only "trade and business experience" as a "printer" with "Edward Curtis, Seattle, from 1907–1909." Weston listed his credentials as "Photography, personal instructions for 30 years, . . . Professional Photographer since about 1910," and for education, "1st year only of high school, 1903." Ansel Adams sent his form to MacAgy from "the gold rush wilderness" of Juneau, Alaska. He listed himself as a "part-time visiting instructor" for fall/spring 1948–49, obviously hoping he would be returning to San Francisco by Christmas and could participate at the end of the first term. Adams was sketchy about his biographical information, as he couldn't "remember things about myself anyway, especially dates." His comment that "anyway, it isn't a 'loyalty' questionnaire!!" was followed by his reporting to MacAgy that he had been told that the Veterans Administration "is cracking down on photo schools . . . demanding definite assurance that such study is serious and that a job hovers in the offing."[143] MacAgy was aware of the VA's position on photography programs, and within two weeks of Adams's warning the school had been approved and all was well.

Adams, Weston, and Cunningham would join White, Quandt, and Childress as faculty for the 1948–49 school year. The questions on the 1948 student survey were more open-ended than before, but there was still a need to know "your preference in music" and "Why do you want to make photography a career?" Also asked were, "What are your hobbies?" "Who do you think is doing the finest photography today?" "Have you sold any prints?" and "What is your opinion of *U.S. Camera Annual, American Photography*?" Entering students were recommended to have at least two years of college, "preferably in the liberal arts, . . . previous knowledge and experience in photography, . . . [and] more than a cursory interest in all branches of art."[144]

Disappointing news was received by MacAgy and Spencer by late September, when Mrs. Charles deYoung Elkus, Jr., of the Columbia Foundation, wrote to say that "it was gratifying to know the

International

The North Atlantic Treaty Organization (NATO) is founded.

Soviet officials lift the Berlin blockade and Germany is divided into two nations; the German Democratic Republic in the east and the Federal Republic of Germany in the west.

U.S. recognizes Israel as a sovereign nation.

The Soviet Union conducts atomic bomb tests.

Racial apartheid is instituted in South Africa.

The Chinese Civil War ends; Communist leader Mao Tse-tung becomes chairman of the People's Republic of China.

National

In his State of the Union Address, President Truman promises to give Americans a "fair deal."

William Hastie is first African American on the U.S. Circuit Court of Appeals.

Science & Technology

The U.S. makes 4.8 million new cars per year; Pan Am introduces first scheduled transatlantic passenger service.

Culture

Art: *Number 8* by Jackson Pollock.

Architecture: Philip Johnson builds his glass house in New Canaan, Connecticut.

Literature: William Faulkner awarded Nobel Prize in literature, *1984* by George Orwell, *The Second Sex* by Simone de Beauvoir.

Film: *All the King's Men*, *The Heiress*, *Twelve O'Clock High*.

Theater: *South Pacific*, *Death of a Salesman*.

Music: Term "rhythm 'n' blues" coined; Birdland opens in New York City, featuring Charlie Parker; mambo craze begins; "Some Enchanted Evening," "Diamonds are a Girl's Best Friend."

Television: *The Goldbergs* is the first TV sitcom, *Hopalong Cassidy*.

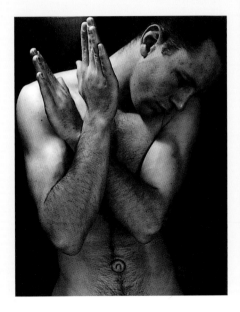

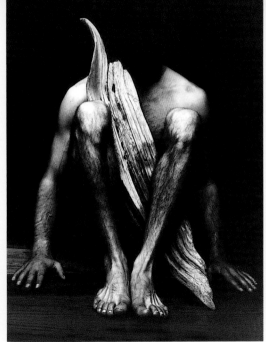

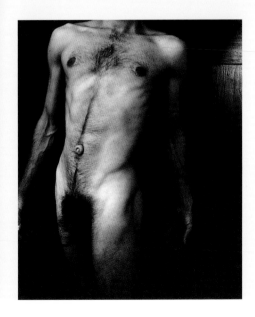

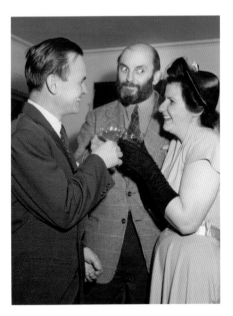

This page: Minor White, *Tom Murphy, 1948, Tom Murphy, 1947, Tom Murphy, 1948,* all from the sequence *The Temptation of Saint Anthony Is Mirrors,* 1948; F. W. Quandt, Ansel Adams presiding over the wedding of Pirkle Jones and Ruth-Marion Baruch at Yosemite, 1949.

Opposite page: Bill Heick, Sidney Peterson's film class, 1948.

Department of Photography has gained widespread recognition," but "because our funds are limited . . . we can not undertake . . . more than the contribution of initiating . . . any one project."[145] MacAgy, Adams, Spencer, and White had misread the possibilities of Columbia's support, not realizing that it was outside their mandate to go beyond startup costs for proposals.

By the fall of 1948, MacAgy anticipated that there would "undoubtedly be a drastic decrease in the enrollment of G.I. students." Consequently, he thought CSFA should establish itself as one of the outstanding art schools in the country by affiliating as a charter member of the National Association of Schools of Art and Design in order to gain as much credibility as possible with potential students and accreditation agencies.[146]

The year 1948 was eventful for White outside of his teaching and administrative duties at the school. Point Lobos stimulated the continuation of his landscape work, but he also began "a substantial body of work in portraiture and figure composition," focusing on "theatrical lighting, character revealment, and directorial projection." Of particular note was White's *The Temptation of St. Anthony Is Mirrors,* "a sequence of nudes and portraits of a student model, Tom Murphy." White also had a solo exhibition, Song Without Words, at the San Francisco Museum of Art, and he continued to write.[147] Adams busied himself during 1948 with his renewed Guggenheim grant and the continuation of his national parks project, as well as publishing *Camera & Lens, The Negative,* and *Yosemite and the Sierra Nevada.* He also produced *Portfolio One: In Memory of Alfred Stieglitz,* who had died in 1946. Assisting Adams with the preparation of this portfolio, as well as processing film from Adams's Alaska trips, was Pirkle Jones, a third-year student who continued as Adams's assistant until 1953. Adams, although remote, stayed attached to the students and to the school, as shown by the connection with Pirkle. In fact, when Jones married his fellow student, Ruth-Marion Baruch in January 1949, the wedding was in Yosemite at Adams's home.

The 1949 CSFA letterhead proudly listed thirty-eight faculty members, including six photographers—Ansel Adams, Clyde Childress, Imogen Cunningham, Frederick William Quandt, Edward Weston, and Minor White. Also listed were painters Richard Diebenkorn, Elmer Bischoff, Clyfford Still, Dorr Bothwell, Clay Spohn, David Park, and Jean Varda; sculptors Claire Falkenstein, Antonio Sotomayer, and Robert Howard; designers Walter Landor, Paul Forster, and Juliette Steele;

and filmmaker Sidney Peterson. While some of these instructors were considered "guests" or "visitors," and at least one—Adams—was rarely in residence, it nevertheless was an astonishing collection of distinguished or soon-to-be-distinguished artists. The school's profile was further enhanced when in April 1949 MacAgy organized the Western Roundtable on Modern Art, which included artists, critics, philosophers, an architect, and a musician to discuss, in a three-day symposium, the issues of contemporary art, the responsibility of the critic, and the role of the museum.[148] These educational triumphs did little to alleviate MacAgy's anxiety about the expected drop in enrollment that would coincide with the graduation of the first wave of G.I. Bill students. He prepared a chart for a March 1949 board meeting that graphically showed "the rate of decline in veteran enrollment through the Summer of 1952."[149] MacAgy must have also been worried about Adams's warning that "Minor White has been offered the direction of the Department of Photography of the School of Design in Chicago." Adams, of course, thought it a "real feather in his [White's] cap, and indirectly a boost for the School," but thought it would be very sad to have him go to Chicago.[150] He was trying to do everything he could to ensure the success of the school, including making certain that MacAgy was poised to do what was necessary to keep White at CSFA.

The school's summer 1949 photography plans again had White and Quandt sharing the teaching duties, along with Weston's participation on the Monterey Peninsula. The program covered "the basic technical and esthetic aspects, . . . visualization, the zone system, . . . view and miniature cameras, printing, and print presentation."[151] CSFA visiting faculty included Mark Rothko, who had taught painting during the summer of 1947, and Sidney Peterson, who conducted a film workshop. Peterson's film classes were popular with some of the best photography students, including William Heick and Benjamen Chinn. Heick, who had finished his photography classes the previous semester, was given a one-man exhibition of "33 photographs . . . from texture studies to landscape and character portrait prints" at the San Francisco Museum of Art in June 1949, demonstrating the immediate success of the school's photography students.[152] On the heels of Heick's exhibition, Adams "got a swell review" of an exhibition curated by Dr. Grace McCann Morley at the SFMA.[153] Photography was making itself known in the elite art circles of San Francisco.

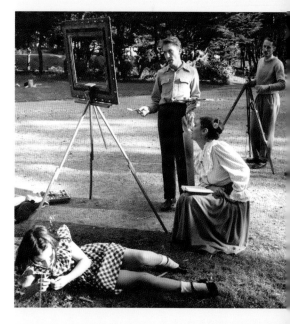

The July 1949 issue of *U.S. Camera* published "Photography in an Art School," presenting White's assessment of the program at the school. He emphasized that the department had been based on the belief that the "craftsmanship of technique" and the "craftsmanship of feeling" were "essential to the vitality of photography." The focus on technique was explained by White thusly: "A magnificent print can carry a great quantity of trash, but the theory that content can overcome bad technique is a little like playing Beethoven's Fifth on a harmonica." However, "while control methods are emphasized, it is recognized that discipline is the death of imaginative activity" with some students. Just as important as technique were the concepts explored with the second-year students called the "creative condition," a "subject of constant discussion both in class and in 'bull sessions.'"[154] Not all students participated in the bull sessions. Chinn, who had his own darkroom, "didn't sit around and shoot the bull like most," revealing that the mature G.I. students followed their own path.[155]

Another ingredient in the success of the CSFA program was the integration of the "highly prized . . . guest instructor" into the faculty mix. White's article highlighted Adams, who "is always a source of technical information," and Dorothea Lange, who "conducts a seminar on documentary photography" and occasionally lectured on working "with the miniature camera." White also illustrated the strong student interest in the mechanics of photography by describing how optics

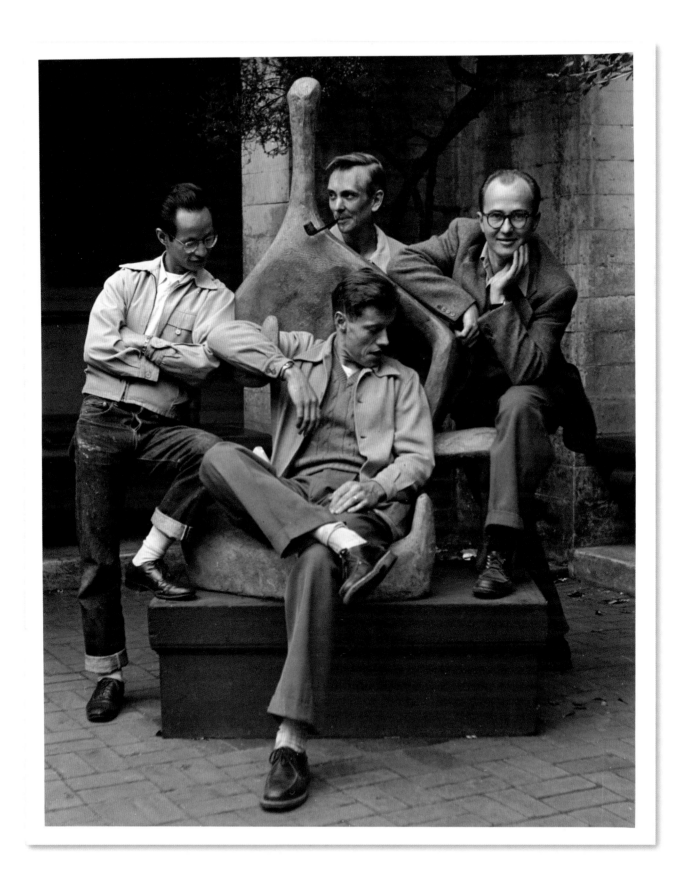

expert Robert McCollister gave a class "solely to first-year" students, but "the rest of the department crowds the lectures for review." White brought to the attention of *U.S. Camera*'s national readership the fact that Imogen Cunningham taught at the school and that "many a student finds his way to her house for more of her sharp wit and practical understanding of . . . portraiture." One of those students was Heick, who took care of Cunningham's garden on the other side of San Francisco's Russian Hill from the school. In exchange for yard work, Heick would receive photographs, as well as the chance to mingle with Cunningham, with her "sharp wit," and her photographer friends, who included the freelance press photographer Arthur Fellig, known as Weegee, when he was visiting Northern California. Finally, White cited the "project plan" that included the work produced by the field trips to Mendocino, Benicia, and Point Lobos, as well as the thematic assignments such as Power and Light in San Francisco, the commissions from Stanford, Pepsi-Co, Maybeck, "and other smaller jobs." White wanted to make sure that readers understood that the CSFA photography department "provides a place where integrity of the artist and photographer is all important, . . . where vitality is not confused with impact, . . . where students are taught, instead of courses."[156]

The July 1949 issue of *U.S. Camera* triggered numerous inquiries about the program from potential students. Eager applicants wrote that the school sounded ideal, a place "where creative efforts wouldn't be stifled by commercial, mass production training."[157] White's response to a potential student's inquiry about "a school of photography" conducted by Adams tactfully acknowledged that "Mr. Adams does not spend much time teaching here at present, however, his methods and philosophy are used constantly."[158]

White's suggestions for department changes that needed to be in place by the fall of 1949 included reintroducing the night course, installation of the color lab along with a color course, designated scholarships for photography students, additional lighting equipment, the introduction of a class in photography for the fine art students, and establishing a library fund to purchase photo books. White also wanted to know if MacAgy thought it possible for a third-year student to take his last year in the photography department. White's persistent efforts to bridge the photography program with the fine arts curriculum led him to suggest Photo 37, a "short course in Photography for Art Majors . . . to acquaint them with photography as an Art Medium." Assuming that CSFA

This page: *U.S. Camera* article, July 1949.

Opposite page: Clockwise from upper left: Benjamen Chinn, Walter Stoy, Bill Quandt, and Philip Hyde, c. 1948.

painting students knew composition and "organizational seeing," this new course, entitled Camera Medium, would concentrate on "basic processes, . . . techniques, . . . in simplified form, the zone system and visualization."[159]

There were concerns by White, students, and other faculty that the department left students finishing the color component of the curriculum, as White said, "unprepared . . . for the commercial world," and unless an "adequate color class" were initiated, "it will be necessary to delete any mention of color photography" from the 1949–50 catalog. To remedy the "grossly insufficient" time spent on color work and to address the issue of the lack of facilities, White suggested a "third year be added to the basic course . . . devoted mainly to color," hiring "competent color printers and photographers" and installing additional darkrooms, a color printing lab, and a "studio set aside for color work exclusively," something that would have happened had the Columbia Foundation funding materialized. In the meantime, the color class could "give no more than a 'feeling' of color." Student Philip Hyde complained to MacAgy about the color course, which he said could "hardly be called a course. To say that it was inadequate is understatement." Hyde criticized the limited time allotted to color instruction in the curriculum, "the overcrowded conditions" in the photo lab, and the lack of equipment for color work. MacAgy recognized the problems with the department's "experiment" in color photography, and decided that "until we can install adequate equipment," the "color side of photography instruction" would be suspended.[160]

The reorganization of the night photography class was made possible because of interest from potential students as well as the availability of "CSFA trained instructors." White suggested that third-year student George Wallace oversee the course, with guest instructors brought in to teach selected sections. Technique would be covered by Quandt, White would do Space Analysis and Creative Approach, Childress would be the guest for artificial light, Mandel for comparative photo, Dorothea Lange for documentary, and Adams would summarize color.

The fall 1949 enrollment included sixteen students beginning the third-year program, ten students in the second year, and ten in their first year. Immediate action needed to be taken on various problems concerning the department, including securing permission for Lisette Model to teach Miniature Camera for the first three or four weeks of the semester as a visiting instructor. Model had visited the school in the summer of 1946 when her husband, Evsa, was the guest instructor in MacAgy's first summer session, and she must have become acquainted with the photography program. Model wanted her second- and third-year students to document the activities of the Opera Association. MacAgy gave a blanket letter of introduction to Lisette Model to secure venues. He wrote to San Francisco's Cow Palace management when the circus came to town, attesting to Model's "long experience in circus photography" in order to pave the way for her class to document the "Greatest Show on Earth."[161] White urged MacAgy to approve Rose Mandel to teach "Space Analysis" to entering students, as well as to start at once the process of getting the color lab and color course ready for the fall of 1950.[162] Model's arrival at the school coincided with White's massive, multiyear project using a small-format camera to photograph San Francisco's urban environment resulting in, as Peter Bunnell wrote, "some 6,000 negatives . . . thought to be a catalogue of everything in the city . . . Chinatown, new suburban housing, the docks, the financial district, people on the streets, at art fairs, at parades, and at the circus."[163]

Adams continued to drift away from the direction of the contemporary art world. Down from the mountains, or Alaska, or from any number of national parks, he made abrupt appearances in the

This page: Rose Mandel, *Lisette Model*, 1949.

Opposite page: Bill Heick, Bob McCollister teaching optics, 1947.

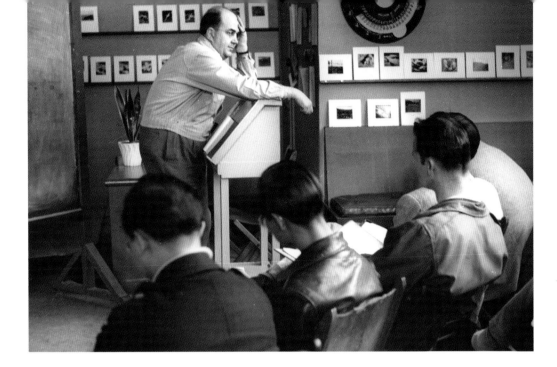

CSFA courtyard. It must have seemed otherworldly to stand in front of abstract expressionist paintings after spending weeks in the Tetons, Death Valley, and beneath Half Dome. Adams wrote he had "come to a conclusion. I am not an artist." He felt estranged: "The clique of 'artists' in this year of our fraud ain't my clique." He had a particular loathing "in no uncertain terms . . . to non-objective art" and thought "we must go through a real fire of some kind to re-establish a sense of reality." He complained, "The esoteric cliqueisms based on arbitrary symbols is indicative of the whole world viewpoint."[164] His ideas of modern art differed from the non-objective art vanguard that was the staple of the MacAgy era, while White's thinking was much more in line with the San Francisco version of abstract expressionism.

Always an advocate for his students, White submitted work by twenty of them for inclusion in the 1951 *U.S. Camera Annual,* asking the editor to send back any comments: "In our class work reasons for rejection . . . are as interesting as reasons for acceptance."[165] The CSFA student association sponsored a roundtable discussion on "What is Photography's Position in Fine Art?" On the panel were faculty members Imogen Cunningham and painter/collagist Jean Varda, *San Francisco Chronicle* art critic Robert Hagan, and photography student Charles C. MacCauley.[166]

As the academic routine of soliciting students, promoting student work, and dealing with curricular issues and facilities wore on during the spring 1950 semester, White continued with his work, sequencing photographs "like a cinema of stills. A cinema arrested at the high points and which lock the story to the memory."[167] Sidney Peterson's Workshop 20 film class, as well as the Art in Cinema series that CSFA cosponsored with SFMA may have influenced White during this period. He spoke of his love for teaching in a May 1950 letter to Beaumont and Nancy Newhall: "One of the values of teaching, to me, is . . . to be what I am expected to be." White told of a question from third-year student Phil Hyde, who, he said, "really has something to give to the world," asking, "Is art to be a reflection of the hopelessness of the present day man or is it to be one of the solid things which he can hang on to[?]" White said, "Soooo, at lecture Monday I had to go on record saying that for me, art was one of the faiths of the world. That jarred a few of the boys . . . But it is worth it. I grow up in that class." White was relieved that, fortunately, most teaching was not presented so directly, but done as "discussion over prints and over hootch." Arriving home after such a stimulating class,

International

Korean War begins.

The U.S. begins military support of French forces in Indochina (Vietnam).

In South Africa, the Population Registration Act (No. 30) provides the basis for separating the citizens in South Africa into different races.

National

Alleged Soviet spy Alger Hiss is convicted of perjury.

Senator Joseph McCarthy begins investigation of suspected Communists in government.

California State Supreme Court rules that bars cannot be discriminated against because they choose to cater to gays or lesbians.

Urbanites begin moving to the suburbs.

Roughly 8 million television sets in use.

Science & Technology

Credit cards are introduced; first photocopier is introduced.

Culture

Art: *Chief* by Franz Kline, *Excavation* by Willem de Kooning, *Number 1 (Lavender Mist)* by Jackson Pollock.

Architecture: Ludwig Mies van Der Rohe's Farnsworth House is completed.

Literature: *The Grass Is Singing* by Doris Lessing, *Canto General* by Pablo Neruda, *The Lion, the Witch and the Wardrobe* by C.S. Lewis, *Yertle the Turtle* by Dr. Seuss, *The Martian Chronicles* by Ray Bradbury.

Film: *All About Eve, Sunset Boulevard, Cinderella.*

Theater: *Guys and Dolls, Call Me Madam.*

Music: "Luck Be a Lady," "White Christmas," "Mona Lisa."

Television: *What's My Line?*

Print: Charles Schulz begins syndication of *Peanuts.*

Radio: Radio Free Europe begins broadcasting.

This page: Stan Zrnich, portrait of Minor White, c. 1952; Stan Zrnich, portrait of Bill Quandt, 1952.

Opposite page: Gene Peterson, New CSFA director Ernest Mundt, David Park (acting director for the summer session), and outgoing director Douglas MacAgy, 1950; Gerald Ratto, portrait of Zoe Lowenthal, c. 1952.

"tired and feeling free more than usual . . . A shot and Bach fugues and I was off on a binge of sheer lyricism."[168]

Near the end of the 1949–50 school year, White once again pondered the current condition and future possibilities for the program. He compiled "general aims" that were followed by five detailed pages explaining how the curriculum achieved these goals. These objectives included "technical craftsmanship," "craftsmanship of feeling," and "craftsmanship of communication." Communication was achieved by students studying analysis of design, style, space, and subject matter, along with criticism and symbolism with "the current symbolism of psychology . . . touched upon. The dual dangers of symbolism are pointed out—too little and too much." Finally, it was important that students have "a love of the medium thru mastery of it." He made sure to broaden the range of photography by embracing photojournalism, commercial, hobby, scientific, experimental, portraiture, propaganda, "expressive," and "creative," calling attention to these last two areas as "the life blood of the medium."[169]

White's new curriculum outline never made it to CSFA director MacAgy, who submitted his resignation to the board on May 4, 1950. MacAgy joined filmmaker Sidney Peterson as executive directors of Orbit Films, "a moving picture corporation" in Seattle, knowing that fewer G.I. students would result in fiscal chaos at the school. While MacAgy's resignation letter said it was "a pleasure to report that the organization, in fact and spirit, is in excellent condition," his appraisal of the situation hid the fact that the financial future for the school looked glum.[170] Painter David Park filled in as interim director until fine arts faculty member and new CSFA director Ernest Mundt returned from a summer teaching position in Oregon. MacAgy had hired Mundt, a sculptor, in 1947 because of his strong design background so that "students . . . might be exposed to Bauhaus principles." Mundt's plan as director was to resolve the looming financial troubles by eviscerating much of the cultural innovation begun by MacAgy and retooling as a "training school for advertising and industry."[171] He and many board members believed that bringing more commercial and applied art classes into the curriculum in conjunction with a reduced fine arts program would attract the kind of students that could replace the shrinking G.I. base.

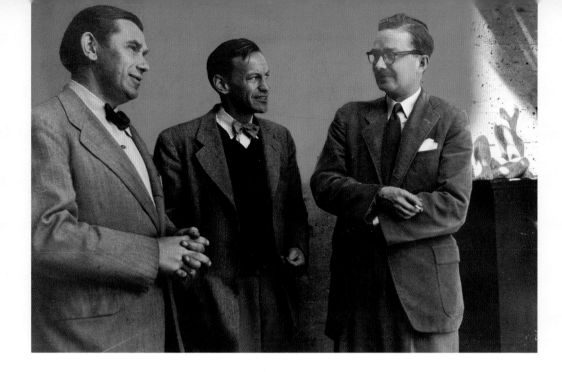

By the summer of 1950, it became necessary to scale back the photography department's course offerings, as "only one instructor can be committed." White and Quandt were both looking for other jobs, and whichever one did not find work would be assigned the summer class.[172] White received the assignment, teaching The Miniature Camera, which consisted of Bay Area field trips, but there is no mention of Weston's participation at Point Lobos. Adams continued to participate in classes; both he and White were eager to promote photographic projects for students. Third-year students Paul Mathews and Leon Kuzmanoff fulfilled an assignment given by Adams to take a series of photographs documenting "aircraft maintenance at United Airlines." Another student, Olen Mashburn, got CSFA acting director David Park to write a letter for him to gain access to Treasure Island Naval Station to photograph views of the San Francisco waterfront, Bay Bridge traffic, and "incidental harbor traffic."[173] Adams also pursued a substantial plan for students to document "seven or eight reservations in the West and one or two in the East" with D. S. Myer, commissioner of the Bureau of Indian Affairs, who knew Adams through his photo essay *Born Free and Equal, the Story of Manzanar.* Myer suggested that "there might be 50 or 60 shots at each place," and that he wanted Adams to express the bureau's "definite interest" in the project to the "school committee and your board of directors."

Adams passed this promising venture along to White, who in turn gave it to David Park to present to the San Francisco Art Association board. Park, however, did not relay Adams's request to the board, "knowing damn well that Photo had already asked for more than they would bloody likely get!" Park added in his message to Mundt, "Don't tell Minor."[174] Territorial and departmental squabbles surfaced as budgets tightened at the school. White, always willing to promote student work, sent the work of eight students (Bob Hollingsworth, George Knight, Yukio "Bill" Kajiyama, Joe Humphries, Nata Piakowski, Robert Young, Lois Willard, and Charles Wong) to the Eleventh Annual North American Photographic Exhibit at the California State Fair in Sacramento. Applicants for the 1950–51 school year came from all over the United States, as well as from Saudi Arabia, New Zealand, Mexico, Hong Kong, and Denmark, and even included a young man incarcerated at the California Youth Authority in Whitmore.[175]

Everyone rushed to invent plans to generate revenue, faced with a predicted 35 percent drop in veteran enrollment for fall 1950. White proposed the resurrection of the moribund night school,

which had been nonexistent for the previous two semesters. He also proposed the reinstatement of the Basic Photography class, using a "workshop method" with lab assistant Dwain Faubion and Bill Quandt as instructors. The resultant publicity for this evening class touted the teaching of the "Zone System . . . introduced at CSFA by Ansel Adams."[176] For the first time in five years, the department failed to fill its capacity of thirty-six students. The fall 1950 entering class had sixteen students, the continuing second-year enrollment stood at eight, and there were seven third-year students. Although photography was down only five students, it did contribute to the nearly 15 percent drop in students school wide—less than anticipated, but which nevertheless prompted Ernest Mundt to cut nineteen teaching periods, including two in photography, and replace them with more cost-effective "studio time for students." By the second day of classes, White suggested that there be some sort of "tie-in with some government agency" that might generate revenue, as well as the possibility of "training of military photographers."[177]

The start of the Korean War that summer, coupled with the dismal predictions for enrollment, produced a somber "opening statement" from White to the students: "This may be a year we have deserved. It is one in which we are unenthusiastically at war . . . We can expect the uncreative photographer or artist to do no more than reflect his discomfort at the times. The creative one produces in his time that which he would have the world be . . . So here in school, we shall take advantage of the hole in events that a school is to be affirmative. Even though we are students hindered by the learning process from expressing ourselves clearly, the direction of our statements shall be towards art as one of the faiths of the world."[178]

Although White struggled with further fiscal turmoil—low enrollment in the night classes threatened the termination of the evening faculty—he continued to focus on programming. Beaumont Newhall visited the school in 1950, and students heard him lecture on the history of photography and the photographic principles that they were investigating in class—using pinhole cameras. This assignment in Quandt's class prepared the students for "further study into the principles of optics."[179] White's class projects reflected his fascination with the theater and with how "a photographer has to become a director when he is handling people," thus reinforcing his required reading of Boleslavsky's *Six Lessons in Acting*. White had begun working with students during the

This page: F. W. Quandt, Minor White, c. 1950.

Opposite page: F. W. Quandt, Minor White, c. 1952.

previous spring semester, translating "theater into photography," much as Lange "found tragedy in the human and social scene." White's second-year students Joe Humphries, Ralph Joosten, Bill Kajiyama, Ernest Louie, and Olen Mashburn produced a portfolio documenting the production of the play *A Phoenix Too Frequent* by Christopher Fry.[180]

In the middle of the semester, Quandt took a leave from his faculty duties to do "camera work" for Orbit Films, MacAgy and Peterson's new venture.

Although Ansel Adams's name no longer appeared on the school's letterhead, he remained an influence in the department with occasional teaching, by letting White live in his house in San Francisco, and as an advocate for photography. He had finally convinced members of the board who were involved with the $1,200-per-year Bender Grants to give an award in photography as well as in their traditional fields of art and literature. As a result he was appointed the chair of the special jury for the first photography grant that would be awarded for 1951.

To publicize the department and increase revenue for the school, White continued his Print Criticism class for the general public during the spring of 1951 as a series of eight Wednesday night "illustrated lectures" in which he would emphasize the photographer as a critic, the objective nature of criticism, "style analysis," as well as survey the work of Weston, Adams, and Strand along with the "experimental photography" of Man Ray, Moholy-Nagy, and Kepes. In this lecture series, White showed his work as well as analyzed photographs brought in by students.[181] The Student Association organized five monthly exhibits for the spring 1951 term, with the first show being photographs by George Knight, Ernest Louie, Lois Willard, Vincent Scotto, Cameron Macauley, Edgar Stephenson, and Charles Wong.[182] The school's faculty also had an inclusive show with representatives from all departments, prompting *San Francisco Chronicle* art critic Alfred Frankenstein to write that "the photographic section of the [1951 faculty] show is perhaps most remarkable for a series by Minor White entitled *Intimations of Disaster, San Francisco, 1950* . . . White, one gathers, is not a man to be pushed around."[183] In March 1951, SFAA held a special screening at the school for a hundred members and students of Willard Van Dyke's film on Weston, *The Photographer.*[184]

While photography seemed to share the spotlight when it came to illustrative exhibitions planned by students, shows to promote the faculty, and special programs, it was less than

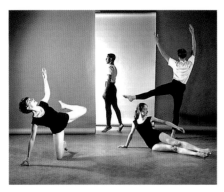

This page: The play, *A Phoenix Too Frequent,* photographed as a class project, 1950; Gerald Ratto, San Francisco Museum of Art and CSFA project photographing dance, c. 1952; Stan Zrnich, *Looking at Looking* exhibition, January 1952.

Opposite page: Gerald Ratto, San Francisco Museum of Art and CSFA project photographing dance, c. 1952.

enthusiastically embraced in other venues. Although not one to be pushed around, White certainly had his hands full with the school's new director, Mundt, who was "not convinced that the photography department as it is now constituted . . . [is] the best possible arrangement for the school."[185] Adams and White struggled for the acceptance of photographers as artists within the Bay Area's most influential art organization, SFAA. When David Park argued that SFAA continue its practice of restricting its artist membership to painters and sculptors "to limit commercial expectations," both Adams and White responded. Adams was "distressed" that Park thought there was "a separation of the arts" and that "competing with the marketplace" is "an unhealthy act." He continued that "the curse of most contemporary painting and sculpture" is the "fact that it *is* apart from humanity and functions in a quasi-dream world of subjective satisfactions." White was more diplomatic and wrote positively of potential "collaborative artist efforts" while suggesting that the acknowledgment of photographers as artists would "lift the Bay Area Camera Club photographic activity from its present state of endless repetition and imitation into some far more creative personal expression."[186]

Adams made headway in his "photography as art" argument when CSFA student Charles Wong received a Bender Grant recognizing "that photography has become . . . an artistic medium of the highest order."[187] Wong first attended the school in 1940 on a scholarship awarded to him while he was attending Mission High School prior to serving in the Army Air Force. He then enrolled in the photography program from 1949 through 1951. His portfolio, *The Year of the Dragon,* was published in *Aperture* magazine in 1953.

In May 1951, Adams responded to Mundt's request to do two lectures for The Role of Art in Society Today, saying that he would "be happy to cooperate" but would have to defer if any "important assignment" should materialize from "Eastman Kodak, . . . *Fortune* magazine or *Life.*" Adams analyzed the role of the artist from the perspective of the photographer while Park represented painters. Mundt reported that at the symposium's "unrehearsed . . . climax . . . the wit and wisdom and occasional forensic sparks delighted the audience."[188] Minor White continued his efforts to get exhibition opportunities for his students as well as to publicize the department. Focus Unlimited, a student exhibition, traveled to the Portland Art Museum, where it was dubbed "an eye-catcher" prior to the show's shipment to the Richmond Art Center.[189] White's remarkable

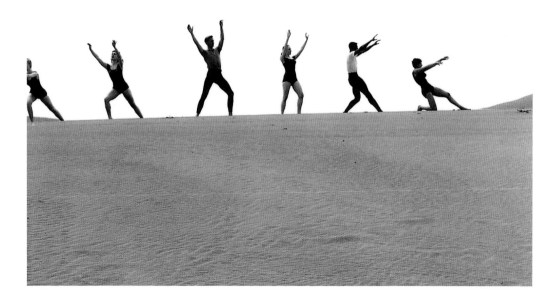

dedication to his students continued after they left the program. He persisted in requiring quality work, as demonstrated in correspondence to former students Tom and Audry Murphy: "What you show me is good. I want more, more, forever more . . . It's oh what I expect. Too hard a demander I am. But it's what I demand of myself. Can I ask less of you?"[190]

The enrollment for photography in the fall of 1951 dropped to twenty-eight students, a loss of only three students from the previous year but 10 percent nevertheless. The night classes were dropped, and White's Print Criticism class was adopted by the Northern California Council of Camera Clubs and taught by him at the Photographic Center. Second-year photography students turned their fall 1951 class project, an examination of "the people who attended the 5th Annual S.F. Art Festival and their reactions to the work displayed," into an exhibit of a hundred photographs held at the school entitled Looking at Looking. Photographers whose work was exhibited included Robert Layton, Don Suhr, John Cockroft, Janet Graham, Gerald Ratto, J. Carroll Mahoney, Allen Murray, Stan Zrnich, Hal Caughrean, and Melton Ferris.[191]

Mundt's curricular changes were slow to take hold at the school during his first eighteen months on the job, but a sea change occurred at the beginning of 1952 that would clear the way for implementing his scheme. He, along with the board, decided to cut back the large number of classes taught by painting faculty members Hassel Smith, Elmer Bischoff, and David Park in order to save money and to redirect the curricula from fine arts faculty to those teaching "commercial and industrial design." When Smith objected, he was fired, resulting in Bischoff's and Park's resignations in January 1952. These three painters taught the majority of the fine arts students, were the most popular teachers, and were influential with their peers. With them gone, Mundt could now hire the faculty that would transform CSFA into a commercial art school. This ominous event must have put the final chill into those faculty members who had begun with MacAgy and who believed that the school should encourage the experimental and not the utilitarian.

White transcended the fiscal and philosophical frenzy at the school by focusing on his new endeavor as editor of the recently founded *Aperture* magazine. Adams, White, the Newhalls, Berenice Abbott, Lange, and others who had met in the fall of 1951 at the Aspen Photo Conference dreamed

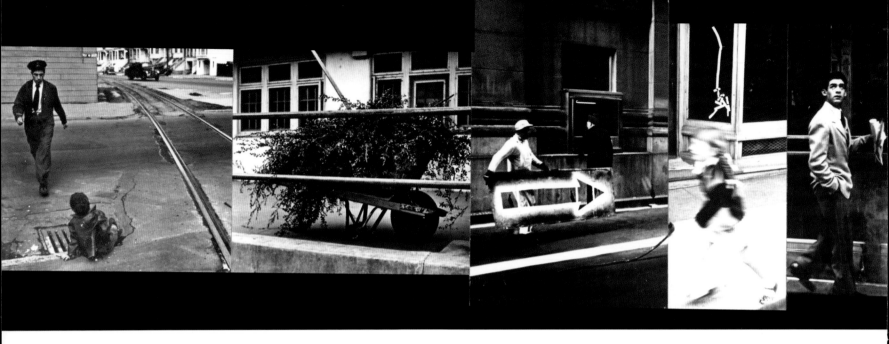

This page advertised a summer 1952 photo workshop conducted by Ansel Adams along

This page: Minor White, *Intimations of Disaster,* 1949–1953; *Aperture,* Vol. 2, No. 1, 1953. Cover image by Ernest Louie; *Aperture,* No. 1, 1952. Cover image by Dorothea Lange.

Opposite page: John Cockroft, Ernest Mundt addressing student concerns, 1952.

up the idea of a new periodical "devoted to serious thinking in photography."[192] White had begun to work on the publication at his new address in San Francisco, 135 Jackson Street. He had relocated from Adams's 24th Avenue home upon the death of Adams's father the previous summer. His first article in *Aperture,* in the premier issue, was on "a rationale for the miniature camera." It included photographs from his *Intimations of Disaster* series and was based upon his time spent with Lisette Model during her fall 1949 tenure at CSFA. After the publication of the inaugural issue of *Aperture,* White wrote that he "was all ready to do another one; and another, and another, for about fifteen years." The first issue advertised a summer 1952 photo workshop conducted by Ansel Adams along with Nancy Newhall, Bill Quandt, and Pirkle Jones, to be held in San Francisco but not at CSFA. Listed as "special consultants" for the workshop were Edward Weston, Dorothea Lange, and Minor White.[193] Former CSFA student Benjamen Chinn made the cover image of the second issue of *Aperture.* He shot the photograph while studying in Paris with Alberto Giacometti. On the masthead as "founding member" and designer of the magazine was another former student, Ernest Louie.

By the summer of 1952, there was little mention of the school's photography department or fine arts department in promotional materials, which instead highlighted Mundt's Visual Communication course, Dorr Bothwell's silkscreen class, and a course on Arts in Architecture sponsored by the American Institute of Architects. The direction of the school had shifted drastically, reflecting Mundt's interests in applied and commercial coursework.[194]

Although the fall enrollment proved dismal, there were still promising applicants to the photography department. Only sixteen students arrived for the fall 1952 semester—three new students for the first-year program, eight for the second-year, and only five for the third-year. The rest of the school fared worse. The fine arts program was decimated after the loss of Park, Smith, and Bischoff. The best Mundt could hope for was to weather what was anticipated to be a temporary fallout and gear up for a future accredited program based upon a mixture of design, commercial, and fine arts classes. Mundt had hired Milt Halberstadt, who would offer "an additional approach in photography" by conducting a workshop "in the creative use of light."[195] The "light workshop" only enticed two of the sixteen photography students. Robert Katz picked up where Sidney Peterson had left off, with a film workshop that was attached to the photography department. Promotional events during

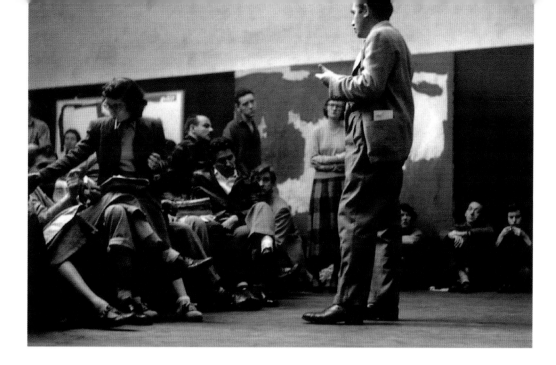

1952

International

Military Coup in Cuba places Fulgencio Batista y Zaldivar in power.

Puerto Rico becomes a commonwealth of the U.S.

National

Republican Dwight D. Eisenhower is elected president. Richard Nixon serves as vice-president.

Malcolm Little changes his name to Malcolm X and becomes a Muslim after release from prison.

McCarran-Walter Act abolishes race as a barrier to U.S. immigration.

Science & Technology

Videotape recorder is invented; Jonas Salk develops the polio vaccine; first frozen TV dinners appear on the retail market.

Culture

Art: *Red Painting* by Ad Reinhardt, *Blue Poles: Number 11* by Jackson Pollack.

Architecture: Lever House by Gordon Bunshaft/SOM completed in New York City.

Literature: *The Invisible Man* by Ralph Ellison, *The Old Man and the Sea* by Ernest Hemingway, *East of Eden* by John Steinbeck, *Charlotte's Web* by E.B. White, "Do Not Go Gentle Into That Good Night" by Dylan Thomas.

Film: *The Greatest Show on Earth*, *High Noon*, *The Quiet Man*, *Ivanhoe*.

Theater: *Water Music*, *The Mousetrap*, *The Seven Year Itch*.

Music: "Your Cheatin' Heart," "I Saw Momma Kissing Santa Claus," "You Belong to Me."

Television: *American Bandstand*, *Today (The Today Show)*.

the semester included a display of 187 photographs culled by Edward Steichen from the first fifteen years of *Life* magazine, along with a weekend "print clinic" conducted by White and Quandt. The last year for the Bender grants included awards to photographers Dody Warren and CSFA alumnus Philip Hyde. Warren planned to photograph a "group of creative workers on the West Coast" with her $1,500 grant, while Hyde proposed to "interpret important natural areas of the Pacific Coast Region." In November, White could send the students to the San Francisco Museum of Art to view his solo exhibition.[196]

The spring 1953 semester limped along with thirteen regular day students in the photography program, a handful in the film workshop, four enrolled for Halberstadt's new advertising photography class, and ten in the resurrected night class taught by Quandt. In February, White exhibited twenty 4×5-inch photographs at SFMA, which were "primarily to aid high school and college students in gaining a greater appreciation of the various elements which can be used by the photographer to build the totality of his picture." Ever the teacher, White hoped that viewers would "develop an awareness of the forms that create emotional reactions."[197] White may have lost his large base of students at the school and been excommunicated by Director Mundt in his interpretation of "art as a faith," but he nevertheless continued to promote expressionistic photography to a wider audience. To go along with his *Aperture* editorial duties, he became a consulting editor with *American Photography*. The classmates of third-year photography student Zoe Lowenthal awarded her the prestigious Robert Howe Fletcher Cup at graduation, illustrating her fellow students' acceptance of photographers within the realm of CSFA. The summer 1953 issue of *Aperture* published Charles Wong's *Year of the Dragon* photo essay, as well as the class project to photograph San Francisco's Chinese New Year, thus filling the entire issue with work by current and former students Wong, Don Bryan, Edward Stiles, Lowenthal, George Daffen, and Leonard Zielaskiewicz, plus White.[198]

The roll books for summer 1953 omit White and only list Quandt's day and evening classes in The Photographic Process.[199] By the fall of 1953, Mundt had changed the program to the point that White must have realized that the school, at best, was educating "good commercial men and nothing more."[200] This semester inaugurated CSFA accreditation—the school was now able to offer

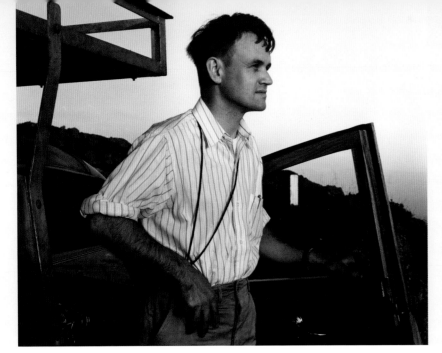

This page: Ansel Adams, *Pirkle Jones, Marin County,* 1948; *Perceptions* catalogue: Edward Weston, *Zomah and Jean Charlot,* 1933; Gerald Ratto, portrait of Stan Zrnich, c. 1952.

Opposite page: Al Richter, Minor White's going-away party, 1953.

a BFA degree with a photography major, something McAgy had hoped would be a stimulus for new students when he initiated the program in 1948.[201] But the semester proved a failure with Mundt's curriculum coupled with the demographics of the fall of 1953. There were only seven students in the day program—five first-year enrollees, and one each in the second- and third-year programs. There was a limited effort to revive the night school, which mustered only twelve students for one evening a week. Halberstadt's advertising photography class was symptomatic of the rest of the school's new program, with a class enrollment of one.[202] The highlight of the otherwise dismal semester was the production of a promotional film titled *Let's Go to Art School,* which had former student David Meyers as "photographer and editor . . . assisted by the . . . Department of Photography" and film instructor Robert Katz. The film had Mundt narrate a tour of the school, complete with footage of White in the photography studios.[203]

White suspected that there was an effort underway at the school to get him fired. Mundt was never comfortable with the artistic aims of the photography department, and White, more than Adams, represented the MacAgy view of the expressionistic artist-photographer. By this time, even Adams had lost interest in the CSFA program, as was made evident by his rival summer school workshop in 1952. He must have been repulsed to see that Mundt's vision mimicked that of the commercially oriented Art Center School in Los Angeles. White had also lost interest. He never submitted his annual curriculum proposals for the department after MacAgy's departure, and he must have felt that it would be futile to suggest innovative ideas for the program knowing Mundt's proclivity toward the commercial. There also had to be personal issues between the two that were compounded by the fiscal fiasco of the time. Furthermore, Quandt was the technical expert, and his talents could more easily be utilized in Mundt's new applied arts agenda. White was the one to go, and he was probably not surprised to receive Mundt's October 2, 1953, letter stating, "I am very sorry to inform you that in view of the insufficient enrollment the Board at its meeting yesterday has felt unable to endorse your appointment for the current year." His seven-year "unique experience in teaching photography" at the California School of Fine Arts ended with his class on October 16.[204] The photography department was left in the hands of Quandt and Jones, but the direction came from Mundt. The curricular changes did not attract students, and there was an emphasis on courses, not students.

1953

International

Korean War ends with an armistice.

CIA- and MI6-engineered coup puts Muhammad Reza Shah Pahlevi back in power in Iran.

Soviet leader Joseph Stalin dies.

Edmund Hillary and Tenzing Norgay are the first to reach the summit of Mount Everest.

National

Nuclear test in Nevada creates fallout exposing residents of Iron County, Utah, to radiation.

Julius and Ethel Rosenberg, accused of Cold War espionage, are executed.

Over 25 million households have a TV set. Commercial advertising is widespread.

Science and Technology

Experiments with mice link cancer to tobacco; Francis Crick and James Watson discover the "double helix" of DNA.

Culture

Art: Georges Braque designs stained-glass windows for the church of Varengeville; *Washington Crossing the Delaware* by Larry Rivers; *Woman and Bicycle* by Willem de Kooning.

Architecture: United Nations Headquarters by Wallace K. Harrison in New York City is completed.

Literature: *Go Tell It on the Mountain* by James Baldwin, *Fahrenheit 451* by Ray Bradbury, *The Adventures of Augie March* by Saul Bellow, *Junkie* by William Burroughs.

Film: *From Here to Eternity, Roman Holiday, Shane.*

Theater: *Waiting for Godot, The Crucible, Wonderful Town, Can Can.*

Music: "That's Amore," "That Doggie in the Window," "That's Entertainment."

Television: *The Colgate Comedy Hour.*

Print: *Playboy* magazine founded by Hugh Hefner, *TV Guide* begins publication.

Minor White strove to solicit a class of eight students for a private course "on the creative approach to photography" that would run from January until June 1954. His advertisement in *Aperture* claimed, "the class will be expensive, demand hard work, maintain strict technical standards and require long hours,"[205] but the class never materialized because by November White had left San Francisco to begin work as an assistant to Beaumont Newhall, curator of photography at the George Eastman House in Rochester, New York. White had "consulted the *I Ching*," which had given him the impression "that the move . . . had to do with leaving the boy behind and entering 'the man's world.'"[206] Adams hosted a parting soiree for White, which proved to be a gathering of "a bunch of photographers . . . for a little fun." The gathering included, among others, Benjamen Chinn, Brett Weston, Imogen Cunningham, Stan Zrnich, Paul Caponigro, and Dorothea Lange.[207]

Prior to leaving San Francisco, White was instrumental in organizing an important exhibition entitled *Perceptions: A Photographic Showing* from San Francisco, 1954, at the San Francisco Museum of Art.[208] A veritable who's who from the CSFA photography department were included in the exhibit when it was realized that "no comprehensive showing of serious local work had been displayed for many years." The exhibit was "selected and designed by the photographers." The photographs were presented "untitled and unsigned," to "stand or fall" on their own "intrinsic visual merits."[209] The Photographer's Gallery also opened in 1954, a direct "outgrowth of the zeal and idealism fostered by the CSFA," much like the King Ubu and Six Gallery created by painters and sculptors affiliated with the school.[210] The core group that founded the artist-run gallery had studied with White and included, among others, Oliver Gagliani, Charles Wong, Stan and Barbara Zrnich, Ed Stiles, Gerald Ratto, Bob Layton, Janet Graham, John Cockcroft, and Paul Burlingame.

White had a particularly tough time adjusting to Rochester, "hating the town" and calling it a "miserable burg." He even criticized "the hoodlums around the city" who could neither "write or draw," as evidenced by his having seen only "one pornographic picture and they only know one four letter word." White realized his bitterness was not only with Rochester but because he missed "S.F. so much . . . Pulling up the S.F. roots was hard and made me homesick." He missed the CSFA photography department after his move; he wrote, "Without school I have nothing important to me,"

and as a result he made sure to make the best of *Aperture*.[211]

The CSFA drifted after White left, with Mundt driving the curriculum and students abandoning the fine arts programs until 1955. In 1957, White published an appraisal of his seven years teaching at the CSFA in *Aperture*. A San Francisco visit in the fall of 1956, as well as his increased teaching at the Rochester Institute of Technology, must have prompted the article. White wrote that there were many factors that led to the department's "unique experience," not the least of which "was the freedom to concentrate on photography" in an "atmosphere of abstract painting, non-objective drawing and experimental sculpture." It was "an experience of teaching photography at the graduate level . . . the only way it can be taught effectively, namely by doing, by intensely doing." Although noted for its fine technique, the program stressed "the creativeness that happens at the moment of *seeing* over the kind that takes place in the darkroom." Essential to the inimitability of the program were "the quality of the students, . . . the location of the school, . . . the magnets of photography: Edward Weston, Ansel Adams, Imogen Cunningham, . . . guest instructors, Lisette Model, . . . Homer Page, . . . [and] the nature of School policy . . . uncomfortably modern practically overnight under the directorship of Douglas MacAgy."[212]

The school's long history of artistic photography began with Muybridge, gelled with Adams and White, and coalesced with prominent faculty and dynamic students. Although the program was built upon solid technique and aesthetic astuteness, the students and faculty gained most by being grounded within the school's distinct fine arts context—a place where students could, MacAgy said, "adopt a creative attitude which permits independent discovery" on the side of Russian Hill, where art was considered, as White maintained, "one of the faiths of the world."[213]

This page: *Let's Go to Art School,* film clip, 1953; Stan Zrnich, visitors viewing work during an opening at the Photographers Gallery, 1954; Stan Zrnich, Janet Graham outside the Photographers Gallery, May 1954.

Opposite page: Larry Colwell, portrait of Minor White, c. 1951.

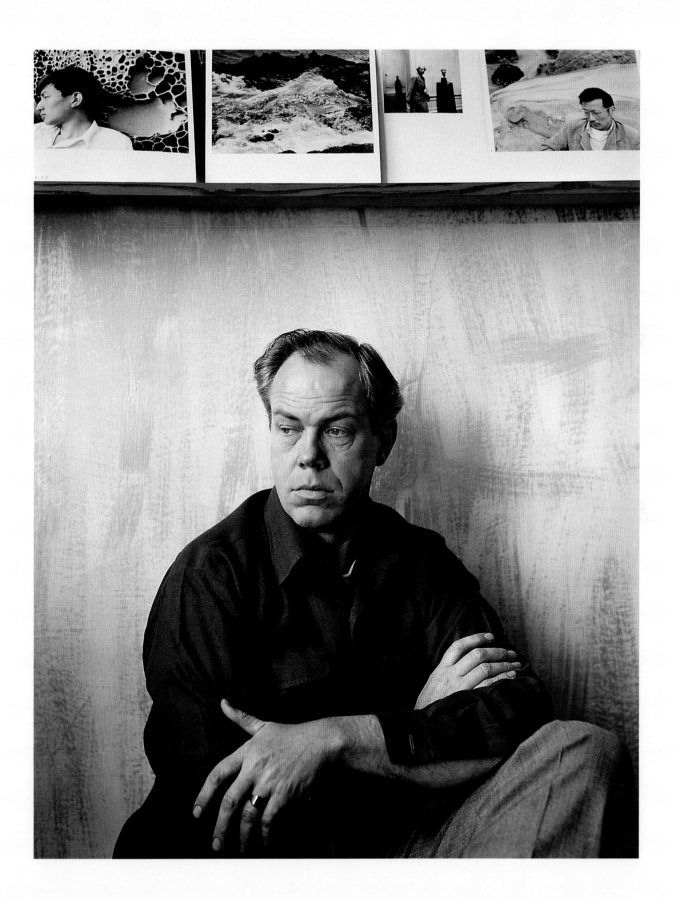

EPILOGUE

It was not until after a failed merger with the Art Center of Los Angeles in 1954, the hiring of a new director, Gurdon Woods, in 1955, and the second batch of G.I. students from the Korean War that the school came out of its doldrums. Woods rehired Elmer Bischoff, who, together with Dean Richard Fiscus, attracted a revitalized faculty, including Frank Lobdell, Bruce McGaw, and Jack Jefferson. The school's enrollment "more than doubled in the first year" and its reputation "as an experimental center was re-established."[214] Woods even managed to attract a thriving design department that included Paul Forster, Jack Stauffacher, Cal Anderson, James Robertson, and Walter Landor.

As prospects for the school improved in 1956, the time seemed right to build up the photography department. Adams thought new director Woods was "doing a swell job." Woods had solicited Adams's opinion about photography, and he enthusiastically suggested "the idea of Minor White taking over the Deanship of the Department."[215] Adams knew that White was willing to leave Rochester. His advocacy led to the planning of a fall 1956 workshop/lecture series given by White, coordinated by former students Stan and Barbara Zrnich, and sponsored by CSFA. Woods was particularly intrigued by White's proposal, which was based on a similar lecture series he had done at Indiana University for Henry Holmes Smith that summer. Woods thought the workshop would "obviously be stimulating," but it would also give him the opportunity to talk with White "in detail about ideas and possibilities for the future . . . for setting up a program." Woods was glad to hear that White still liked "this gorgeous hunk of geography out here."

White wrote to Woods that he was eager to do the October lectures and "looking forward to trudging up the hill to CSFA again!"[216] His reintroduction to the Bay Area photography community and CSFA consisted of a four-day stint with a Friday evening seminar, weekend sessions that lasted from 9 AM to 10 PM, and a public lecture on Monday, October 29. Although this "series of discussions" proved an ideal forum to survey White's ideas and teaching skills, it was probably not simply an audition to take over the department.[217] White must have been the prime candidate to resurrect the photography department after the Mundt years, but the finances at the school necessitated frugal

Opposite page: Stan Zrnich, contact sheet, 1952.

western union **Telegram**

RNA124(1313)(2-030051E127)PD 05/06/76 1312

ICS IPMMTZZ CSP

 6176410374 TDMT ARLINGTON MA 61 05-06 0112P EST

FON 415 771 7020

ROY ASCOTT ACTING PRESIDENT SAN FRANCISCO ART INSTITUTE

800 CHESTNUT ST

SAN FRANCISCO CA 94133

NBR	To VAL
By 145 At 150P	To Be MLD

CB 130p

BT

MY HEART IS MOVED TODAY BECAUSE I CAN PARTICIPATE VICARIOUSLY IN THE
COMMENCEMENT AWARDS AT YOUR INSTITUTE. I ALWAY FEEL THIS CEREMONY
MAKES A BEGINNING NO MATTER WHAT THE AGE OF THE RECIPIENT.
ESPECIALLY NOW, AFTER A LONG ILLNESS, I CELEBRATE THE BEGINNING OF
THE FINAL STATE OF MY LIFE'S DEVELOPMENT. CONGRATULATIONS ON YOUR
COMMENCEMENT EXERCISES. BLESSINGS FOR ALL OF US.
 MINOR WHITE

SF-1201 (R5-69)

steps. White probably viewed it as little more than an opportunity to reconnect with the friends and landscapes of the West Coast and to set up future workshops, conferences, and seminars. Along with White's seminar was an exhibit at the California Academy of Sciences entitled *Lyrical and Accurate,* a show designed by White "to define the characteristic of pure photography."[218]

Woods continued his attempts to reorganize the photography department. Dorothea Lange did a fourteen-week workshop at the school during the spring of 1957, and Woods and White continued to correspond about the department's future. White wrote to Woods that he was on a "two day a week schedule at RIT [Rochester Institute of Technology]" for the fall of 1957, where he was teaching Visual Communication and a class for art majors, "and as I am preparing to teach again this year I am reviving as much of . . . the ancient history [of the CSFA curricula] . . . as possible in the environment and type of school that is RIT."[219]

In 1958, Woods announced that Adams, Lange, and Milton Halberstadt would serve as an advisory committee to the photography department's new chair, Paul Hassel, and faculty member Ted Castle. The department hired FSA photographer John Collier, Jr., in 1958, who remained a faculty member until his death in 1992. The mid to late 1950s saw the arrival of another stellar group of students to CSFA, including painters and sculptors Joan Brown, Bill Allan, Bill Wiley, and Manual Neri; design students George McWilliams, Win Ng, Michael Cross, and Spaulding Taylor; and photographers Phil Green, Elaine Mayes, Phil Perkis, Arthur Freed, Ralph Gibson, Tony Laraschi, Jim Mitchell, and Jerry Burchard. Burchard, from Rochester, had met with White, who encouraged him to attend CSFA. Burchard went on to chair the department in the late 1960s and early 1970s, and he hired Linda Connor and Jack Fulton, who, along with Henry Wessel, Reagan Louie, Pirkle Jones, John Collier, and Larry Sultan, constituted the core of the faculty through the 1980s and 1990s.

White repeated his workshop at the school in August 1959 and made other guest appearances at the school through the 1960s. His legacy in San Francisco was not only apparent at CSFA. He cut the umbilical cord slowly after moving to Rochester, waiting two years before he had his books, equipment, and photographs shipped to him. By 1957 he had arranged for "over 900 original negatives and vintage workprints" representing his field trips with students from 1946 to 1953 to be donated to the California Historical Society.[220]

In 1961, the school changed its name to the San Francisco Art Institute, and by 1966 it had eliminated its design curriculum to focus solely on the most experimental of the fine arts. In 1968, the filmmaking classes begun by Sidney Peterson and attached to the photography department in the 1940s and 1950s were shaped into a separate department under the direction of Robert Nelson, extending the experimental work he had done with Bruce Nauman, Bill Wiley, and Bill Allan into something "organized" and accredited. By 1979, under the direction of conceptual sculptor Howard Fried and with Paul Kos and David Ross, the school invented the performance video department, soon to produce alumni including Karen Finley, Tony Labat, and Sammy Cucher. The San Francisco Art Institute president, Stephen Goldstine, who had been a thirteen-year-old student in White's 1951 summer session class, funded the new P/V department with the sale of Eadweard Muybridge prints found in the school's library.[221] Thus, the advent of a new artistic discipline at the school grew from photographic roots planted in the nineteenth century.

This page: Minor White, *Forty-Second Ave. and Pacheco, San Francisco, 18 August 1949;* Minor White, *"Old Spanish Prison," Filbert Street, San Francisco, 20 July 1949;* Minor White, *"Claremont Rooms, 15 October 1948," First and Harrison, San Francisco.*

Opposite page: Telegram from Minor White to Roy Ascott, 1976.

Notes

SFAIA = San Francisco Art Institute Archives

1 Allan Arbus to Minor White, 22, June 1949. SFAIA.

2 Beaumont Newhall, *History of Photography* (New York: Museum of Modern Art, 1964), 85. Copyright © 1964, Beaumont Newhall, the Estate of Beaumont Newhall and Nancy Newhall. Permission to reproduce courtesy of Scheinbaum and Russek Ltd., Santa Fe, NM.

3 Ansel Adams, *An Autobiography* (Boston: Little, Brown, 1985), 81–83.

4 Rebecca Palmer, "The Photographer's Gallery," *PhotoMetro* (January 1995): 25; San Francisco Art Association (SFAA) Board minutes, September 1934, 28. SFAIA.

5 SFAA Board minutes, October 1934, 25. SFAIA.

6 Ibid., November 1935, 7. SFAIA.

7 California School of Fine Arts (CSFA) College Catalog 1939–1940 SFAIA; Ansel Adams, *An Autobiography* (Boston: Little, Brown, 1985), 392.

8 Adams's *Pageant of Photography* for the Golden Gate International Exposition (GGIE) exhibit included a historical section with original photographs by Brady, Jackson, Watkins, O'Sullivan, and Muybridge; "technological photography"; "color photography"; two galleries reserved for changing one-person and group shows that included Strand, Weston, Sheeler, Abbott, Moholy-Nagy, and others; and "two striking documentary exhibits"—*The American Small Town* from the Farm Security Administration and *Harlem Document* from the Photo League. Other aspects of the GGIE's art activities included Diego Rivera's execution of his *Pan American Unity* mural, now at City College of San Francisco, and the exhibitions *Old Master Drawings, California Art in Retrospective, 1850–1915, Architecture-Planning-Housing, Mexican Art, Contemporary American Art,* and *The History of the Motion Picture.*

9 Ansel Adams to Edward Weston, 1943, in *Ansel Adams: Letters & Images, 1916–1984,* ed. Mary Street Alinder (Boston: Little, Brown, 1988), 141; Ira Latour, "Ansel Adams, The Zone System and the California School of Fine Arts," *History of Photography,* 22, no. 2 (Summer 1998): 148.

10 Ansel Adams to Eldridge T. Spencer, proposal for CSFA photo lecture series, 12 August 1944. SFAIA.

11 Ansel Adams to Ted Spencer, 10 October 1944. SFAIA.

12 Ansel Adams to Alfred Stieglitz, 25 December 1944, in *Adams: Letters,* 154.

13 Ansel Adams, Report on the Proposed Department of Photography, California School of Fine Arts, 19 May 1945. SFAIA.

14 Ibid.

15 Ansel Adams to David McAlpin, 18 September 1945, in Latour, "The Zone System," 148.

16 Richard Candida Smith, *Utopia and Dissent: Art, Poetry, and Politics in California* (Berkeley: University of California Press, 1995), 91.

17 David Beasley, *Douglas MacAgy and the Foundations of Modern Art Curatorship* (Simcoe, Ontario: Davus, 1998), 30.

18 Alexander Fried, "Director Outlines New Vista for Arts School," *San Francisco Examiner,* 24 June 1945.

19 Douglas MacAgy, "The CSFA and Its Eastern Counterparts," report to the San Francisco Art Association Board, 30 October 1947. SFAIA.

20 Thomas Albright, *Art in the San Francisco Bay Area, 1945–1980* (Berkeley: University of California Press, 1985), 18.

21 MacAgy, "The CSFA."

22 Minor White, "A Unique Experience in Teaching Photography," *Aperture* 4, no. 4 (1956): 151. Copyright © 1956 by Minor White renewed by the Trustees of Princeton University. Publication here is with permission of the Minor White Archive, Princeton University Art Museum.

23 Ansel Adams to Douglas MacAgy, 25 July,1945. SFAIA.

24 Ansel Adams to Lindley Bynum, 25 July 1945. SFAIA. Adams pursued his idea to affiliate with a major academic institution and offer some sort of joint degree. He had sent University of California president Robert Gordon Sproul the proposal for the department with his enthusiastic appraisal of the Bay Area's potential as a photography center, thinking it would "rapidly assume a leading position in the entire hemispheric cultural scene." Sproul wrote back to Adams that "our academic life would be richer for the presence of Ansel Adams" and suggested Adams meet with U.C. art department chair Stephen Pepper and that together they "might work out something of world shaking significance to Art." The idea remained just that, and the two schools were never able to combine forces. Robert Sproul to Ansel Adams, 27 September 1945, SFAIA; Ansel Adams to Douglas MacAgy, 30 September 1945, SFAIA; Ira Latour, "The Zone System," 151.

25 Ansel Adams to Douglas MacAgy, 13 July 1945. SFAIA.

26 Beaumont Newhall, "Basic Books for a Photographic Library compiled for the San Francisco Art Association," 7 July 1945. SFAIA. Copyright © 1945, Beaumont Newhall, the Estate of Beaumont Newhall and Nancy Newhall. Permission to reproduce courtesy of Scheinbaum and Russek Ltd., Santa Fe, NM.

27 Douglas MacAgy to Ansel Adams, 2 August 1945. SFAIA.

28 Beaumont Newhall to Douglas MacAgy, 24 August 1945. SFAIA. Copyright © 1945, Beaumont Newhall, the Estate of Beaumont Newhall and Nancy Newhall. Permission to reproduce courtesy of Scheinbaum and Russek Ltd., Santa Fe, NM.

29 Eldridge T. Spencer to the directors, Columbia Foundation, 6 September 1945. SFAIA.

30 SFAA *Bulletin,* November 1945. SFAIA.

31 "U.S. Funds Give Fighters Start," *San Francisco Call-Bulletin,* 1 August 1945.

32 Ansel Adams to Douglas MacAgy, 22 September 1945. SFAIA; Ansel Adams to Alfred Stieglitz, 12 August 1945, in *Adams: Letters,* 160.

33 SFAA Board minutes, 18 October 1945. SFAIA.

34 Ansel Adams to Douglas MacAgy, 30 September 1945; Ansel Adams to Gordon Willis, KQW, 17 October 1945; Ansel Adams to Douglas MacAgy, 17 October 1945. SFAIA.

35 SFAA *Bulletin,* November 1945. SFAIA.

36 Ansel Adams to Phil Hyde, 1 November 1945. SFAIA.

37 Mrs. Charles deYoung Elkus, Jr., to Eldridge T. Spencer, 1 November 1945. SFAIA.

38 Ansel Adams to Phil Hyde, 13 November 1945. SFAIA.

39 Draft announcement of $10,000 Columbia Foundation Grant, November/December 1945. SFAIA.

40 Ira Latour, "The Grove of Akademus," *Photometro* 15, no. 142 (December 1996): 43; Latour, "The Zone System," 148–149.

41 Latour, "The Zone System," 149.

42 Ansel Adams, "Basic Plan of Curricula at CSFA Photography Department," 25 November 1945; Ira Latour to Deborah Klochko, August 2003. SFAIA.

43 Ansel Adams, "Report No. 3," to Douglas MacAgy, 20 December 1945. SFAIA.

44 Ansel Adams, "Report No. 4," to Douglas MacAgy, 20 December 1945: Ansel Adams to Douglas MacAgy, 27 December 1945. SFAIA.

45 Ansel Adams to Nancy Newhall, 7 January 1946, *Adams: Letters,* 166.

46 Ansel Adams, Department of Photography Proposal to SFAA School Committee, 27 January 1946. Ansel Adams to Douglas MacAgy, 11 March 1946. SFAIA.

47 Ansel Adams to Nancy Newhall, 7 January 1946 *Adams: Letters,* 166.

48 David Travis, *Edward Weston: The Last Years in Carmel* (Chicago: Art Institute of Chicago, 2001), 48.

49 Beaumont Newhall to Ansel Adams, 7 March 1946, *Adams: Letters,* 168. Copyright © 1946, Beaumont Newhall, the Estate of Beaumont Newhall and Nancy Newhall. Permission to reproduce courtesy of Scheinbaum and Russek Ltd., Santa Fe, NM.

50 Ansel Adams to Douglas MacAgy, 11 March 1946. SFAIA.

51 Beaumont Newhall to Douglas MacAgy, 24 April 1946. SFAIA. Copyright © 1946, Beaumont Newhall, the Estate of Beaumont Newhall and Nancy Newhall. Permission to reproduce courtesy of Scheinbaum and Russek Ltd., Santa Fe, NM.

52 Ansel Adams to Douglas MacAgy, 5 May 1946. SFAIA.

53 Ansel Adams, "Outline of Summer Sessions," Spring 1946. SFAIA.

54 Douglas MacAgy to Leah Hamilton, SFAA School Committee, 25 May 1946. SFAIA.

55 SFAA Board minutes, 9 May 1946. SFAIA.

56 CSFA, Department of Photography Summer Session, Spring 1946; Supplementary Information for Admission, 1946. SFAIA.

57 Ansel Adams to Edward Weston, April 1946, *Adams: Letters,* 169.

58 SFAA School Committee report, 25 June 1946. SFAIA; Susan Ehrens, *Alma Lavenson: Photographs* (Berkeley: Wildwood Arts, 1990), 94.

59 CSFA roll book, Ansel Adams, Summer 1946, days. SFAIA.

60 James Danziger and Barnaby Conrad III, *Interviews with Master Photographers* (New York: Paddington, 1977), 22; Minor White, "Memorable Fancies," 9 July 1946, in Minor White, *Mirrors Messages Manifestations* (Millerton, NY: Aperture, 1969), 41; James Baker Hall, "Biographical Essay," *Minor White: Rites & Passages* (Millerton, NY: Aperture, 1978), 87. Copyright © by the Trustees of Princeton University. Publication here is with the permission of the Minor White Archive, Princeton University Art Museum.

61 Minor White to Alfred Stieglitz, 7 July 1946, in Peter C. Bunnell, *Minor White: The Eye that Shapes* (Boston: Little, Brown, 1989), 24–25. Copyright © by the Trustees of Princeton University. Publication here is with the permission of the Minor White Archive, Princeton University Art Museum.

62 White, "Teaching Photography," 150.

63 White, "Biographical Sketch of Minor White," 1948. SFAIA. Copyright © by the Trustees of Princeton University. Publication here is with the permission of the Minor White Archive, Princeton University Art Museum.

64 Nancy Newhall to Ansel Adams, 15 July 1946; Ansel Adams to Nancy Newhall, 17 July 1946 in *Adams: Letters,* 176, 178.

65 Ansel Adams to Douglas MacAgy, 11 July 1946. SFAIA.

66 Adams, *An Autobiography,* 318.

67 White, "Teaching Photography," 152.

68 Latour, "Grove of Akademus," 43.

69 White, "Teaching Photography," 152.

70 Adams, *An Autobiography,* 318.

71 Hall, "Biographical Essay," 88.

72 Leonard Lundin, interview by Thomas Clark, 10 October 1972, Indiana University Oral History Research Project, in James Madison, *The Indiana University Department of History, 1895–1995* (Bloomington, 1995), 7.

73 "CSFA Enrollment Figures and Lists, 1945–1956," cited in Smith, *Utopia and Dissent,* 474.

74 White, "Teaching Photography," 151.

75 Douglas MacAgy to John J. Madigan, 13 November 1946; Minor White, report, CSFA Department of Photography, 30 May 1947. SFAIA.

76 Minor White, CSFA Department of Photography, report, 30 May 1947. SFAIA. Copyright © by the Trustees of Princeton University. Publication here is with the permission of the Minor White Archive, Princeton University Art Museum.

77 Ira Latour, "West Coast Photography: Does It Really Exist?" *Photography* (London), 12, (June 1957): 28. This is an excerpted transcription of a symposium organized by Latour and held at San Francisco State University with Pirkle Jones, Ruth Baruch, Ansel Adams, Wayne Miller, and Imogen Cunningham.

78 Ansel Adams to Eldridge Ted Spencer, late 1946, in *Adams: Letters,* 178.

79 SFAA Board minutes, 23 January 1947. SFAIA.

80 "Night Photography Schedule, Spring 1947," December 1946; "Supplementary Information" [for admission to photography students], December 1946. SFAIA.

81 SFAA Board minutes, 23 January 1947. SFAIA.

82 Adams, *An Autobiography,* 318; Ansel Adams to Beaumont and Nancy Newhall, 23 January 1947, reprinted in *Adams: Letters,* 179.

83 Ansel Adams to Minor White, late January/early February 1947, in *Adams: Letters,* 180–81.

84 Bunnell, *Minor White,* 5–6.

85 Ansel Adams to Eldridge Ted Spencer, 28 February 1947, in *Adams: Letters,* 183.

86 Adams, *An Autobiography,* 318.

87 Douglas MacAgy to James McCullum, 18 March 1947. SFAIA.

88 Beaumont Newhall to Douglas MacAgy, 7 January 1947. Copyright © 1947, Beaumont Newhall, the Estate of Beaumont Newhall and Nancy Newhall. Permission to reproduce courtesy of Scheinbaum and Russek Ltd., Santa Fe, NM; Douglas MacAgy to Beaumont Newhall, 13 January 1947; Douglas MacAgy to Beaumont Newhall, 17 January 1947; Minor White, memo to Douglas MacAgy, 6 March 1947. SFAIA. Copyright © by the Trustees of Princeton University. Publication here is with the permission of the Minor White Archive, Princeton University Art Museum.

89 Beaumont Newhall to Douglas MacAgy, 2 March 1947; Douglas MacAgy to Beaumont Newhall, 12 March 1947. Copyright © 1947, Beaumont Newhall, the Estate of Beaumont Newhall and Nancy Newhall. Permission to reproduce courtesy of Scheinbaum and Russek Ltd., Santa Fe, NM.

90 Minor White to Douglas MacAgy, 7 March 1947; Douglas MacAgy to CSFA School Committee, 11 March 1947. SFAIA.

91 Minor White to Ansel Adams, 8 March 1947, in Bunnell, *Minor White,* 25.

92 Minor White to Douglas MacAgy, 20 March 1947. SFAIA. Copyright © by the Trustees of Princeton University. Publication here is with the permission of the Minor White Archive, Princeton University Art Museum.

93 Ansel Adams to Douglas MacAgy, May 1947 and 1 May 1947. SFAIA.

94 Ansel Adams, CSFA Department of Photography report, 30 May 1947. SFAIA.

95 Ansel Adams to Douglas MacAgy, cover letter to CSFA Department of Photography report, 30 May 1947. SFAIA.

96 Minor White, CSFA Department of Photography report, 30 May 1947. The two distinguished students were Rose Mandel and Lee Blodget. SFAIA. Copyright © by the Trustees of Princeton University. Publication here is with the permission of the Minor White Archive, Princeton University Art Museum.

97 Bunnell, *Minor White,* 6.

98 Minor White to Douglas MacAgy, August 1947. SFAIA. Copyright © by the Trustees of Princeton University. Publication here is with the permission of the Minor White Archive, Princeton University Art Museum.

99 Adams, *An Autobiography,* 191.

100 Alvin C. Evrich to Douglas MacAgy, 20 May 1947. SFAIA.

101 Minor White, "Memo: Report on Stanford Contract," August 1947. SFAIA. Copyright © by the Trustees of Princeton University. Publication here is with the permission of the Minor White Archive, Princeton University Art Museum.

102 White, "Teaching Photography," 151.

103 Frederick W. Quandt, Jr., resume, July 1947. SFAIA.

104 Douglas MacAgy to Homer Page, 7 July 1947. SFAIA.

105 Fall 1947 entering class questionnaire, May–June 1947. SFAIA.

106 "Additional Information and Requirements" for photography students, May–June 1947. SFAIA.

107 Hall, "Biographical Essay," 87.

108 "Assignments, Creative Condition, Photography Department," 1947. SFAIA.

109 Minor White, "Photography Is an Art," *Design* 49, no. 4 (December 1947): 8. Copyright © by the Trustees of Princeton University. Publication here is with the permission of the Minor White Archive, Princeton University Art Museum; Bunnell, *Minor White,* 16; Danziger and Conrad, *Master Photographers,* 23.

110 White, "Photography Is an Art," 8, 20.

111 Ibid., 6; White, "Teaching Photography," 153.

112 Minor White to Douglas MacAgy, 26 November 1947, SFAIA. Copyright © by the Trustees of Princeton University. Publication here is with the permission of the Minor White Archive, Princeton University Art Museum; White, "Photography Is an Art," 6; White, "Teaching Photography," 151; undated document filed spring 1947. SFAIA.

113 White, "Teaching Photography," 153.

114 Photography department curriculum, Fall 1947. SFAIA. Copyright © by the Trustees of Princeton University. Publication here is with the permission of the Minor White Archive, Princeton University Art Museum.

115 Bunnell, *Minor White,* 20.

116 White, "Teaching Photography," 155.

117 Bill Heick, telephone conversation with author, 31 March 2003.

118 Ansel Adams to Douglas MacAgy, 12 November 1947. SFAIA.

119 Dorothy Warren to Dorothea Lange, 8 January 1948. SFAIA.

120 Minor White to Douglas MacAgy, "Color Instruction," 26 November 1947. SFAIA. Copyright © by the Trustees of Princeton University. Publication here is with the permission of the Minor White Archive, Princeton University Art Museum.

121 Minor White to Douglas MacAgy, 24 November 1947. SFAIA. Copyright © by the Trustees of Princeton University. Publication here is with the permission of the Minor White Archive, Princeton University Art Museum.

122 CSFA roll books, 1946, 1947, 1948. SFAIA.

123 Douglas MacAgy to Minor White, "Schedule Changes," 12 March 1948; Minor White to Douglas MacAgy, "Report of Cancellation of Photo 53," 26 March 1948. SFAIA. Copyright © by the Trustees of Princeton University. Publication here is with the permission of the Minor White Archive, Princeton University Art Museum.

124 Latour, "The Zone System," 151.

125 Minor White to Douglas MacAgy, 15 March 1948. SFAIA. Copyright © by the Trustees of Princeton University. Publication here is with the permission of the Minor White Archive, Princeton University Art Museum.

126 Minor White to Douglas MacAgy, "Summer Photo Course," 6 February 1948. SFAIA. Copyright © by the Trustees of Princeton University. Publication here is with the permission of the Minor White Archive, Princeton University Art Museum.

127 Minor White, "Summary of Courses and Periods of Instruction," 19 March 1948. SFAIA. Copyright © by the Trustees of Princeton University. Publication here is with the permission of the Minor White Archive, Princeton University Art Museum.

128 Ibid.

129 Minor White, "A New Course Proposed as Photo 53," 29 March 1948. SFAIA. Copyright © by the Trustees of Princeton University. Publication here is with the permission of the Minor White Archive, Princeton University Art Museum.

130 Minor White, "Summary of Courses and Periods of Instruction," 19 March 1948; Minor White, "Photo 51, 52, 53, Appendix 2 Proposed Subjects for Seminars," 29 March 1948. SFAIA. Copyright © by the Trustees of Princeton University. Publication here is with the permission of the Minor White Archive, Princeton University Art Museum.

131 Ansel Adams to Edward Weston, 10–14 April 1948, in *Adams: Letters,* 190.

132 Fredrick Quandt, Jr., "Recommended by Clyde Childress," 14 April 1948; Douglas MacAgy, Columbia Foundation Grant report to president, SFAA, 25 March 1948. SFAIA.

133 Frederick Quandt, Jr., "Plan for a Proposed Dark Room," 27 April 1948; Frederick Quandt, Jr., to Douglas MacAgy, 15 June 1948. SFAIA.

134 SFAA *Bulletin,* May 1948 and January 1949; *U.S. Camera Annual 1950* (New York, 1949), 225.

135 Jacob Deschin, "Contrast in Schools: Examples of Two Ways of Teaching Photography," *New York Times,* 13 June 1948.

136 Minor White to Nancy Newhall, 19–25 July 1948, in Bunnell, *Minor White,* 26.

137 White, "Teaching Photography," 155; Douglas MacAgy to Leah Rinne Hamilton, 31 May 1947. SFAIA; Minor White, "Photography In an Art School" (typed draft manuscript, 1948), in *U.S. Camera* (July 1949): 10. SFAIA. Copyright © by the Trustees of Princeton University. Publication here is with the permission of the Minor White Archive, Princeton University Art Museum.

138 Minor White to Edward Weston, 15 January 1957, in Bunnell, *Minor White,* 33.

139 Ruth-Marion Baruch resume. SFAIA. Baruch's 1946 MFA in photography from Ohio University is believed to be the first such degree awarded in photography.

140 CSFA Summer 1948 brochure. SFAIA.

141 Douglas MacAgy to Eldridge Ted Spencer, 5 August 1948. SFAIA.

142 SFAA Board minutes, 1 July 1948. SFAIA.

143 CSFA personnel data sheets, Edward Weston and Imogen Cunningham, July 1948; Ansel Adams to Douglas MacAgy, 24 July 1948. SFAIA.

144 CSFA, Bulletin—Photography Department #3 [July 1948]. SFAIA.

145 Mrs. Charles deYoung Elkus, Jr., to Eldridge Ted Spencer, 29 September 1948. SFAIA.

146 SFAA Board minutes, 28 October 1948. SFAIA.

147 Bunnell, *Minor White,* 6.

148 Included in the Western Roundtable on Modern Art were Marcel Duchamp, Gregory Bateson, Darius Mihaud, Mark Tobey, Frank Lloyd Wright, Kenneth Burke, Alfred Frankenstein, Andrew Ritchie, Dr. George Boas, and Robert Goldwater. Omitted was a photographer. Ansel Adams wrote to the new SFAA Board president, Henry Swift, that "in spite of my opinions as written to you, I hope it turns out to be a real success . . . I do hope in the future photography gets a better break." Adams to Swift, 30 March 1949. SFAIA.

149 SFAA Board minutes, 31 March 1949. SFAIA.

150 Ansel Adams to Henry Swift, 30 March 1949. SFAIA.

151 CSFA summer session photography department, Spring 1949. SFAIA.

152 SFAA *Bulletin,* June 1949. SFAIA.

153 Ansel Adams to Beaumont Newhall, 11 July 1949, in *Adams: Letters,* 211.

154 White, "Photography in an Art School".

155 Lord Martine, "Focus Chinatown: Photographer Studied with Greats," *San Francisco Chronicle,* 31 January 2003.

156 White, "Photography in an Art School"; Bill Heick, telephone conversation, 31 March 2003.

157 William R. Lieb to CSFA registrar, 2 July 1949; Photo Department inquiries, July 1949. SFAIA.

158 Minor White to Sgt. Leonard Ash, 29 June, 1949. SFAIA. Copyright © by the Trustees of Princeton University. Publication here is with the permission of the Minor White Archive, Princeton University Art Museum.

159 Minor White to Douglas MacAgy, 26 May 1949. Copyright © by the Trustees of Princeton University. Publication here is with the permission of the Minor White Archive, Princeton University Art Museum.

160 Minor White to Douglas MacAgy, 26 May 1949; Minor White to Douglas MacAgy, 12 May 1949. Copyright © by the Trustees of Princeton University. Publication here is with the permission of the Minor White Archive, Princeton University Art Museum; Philip Hyde to Douglas MacAgy, 13 August 1949; Douglas MacAgy to Philip Hyde, 16 August 1949. SFAIA.

161 Douglas MacAgy to Roland Butler, 20 September 1949. SFAIA.

162 Minor White to Douglas MacAgy, 12 September 1949. SFAIA. Copyright © by the Trustees of Princeton University. Publication here is with the permission of the Minor White Archive, Princeton University Art Museum.

163 Bunnell, *Minor White,* 6.

164 Ansel Adams to Nancy Newhall, 27 February 1950 and 15 September 1948, in *Adams: Letters,* 215, 198.

165 Minor White to *U.S. Camera Annual* editor, 14 March 1950. SFAIA. Copyright © by the Trustees of Princeton University. Publication here is with the permission of the Minor White Archive, Princeton University Art Museum.

166 SFAA *Bulletin,* April 1950. SFAIA.

167 Minor White, "Memorable Fancies," 2 April 1950, in Bunnell, *Minor White,* 26.

168 Minor White to Beaumont and Nancy Newhall, 25 May 1950, in Bunnell, *Minor White,* 27.

169 Minor White, "Outline of the Photographic Course—California School of Fine Arts," May 1950. SFAIA. Copyright © by the Trustees of Princeton University. Publication here is with the permission of the Minor White Archive, Princeton University Art Museum.

170 Douglas MacAgy to Henry Swift, 1 May 1950. SFAIA.

171 Smith, *Utopia and Dissent,* 127.

172 Minor White to Ernest Mundt, 1 March 1950. SFAIA. Copyright © by the Trustees of Princeton University. Publication here is with the permission of the Minor White Archive, Princeton University Art Museum.

173 Paul Mathews and Leon T. Kuzmanoff, General Information on United Airlines Project, 1950; David Park to Treasure Island Naval Station, 7 July 1950. SFAIA.

174 D. S. Myer to Ansel Adams, 20 June 1950; Ansel Adams to D. S. Meyer, 2 July 1950. Minor White to David Park, July 1950; David Park to Ernest Mundt, August 1950. SFAIA. Copyright © by the Trustees of Princeton University. Publication here is with the permission of the Minor White Archive, Princeton University Art Museum.

175 1950–51 Inquiries/Applications. SFAIA.

176 Minor White to Douglas MacAgy, 2 May 1950; publicity release, evening courses, fall 1950. SFAIA. Copyright © by the Trustees of Princeton University. Publication here is with the permission of the Minor White Archive, Princeton University Art Museum.

177 SFAA Board minutes, 28 September 1950; Minor White to Ernest Mundt, 12 September 1950. SFAIA. Copyright © by the Trustees of Princeton University. Publication here is with the permission of the Minor White Archive, Princeton University Art Museum.

178 Minor White, "Opening Statement, Photography Department," 12 September 1950. SFAIA. Copyright © by the Trustees of Princeton University. Publication here is with the permission of the Minor White Archive, Princeton University Art Museum.

179 Frederick William Quandt, Jr., "Preliminary Orientation to Photographic Technique, CSFA," 1950. SFAIA.

180 SFAA Bulletin, November 1949; White, "Memorable Fancies," 10 April 1953, in White, Mirrors Messages Manifestations, 90; Minor White, A Phoenix Too Frequent, portfolio of original photographs, 1950. SFAI Library.

181 "Print Criticism: A Series of Illustrated Lectures by Minor White at CSFA" (typed proposal), January 1951. SFAIA. Copyright © by the Trustees of Princeton University. Publication here is with the permission of the Minor White Archive, Princeton University Art Museum.

182 SFAA Bulletin, January 1951. SFAIA.

183 Reprint of San Francisco Chronicle, 25 March 1951, appeared in SFAA Bulletin, April 1951. SFAIA.

184 SFAA Board minutes, 29 March 1951. SFAIA.

185 Ernest Mundt, "Report to the School Committee," 13 October 1950. SFAIA.

186 SFAA Bulletin, April 1951. SFAIA.

187 SFAA Bulletin, June–July 1951. SFAIA.

188 Ansel Adams to Ernest Mundt, 2 May 1951; SFAA Bulletin, June–July 1951. SFAIA.

189 Betty Jones to Minor White, 20 July 1951. SFAIA.

190 Minor White to Tom and Audrey Murphy, 18 October 1951, in Bunnell, Minor White, 28.

191 SFAA Bulletin, January 1952; press release, "Looking at Looking," January 1952. SFAIA.

192 SFAA Bulletin, April–May 1952. SFAIA.

193 Minor White, "Exploratory Camera: A Rationale for the Miniature Camera," Aperture, 1, no. 1 (1952). Copyright © by the Trustees of Princeton University. Publication here is with the permission of the Minor White Archive, Princeton University Art Museum; Danziger and Conrad MasterPhotographers, 24; Aperture, 1, no. 1 (1953): 30.

194 SFAA Bulletin, April–May 1952. SFAIA.

195 SFAA Bulletin, June–July 1952; CSFA roll books, fall 1952. SFAIA.

196 San Francisco Chronicle, 21 September 1952; San Jose News, 3 October 1952; SFAA Bulletin, August–September and October–November 1952. The Bender Grants-in-Aid in Art and Literature were given from 1942 through 1952. In 1951 and 1952 additional grants were designated for photography. The grants were set up by the Albert M. Bender Memorial Trust after Bender died in 1941, and they were intended to last until the initial funds were exhausted, which occurred with the awarding of the grants for 1952.

197 "Totality Exhibit," San Francisco Examiner, 8 February 1953.

198 SFAA Bulletin, February–May 1953 and June–July 1953; Aperture, 2, no. 1 (Summer 1953).

199 CSFA class roll books, summer 1953. SFAIA.

200 Minor White to Ansel Adams, 8 March 1947, in Bunnell, Minor White, 25.

201 Jane Kastner to CSFA applicants, 30 August 1953. SFAIA.

202 CSFA class roll books, fall 1953.

203 SFAA Bulletin, October–November, 1953. SFAIA.

204 Ernest Mundt to Minor White, 2 October 1953; White, "Teaching Photography." SFAIA.

205 Aperture, 2, no. 2. This was the last issue of Aperture published in San Francisco. Copyright © by the Trustees of Princeton University. Publication here is with the permission of the Minor White Archive, Princeton University Art Museum.

206 Hall, "Biographical Essay," 89.

207 Paul Caponigro, "My Friend and Teacher," in Benjamen Chinn at Home in San Francisco, Irene Poon, editor. San Francisco: Chinese Historical Society of America Museum and Learning Center, 2003, 27–28, 38.

208 Perceptions opened at the San Francisco Museum of Art on 10 April 1954. Among the forty-six photographers in the exhibition were Ansel Adams, Imogen Cunningham, Dorothea Lange, Edward Weston, and Minor White. Also included in the exhibition were ten photographers who had been students at CSFA.

209 Perceptions: A Photographic Showing from San Francisco, 1954 (San Francisco: San Francisco Museum of Art, 1954). Copyright © by the Trustees of Princeton University. Publication here is with the permission of the Minor White Archive, Princeton University Art Museum.

210 Rebecca Palmer, "The Photographer's Gallery," PhotoMetro (January 1995): 25.

211 Minor White to Ansel Adams, 15 August 1954; Minor White to Nata Piaskowsky and Martin Baer, 18 October 1954; Minor White to Nancy Newhall, 1 April 1954; all in Bunnell, Minor White, 30–31.

212 White, "Teaching Photography," 150–56.

213 Douglas MacAgy, "The CSFA and Its Eastern Counterparts," a report to SFAA Board, 30 October 1947; Minor White, "Opening Statement, Photography Department," 12 September 1950. SFAIA. Copyright © by the Trustees of Princeton University. Publication here is with the permission of the Minor White Archive, Princeton University Art Museum.

214 Smith, Utopia and Dissent, 132.

215 Ansel Adams to Minor White, 17 March 1956; Ansel Adams to Gurdon Woods, 17 March 1956; SFAIA.

216 Minor White to Gurdon Woods, 30 June 1956; Gurdon Woods to Minor White, 10 July 1956; Minor White to Gurdon Woods, 25 August 1956; SFAIA. Copyright © by the Trustees of Princeton University. Publication here is with the permission of the Minor White Archive, Princeton University Art Museum.

217 CSFA publicity material for the Seminar in Creative Photography, 1956. SFAIA.

218 San Francisco Examiner, 5 November 1956.

219 Minor White to Gurdon Woods, 6 August 1957; Minor White to Gurdon Woods, 3 September 1957. SFAIA. Copyright © by the Trustees of Princeton University. Publication here is with the permission of the Minor White Archive, Princeton University Art Museum.

220 California Historical Society Courier, June 1984.

221 Rebecca Solnit, River of Shadows: Eadweard Muybridge and the Technological Wild West (New York: Viking, 2003), 258.

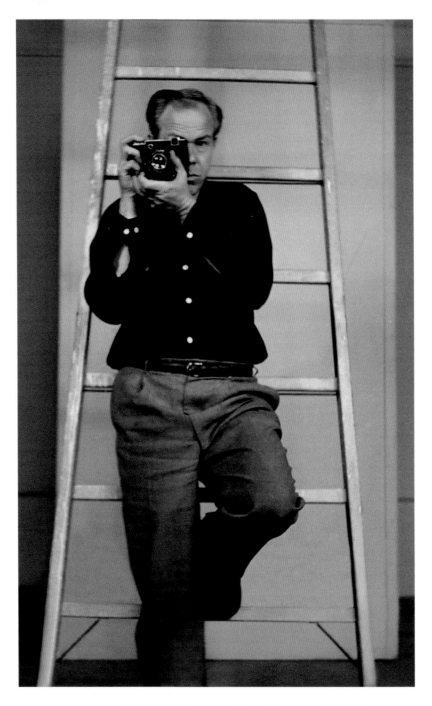

A VISUAL VOCABULARY:
THE PEDAGOGY OF MINOR WHITE

BY DEBORAH KLOCHKO

Although Ansel Adams founded the photography department at the California School of Fine Arts, Minor White guided the development of that unique program. Appointed by Adams in 1946, White began refining his teaching methods and exploring his own creative process during his tenure at the school. White's search for his own photographic voice began in 1937, when he "took up photography seriously." Before completing a graduate degree in botany from the University of Minnesota, White left the program to focus on writing poetry. In the fall of 1937, White moved to Portland, Oregon, where he began teaching photography at the YMCA. He also worked as a photographer for the Works Progress Administration (WPA) and later served as the director of the WPA Art Center, at La Grande, Oregon, until WWII.

Of his service in the Pacific Theater during the war, White wrote, "Army service from 1942–45. The less said about it the better. Photography production at a minimum, writing about photography at a maximum."[1] Following his discharge from the service in 1945 White moved to New York City.

Enrolling at Columbia University, White studied aesthetics with art historian Meyer Schapiro and the philosopher and poet Irwin Edman. He wrote, "Upon escape from the service spent a school year at Columbia with such subjects as Art History, Modern Art and Sculpture, Philosophy of Art etc. Gathered while here the foundation of the courses now taught at the Cal School of Fine Arts Photo Dept."[2]

While in New York, White also studied museum work under the tutelage of the photography curator Beaumont Newhall at the Museum of Modern Art. Not only was White exposed to new ways of thinking about art, he began what would become lifelong friendships with Beaumont and Nancy Newhall, as well as meeting photographers such as Edward and Brett Weston, Paul Strand, and Alfred Stieglitz. Through his conversations with Stieglitz White learned more about "creative thought in photography (especially the theory of the equivalent and the sequence)."[3] Through the influence of the Newhalls White was offered a teaching position in Ansel Adams's new photography program in San Francisco.

Shortly after he began working at CSFA, White wrote to Stieglitz of an earlier conversation that had helped restore his faith, lost during the war, and stating his belief in the importance of photography: "Somewhere in combat, faith in anything but evil disappeared and it was slow returning. I hope I can extend to these students your faith that photography is the most important

‹We emphasized the creativeness that happens at the moment of seeing over the kind that takes place in the dark room.›
——MINOR WHITE, 1956

Opposite page: Gerald Ratto, Minor White, c. 1952.

thing in the world as well as that more encompassing faith in integrity."[4] Photography was central to White's life.

A few years later, writing for *U.S. Camera*, he reflected on the now-established photography program at CSFA. For White, the most important aspect of the program was the intersection of technique and interpretation: "Against the relaxed standards of photography today, the California School of Fine Arts and its photography department provides a place where integrity of the artist and photographer is all-important, where craftsmanship is developed to the highest possible level, where vitality is not confused with mere impact, where inspiration may acquire its disciplines."[5]

White's departure from CSFA in 1953, after seven years, coincided with Mundt's shifting focus to commercial and applied arts. There was also the "open secret" of White's homosexuality that was known to his students, a few close associates, and by that time, the school administration. The change in curriculum combined with decreasing enrollment were the stated reasons for not renewing White's contract. But there was also speculation that the board and the new director were uncomfortable with White's sexual orientation, contributing to his departure from the school. After Mundt's leaving and the hiring of Gurdon Woods as the school's new director, attempts were made to bring White back to CSFA. In 1956, encouraged by Adams, Woods invited White to teach a photography workshop. While the successful workshop was followed by a number of visits over the years, White never returned to CSFA on a permanent basis. Although White would continue to teach photography at Rochester Institute of Technology and later at Massachusetts Institute of Technology, along with conducting workshops and seminars, his time at CSFA was the inspiration for exploring and expanding his core ideas on education.

A prolific writer and a dedicated educator, White provided a rich legacy of this approach to teaching, which covers both the craft and the interpretive aspects of photography. What follows are a selection of writings, published and unpublished—from his personal correspondence to a course outline to articles reflecting back on "A Unique Experience in Teaching Photography"—that trace the evolution of his pedagogy. All illustrate his approach to teaching and making art, which remains current sixty years after its introduction.

This page: F. W. Quandt, Minor White and students, c. 1950.

Minor carried on a lifelong correspondence with both Beaumont and Nancy Newhall.

May 25, 1950, San Francisco

Dear Beau and Nancy:

Enclosed is the usual Spring dither on what we are teaching. It always amazes me to discover how much we expect to lay before the kids. Fortunately much of it is not presented directly, but forms the basis of criticism and discussion over prints and over hootch.

. . . One of the values of teaching, to me, is now and then having to be what I am expected to be. The other day had a letter from a third year man (Phil Hyde—and really has something to give to the world), [which] put me on the spot. Is art to be a reflection of the hopelessness of the present day man or is it to be one of the solid things which he can hang on to. Whew! It came up over by Disaster Series which he felt was a powerful ride straight to destruction and that it was devastating because it did not offer even the faintest possibility of salvation. Soooo, at lecture Monday I had to go on record saying that for me, art was one of the faiths of the world. That jarred a few of the boys, but it vindicated this one man—not that he really needed it—it's his conviction anyway—but perhaps it would cement for him his belief and thus save him years of proving to himself that he was right. It is not often that I have to take a stand, trying to be four teachers at once, I can usually state that facts 1, 2, 3, 4, etc., are facts objectively. If I had other teachers who stood for one view or another I could afford to take one myself. But it is worth it. I grow up in that class because in order to answer their questions, I am forced to. It was a wonderful lift to make that positive statement, art is a communication of ecstasy, it is one of the faiths of man. For all my photographing the lonely, the frustrated, the despair, it is my belief that my aim with art is the solution of these things within the work of art. Came home that evening about 8, tired and feeling free more than usual. A shot and Bach fuges and I was off on a binge of sheer lyricism . . .

Cheerio,
Minor[6]

‹Reaching a "creative" state of mind thru positive action is considered preferable to waiting for "inspiration."›
—MINOR WHITE, 1950

The California School of Fine Arts became Minor White's laboratory, and the students his assistants in experimenting with these new ideas. The students were taught not only how to make fine photographs but how to analyze both the images and the motivation for their vision. Central to White's teaching was the notion of "print analysis," which combined an awareness of formal and technical elements while photographing and the ability to engage in a critical assessment of the resulting images. In one article, White wrote, "complete expressiveness can be achieved only within the framework of perfect mechanics and that mechanics and expressiveness are fundamental outgrowths of each other."[7]

GENERAL AIMS OF THE DEPARTMENT.

[Outline of the Photographic Course—California School of Fine Arts Recommendations for Courses in the Art Department for Photography Students, submitted by Minor White, May 1950[8]]

1. To provide technical craftsmanship which will allow the student to enter most of the professional fields of photography.

2. To develop in the student a craftsmanship of feeling which can be turned to the services of a client at will or used for his own creative purposes.

3. To develop a craftsmanship of communication that can be used at will for either his own purposes or the needs of a client.

4. To present the scope of photography to the student's view, both currently and historically. (From this knowledge and the experience with technique he can specialize according to his needs.)

5. To expose the student to the theory behind the scientific aspect of the medium. (Which is very extensive.)

6. To expose the student to aesthetic theory in general and to help him develop an aesthetic of camera.

7. To develop in the student a love of the medium thru mastery of it, and a sense of responsibility for his own pictures. (This last point is in direct conflict with the experience of photographers working with editors and art directors.)

8. To develop an attitude of "professionalism" which is distinguished from a "creative" one (amateurism at the highest sense) only by bringing to a client's problems all the craftsmanship, knowledge, experience, sympathy and imagination that he has and uses for his own independent production.

9. To help and/or encourage students to make art of and/or in spite of their psychological conflicts.

Implementation of the Aims. (During the basic two years.)

I. Technical craftsmanship includes:

A. Negative and print production, print presentation.
(Covers any brightness and subject problem, and display from a single print to a show.)

B. Five techniques.
(A technique being thought of as the fitting of a man to a specific set of instruments and processes to the point that he instinctively uses the tools in their *characteristic* manner.)

1. View Camera.
The print as the final product. Inanimate subject matter emphasized.
The characteristic of this technique is precision and studied control.

2. Natural light.
Selective seeing (or "found" pictures) is considered characteristic of camera work. So this technique combined with view camera and neutral light constitutes most of first year work. (The general and specific testing methods, negative-print production and basic presentation is taught with the same tools. And in order to present the chain of emotional events that happen to a student learning a new technique—from conscious fumbling to instinctive mastery—the use of this combination is brought to creative pitch. It is this procedure that is mainly responsible for the reputation of the department current outside of school.)

3. Artificial light.
Coincident with this technique is taught *"Organizational Seeing."* That is, the camera as a recorder of essentially hand arrangements of objects as contrasted to "found" ones. (It is in the realm of "organizational seeing" or organizational composition that the photography student should be taught by members of the art faculty rather than practicing photographers who do it by "set-ups" of "studio" photography. The source of "organizational" seeing is in the traditions of painting and design not in photography.

4. Miniature Camera.
Reproduction as the final product. Emphasis on people in action. The characteristic of this technique is the camera as an extension to the human vision, and/or a participation in the immediate event. (This is started second year, enlarging is a part of the technique. While reproduction is usually the end product of most view camera work as well as of miniature, it is convenient to consider it second year after the idea of superb and characteristic photographic quality is thoroughly implanted.)

5. Color Transparencies.
The essential theory is derived from text books. Practice is limited to getting the feel of color expecting that *all* the student has learned in other techniques will be operative in him at this point as always. (The subject of color could easily take the major part of two terms in a third year.)

2. **Craftsmanship of Feeling includes:**

 A. Five approaches to subject matter.

 1. Mechanical recording.
 (Accurate rendition of substance throughout, and the utmost respect for the identity of each object.)

 2. Objective Interpretation.
 (Respect for identity of object plus the same for the essence of spirit.
 Faithfulness to original appearance altered if necessary to state truth of the meaning.
 The personality of the artist is injected sparingly and preferably not at all.)

 3. Impressionistic.
 (Recording the effect of subject on artist without regard for spirit or identity of subject.)

 4. "Equivalent."
 (Conscious use of subject matter to illustrate states of mind or ideas of the artist which are not related to the original subject. Design and/or subject becomes equivalent to a mood.)

 5. Subjective or "Free Photographing."
 (Uncritical seeing at the time of exposure—or instinctive seeing—that reveals the personality of the artist. The results sometimes prove psychological signposts instead of works of art.)

 B. It also includes the practical aspects of reaching a sensitive state of mind thru association with equipment and thru act of making photographs. Reaching a "creative" state of mind thru positive action is considered preferable to waiting for "inspiration."

3. **Craftsmanship of Communication Is Implemented by:**

 A. Analysis of two and three dimensional design for its own sake, and for its effect on spectator.

 B. Analysis of style.
 (An exhaustive tool for contemplation of prints is used, called "Space Analysis" in the jargon of the department. It is a formal analysis of visible effects *always* related to the possible impression of the beholder.)

 C. Analysis of subject matter and its effect on audience.

 D. Criticism.
 The intentions of the artist, his degree of achievement in specific instances, the validity of the intentions. Search for the central vitality (creativeness) of a work of art is considered the keynote of criticism, not subject matter, nor style.

E. Symbolism.
(The current symbolism of psychology is touched on. The dual dangers of symbolism are pointed out—too little and too much.)

4. The scope of photography is presented under the following headings.

A. Scientific.
Recording of facts with maximum accuracy, including those that can not be seen with the eye. Special equipment required, and intimate knowledge of the specific field is more important than camera.

B. "Commercial."
Recording of materials and objects or people in some instances, mainly for record purposes. Use of the medium as a trade or means of making a living. Business sense and personality equally or more important than craftsmanship.
(The uniqueness of the department depends in part on its insistence of "interpretation" and imagination in this field.)

C. Photojournalism.
Recording of events and people concerned.
(Sequence of photographs with text to fit is assigned to students in the second year. The ideal is the picture that needs only the names of the people to accompany it.)

D. Hobby.
The camera club, the salon, the millions of camera users.

E. "Experimental."
The use of light sensitive materials, with or without cameras, in the plastic manner of hand artists.

F. Portraiture.
"Formal." Subjecting the sitter to standard rules somehow thought to be standardized by the "old masters."
"Informal." The ideal is considered, "the portrait is the record of an experience between two people." Use of environment to comment on or augment the personality of the sitter.

G. Propaganda.
Pictures to sell something or to educate. Product (Advertising) Service (Publicity) strata of society (Documentary) Process or equipment (Visual Aid, Educational).

H. "Expressive" photography.
(The term is used artificially and arbitrarily here to stand for discovery and investigation of self thru subjective or "free photographing" followed by objective looking at the pictures for what they reveal of the self. Communication is limited to a conversation between the artist and himself, or at most a few intimates. Accidentally it may coincide with "creative" photography.)

‹*The development of a love of medium and a responsibility for one's own pictures is an overall goal.*›
——MINOR WHITE, 1950

This page: Benjamen Chinn, Minor White teaching, c. 1948.

85

I. "Creative" photography.

Planned work based on the discoveries of self and self revelation with communication purposefully aimed at.

(An accomplished artist-photographer is considered as one whose instinctive handling of his medium contains an awareness of audience just as it contains—well digested—awareness of composition, technique, self.)

(The department leans heavily on "expressive" and "creative" photography thinking them to be the life blood of the medium. We seem to be the only school deliberately so doing.)

5. **The scientific aspect of the medium is introduced to the student thru the use of text books and lectures on theory. It includes:**

 A. Optic

 B. Sensitometry

 C. Nature of Light Sources

 D. Theory of Filters

 E. Chemistry of process.

6. **The aesthetic of camera is developed thru taking pictures and analysis of prints in terms of the characteristic use of the medium and the integrity of the artist.**

 (There is no course by this name, it is under constant discussion in one way or another. Much of the distrust and resentment for "experimental" photography found in the students may be laid to the feeling that such "tricks" are *un*photographic.)

7. **The development of a love of medium and a responsibility for one's own pictures is an overall goal.**

 Everything contributes. The student's evaluation of his achievement, other student's evaluation, that of the instructor, appreciation or lack thereof from untrained and unsympathetic spectators. Some students discover in school that they are not and can not be photographers in the best tradition and give it up.

8. **The development of the "professional" attitude is aided by what is called, in the department, the *project plan*.**

 This is an elaborate check list of the procedure of contacting a client, planning the photography, research, client's problems, cost, production and delivery of finished work. Most of the assignments are done according to this plan. Simulated audience for the pictures and imaginary clients are devised. (It has been found in the past that thru school contacts real clients and real problems can be located for student use which do not conflict with practicing professionals. This is definitely the best approach to the professional attitude to date.)

This page: Al Richter, Minor White teaching, 1949.

The 3rd year program continues much of the above work. The student is expected to start specialization, or to take up color as best he can with no facilities and little supervision.

— He selects his own projects, presents them in planned form for approval, receives supervision when he wants it, or as instructor wishes.
— Projects are aimed at publication, sale or showing.
— Seminar subjects are mainly research problems for students. Covered following this year.

 1. Relation of artist to: society, community, museums, galleries, camera clubs.
 2. His legal rights, fees, practical experience in small commercial jobs.
 3. Print Criticism. Analysis of student and "arrived" artists work along formal lines, camera aesthetic, and psychology. History of photography.

Courses in the Art Department for Photo Students.

Orientation (by whatever title)
— School curriculum art department as well as his own.
— Place of artist, whatever medium, in the community.
— Use of art in industry, trade, culture.
— Place of photography in the art mediums.
— Philosophy and/or intentions of non-representational directions.

Drawing and Composition
— "Organizational Seeing." Seeing by drawing as compared to seeing by camera.
(The differences need not be pointed out in the class room.)
(I would recommend photograms be used by photography students.)
— Revelation of self in the "handwriting" characteristics of the medium used should be pointed out.
— Design for its own sake, design as a means of communication.
— Meanings of composition as they have appeared in history.
— Bring the student to a feeling of what design can be.

Color Control
— "Organizational Seeing" in terms of color.
— Systems of Nomenclature, color systems.
— Significance of color in communication.
— The feeling of color touched on thru experience.
(If the feeling is reached in the mediums of paint or wash, the difference between it and photographic color will be easier to point out.)

Artist and Client
— Reproduction methods for both hand and camera work.
— Portfolio production aimed at a specific client rather than a collection of school assignments.
— Selling methods for artist's professional ability or competence.
— Selling methods and outlets for his product.

This is the first of six articles planned for *American Photography* magazine; only four were ever published.

YOUR CONCEPTS ARE SHOWING
How to Judge Your Own Photographs

First of a series of six articles,[9] May 1951

"You use a camera as if it were a paint brush," I said, handing prints back to a young man.

"Do I?"

"Yes, your concept of photography is obviously to use the camera as if it were a pencil, or a brush, or some kind of hand-art tool. And it shows."

"Is that bad?"

"Not necessarily. If I make an observation on a certain manner of camera handling, I am not, therefore, commenting on whether you do it well or poorly. Someone else might use the camera according to a different concept that would also show."

"How do you mean?"

"Let's back up and first state what a concept is. Then we can get at what I mean more easily. A concept is a kind of central philosophy a man uses in his creative work. He reaches such a working method after some years in close contact with his medium, during which time he learns to influence the medium while in turn it conditions him. Between the two, then, the concept is developed. The concept reflects his personality, his training, his experience—experience including how the camera has channeled his seeing."

"Yes, go on."

"In photography, if we define broadly enough, we can cover the whole field with two concepts. One is the same I have noticed in your work, the camera used as if it were a brush or a pencil. The other is the use of the camera as if it were an extension of vision.

"There are many other concepts, all of them exciting and powerful working methods to those who have developed them. For instance, the camera as a recording device which the scientist uses; as a reporting instrument such as the newsmen use; as an isolation of experience; as a participation in experience; as an imitation of painting such as we find in the expressive use of the medium. Some of the concepts are quite general, others quite personal. Most of them overlap to some degree. However, we shall confine ourselves to the two most general of all, camera-as-brush and camera-as-extension-of-vision, and also confine the discussion to expressive photography."

"Are these new concepts?" the young man asked.

"No, they have persisted side by side since photography started and exist today as well. The camera-as-brush concept is held by pictorialists, those who use hand processes, those who have looked at paintings so long they see nature as an imitation of art and so impose the same kind of seeing on the camera. It also includes the modern 'experimentalists' who, using strictly photographic controls such as solarization, reticulation and montage, still orient their seeing toward painting rather than toward photography.

This page: Stan Zrnich, Minor White critiquing photographs, 1952.

"The camera-as-extension-of-vision concept belongs to the purists, the 'straight' photographers, the documentarians and those who look at nature with little or no knowledge of painting and who remember only how a lens sees."

"Fine," the young man said, "but how can you tell what a man's concepts are by looking at his prints?"

"By comparing things that can be seen in the prints with established criteria of some kind."

The following is a working set of points and definitions for such a comparison. First of all five features are set up: (1) treatment of surface, (2) handwork, (3) composition, (4) reality, (5) creative continuity. Then, by analyzing how artists have responded to these points in the past century of camera work, two attitudes can be defined. The attitudes become the concepts. Briefly they are contrasted as follows. The camera-as-brush attitude is stated first and contrasted with the extension-of-vision attitude second.

(1) Surface of paper made evident and imposed on surface of objects photographed, as contrasted with print surface left as transparent as clear glass.

(2) Handwork considered necessary to creativeness, as contrasted with the idea that eye, camera and brain are sufficient to creativeness.

(3) Composition imposed by photographer on subject matter, as contrasted with letting subject matter generate unique composition by its own vitality.

(4) Reality and the literal thought of as crippling limitations which must be altered, as contrasted with their being considered facts which can be penetrated.

(5) The creative continuity terminated by printing, as contrasted with its being terminated by exposure.

Now, by looking at prints, you can see how each point is treated and, from the description of the two attitudes above, determine which concept a man is showing in his work.

A pair of warnings need to be inserted. First, the five points are not equally provable from concrete evidence in prints. The surface feature is provable easily; the surface is either completely transparent or something else. Handwork is present or absent. Composition is clearly derived from academic rules or it is free. The treatment of reality has to be based partly on the spectator's knowledge of the visual world, and creative continuity, while obvious to the photographer himself, is difficult for the spectator to discern.

Second, it is not necessary for a print to display consistent direction in all five points in order to be a clear-cut example of one concept or the other. Nor will a three out of five percentage always determine which concept. Judgment is necessary, and the weight and importance of each point of the five is needed in the calculations. From the period of contemplation required to catalog the man's direction by the spectator, it is reasonable to expect that something of the spirit of the whole will guide his final placement.

With these warnings in mind we need to produce a phrase which will serve to sum up each concept. "Things as they become" sums up the camera-as-brush concept. "Love of things as they are" is a tight symbol of the extension-of-vision concept. It can be seen from these phrases that the point of comparison—reality and the literal—carries the most weight. (We should note here that "reality" is considered throughout the article to be the tactile-visual perception of objects which to human beings is generally considered the most "real.")

Let us explain more fully what is meant by the five points and by the two attitudes which we claim are two concepts.

1. Attitude Toward Surface

The surface of the canvas is the compositional work bench of the painter. And while he paints so as to suggest depth, he does not quite remove the sensation of the two dimensional plane just under his brush. He can, of course, deny this surface successfully, turn it into a kind of window, but it is a deliberate effort. In photography the reverse is true, it takes deliberate intention to include the sensation of the emulsion plane. Thus when a photograph exhibits its own surface, it tends to show that the maker has an attitude favorable to painting. Matte papers, textures built into the emulsion, texture screens, fogged prints are all used to make the spectator as aware of the surface of the print as he is aware of the surfaces of the objects photographed.

By contrast, prints in which the surface goes unnoticed tend to characterize the extension-of-vision concept. Nothing is to interfere with the vision of the spectator. This usually means glossy papers and negative and print processing of the cleanest possible sort, so that the substance of all things photographed is "touchable" and space around three-dimensional. The surface of the object is considered far more important than the surface of the print. Veiling of any kind, paper surface, flare or fog is felt as an intrusion. Even photographs of mists and fogs must give the feeling to the spectator of only standing in an open doorway waiting to walk freely into the envelopment of the fog.

2. Attitude Toward the Hand

Surveying the centuries of hand art, one understands why creativeness and the hand seem inseparable. However, does literature need more of the hand than dexterity on a typewriter? Does the calligraphy of music composers affect the sound? Still, handwork on negative and/or print—far beyond that needed to overcome manufacturing defects—is frequently justified on the ground of introducing creativeness. Consequently its presence is a fair clue to the camera-as-brush concept.

The method of comparison sketched above is based on five points with two definitions each. One could make a table thus:

Clues to the camera-as-extension-of-vision concept:	Clues to the camera-as-brush concept:
1. Surface of print considered as clear glass.	1. Surface of print included.
2. Omission of handwork, optical and chemical alterations.	2. Handwork on negative and/or print; optical and chemical alterations of negative and/or print.
3. Composition determined by nature of subject.	3. Rules of composition deduced from academic painting imposed on photograph.
4. Reality accepted as the whole working field and penetrated.	4. Reality altered considerably by nearly any means.
5. Creative activity terminated by exposure.	5. Creativeness continuing through printing.

In the past 30 years workers have felt that hand manipulation was not in harmony with the photographic means—optical and chemical changes of the exquisite image. Solarization, montage, prisms, effect of light on sensitized materials without benefit of camera—everything has been tried. While these devices remain photographic and while much of the experimentation was done in the name of exploring the outposts of the medium, the results can *still be* considered evidence of the camera-as-brush concept. Perhaps the best proof of the point is that the most successful work in the field of experimentation has been done by men trained in the hand arts—Man Ray and Maholy-Nagy, for instance.

We should note in passing the work which is a combination of brush or pencil with photographs. These combinations, while only moderately successful to date, have the same potential for magic as welding together words and music.

In the extension-of-vision concept the hand is considered in the same relation to creativeness as typing is to poetry. Thus the camera becomes the most visual of all media; it depends exclusively on an eye and a brain which have been so completely conditioned by the camera itself that it becomes an extension of the creativeness of the eye, as powerful as the brush is an extension of the creativeness of the hand.

3. Attitude Toward Composition

If the work feels as if some preconceived idea of composition has been imposed on the subject matter—dynamic symmetry, current pictorialist traditions, academic painting—then the clue leads toward camera-as-brush concept. The criterion is the imposition of rules, and the feeling is imitation of painting, whether academic or abstract.

There is another situation we must consider, the one in which the print feels as if the maker's memories of hand art are spontaneously appearing in his work. This is always a difficult situation to get around. The spectator is never sure whether it is imitation or influence; and the photographer, since it is largely unconscious, may not be aware himself. About all the analyst can do is assume the photographer does know what he is doing—for if the maker does not wish to take responsibility for what his print says, even unconsciously, there is the handy and hungry wastebasket. Consequently the appearance of a print to a spectator becomes more of a truth than what the work means to its maker. However if we wish to be kind, we can say that spontaneous reflections of hand art composition in a photograph is a sort of overlapping of both concepts.

The extension-of-vision concept is present when free composition is found—when there is a feeling the photographer imposed nothing, but instead let the subject matter itself generate, dictate and determine the composition out of its own shapes and relations. Thus he strives to see new balances, new solutions to the old problems.

Success in this effort requires acute observation by an open mind and sympathy for the nature of things. Because the photographer can observe the new directly from nature or from some of the accidents he finds in his pictures, his own imagination is expanded far beyond his ability if it were left alone. I might explain this effect of the camera on the imagination by saying the imagination always travels in circles always repeating itself sooner or later—unless disrupted from its circling by some outside force. The camera image, the observation of the visual world serves as such a rude interruption, makes the imagination solve new problems.

4. Attitude Toward Visual Reality

Briefly the attitudes swing between avoiding the literal on one hand and embracing it on the other, between altering reality and penetrating it. If there is discomfiture with the literal followed by changing it obviously, then the camera-as-brush concept is present. On the contrary if there is a love of things as they are, a passion to employ the literal magic, the extension-of-vision concept is present.

Means of alteration are legion, from the earlier methods of diffusion, soft focus lenses and the various derivative processes such as bromoil and paper negatives, to the newer methods of boiled negatives, montage, solarization. They all effect the same end of mutilating or even destroying the delicate lens image. And they all indicate either a distaste for the literal or an inability to cope with it.

Now we can ask regarding the use of filters: Are black skies by filtering sufficient alteration of the original to indicate the attitude of the camera-as-brush? And do still lesser tonal changes indicate the same? One can not answer these questions so simply as to point to some one visible effect in a print, say a black sky, or skin masquerading as plaster, and be positive one is dealing with indisputable evidence. We need some other criterion. If we take as a standard, the reaction of the spectator, we can have a workable point of demarkation. So, if the spectator feels that the print is faithful to the original, no matter what alterations have taken place—then alteration, for him, is invisible. As far as he is concerned the extension-of-vision concept is present. On the other hand when the alteration is obvious from the spectator's knowledge of what the original probably looked like, then he is ready to be convinced of the opposite concept. Thus a heavily filtered sky might be a clue in some cases to the camera-as-brush concept. Such deviations as blurs indicating movement, the presence of both sharp and out of focus areas in the same print are examples. (Providing, of course, they are done purposely by the photographer.)

On the other hand when visual reality is embraced as an overflowing reservoir of possibilities instead of an infinity of hurdles, the results indicate the extension-of-vision concept. The attitude stems from a love of things as they are and faith that surfaces of objects and their shapes and the relations of objects in space occasionally give insight into the meanings of objects. Consequently the prints are as accurate as possible in reproducing original substance (or the camera illusion which is generally accepted as true reproduction of visible truths). The prints are sharp or nearly so, tonal relations are kept smooth, each object is treated with respect so that its identity is not lost or subdued.

The visible effects listed above may seem literal to the point of automatic recording. However, such a situation is transcended by a kind of Alice-Through-the-Looking-Glass magic. Objects in reality are looked at so intensely they become transparent to the visionary eye. A mountain stared at becomes lucid about weight after a while, becomes lucid about power slowly applied that can move mountains. Reality is not to be avoided, it is to be penetrated to its other side. Perhaps the other side of reality is exactly the world the painter seeks in his own way of altering the visual world. The camera, however, targets on reality and stops down to get beyond.

5. Attitude Toward Creative Continuity

Briefly the choice is between terminating creative activity with the printing of the negative or terminating all creative activity with exposure. If we recall the photographic process for a moment, it is obvious that seeing and exposure is one period of creativeness, then after an interruption

another creative opportunity occurs in printing. Depending on how these two periods are related to the creative continuity from seeing to final print, we can gather a clue as to which concept is being followed. If the creativeness of the seeing period is somewhat relaxed in order to allow a creative exploration at leisure of the negative for some picture it contains (which the photographer did not see at the time of exposure), then the activity leads toward camera-as-brush.

In this case the interruption in continuity is considered an asset. The original seeing is a starting point, the negative is a second starting point which can be pursued for whatever tangent from the original it will allow. In practice the dependence on the printing period for creativeness will vary widely, from the rather sketchy exploration of a negative by purely photographic printing controls such as high and low-key printing, over- and under-scale, to the much more elaborate optical and chemical explorations of solarization and related devices and even as far as the point of considering the original negative something of a nuisance as is found in paper negative and bromoil printing.

If the creative activity is concentrated in the seeing period and is terminated by exposure, the concept is extension-of-vision. In this manner of treating the creative continuity, printing is kept largely mechanical, or at least as mechanical as making a print that matches the original concept of the print will allow. Thus "straight" printing is considered the ideal because it keeps the interruption between seeing and printing from introducing the hazards of a split continuity.

The hazards are forgetting the print imagined at the time of exposure by the time it is printed, re-experiencing the negative in a frame of mind quite different from when it was made. While this is of no importance to the man creating deliberately at the printing stage, it is thought to be an error by the man wishing to create only at seeing.

The result of this direction of working is to turn the photographer more and more toward seeing purely and creatively.

This fifth point is one that is not easy to find direct evidence of in a print. Indirectly, through the attitude toward reality, is the main method of discovering it. However, this point is included more for the photographer himself. With it he can tag his own way of working. He knows how he considers the two creative points in the photographic process better than anyone else.

Having outlined and explained, now we can put this method to work by analyzing a pair of prints with the view of seeing which concept they show. The first one (Movement Studies Number 56) was chosen because it illustrates a "modern" rather than an academic version of the camera-as-brush concept. The second (Arrows) is simply an illustration of the other concept.

The surface of the first, in the original, is matte to emphasize the two-dimensional design as well as the sense of depth. The second print is originally on glossy paper and printed to the utmost clarity. (Unfortunately reproduction destroys this distinction.) Handwork is missing in both illustrations. Composition in the first is quite free so that point does not lead toward camera-as-brush. In the Arrows a meaningful displacement of the center of interest is used. The center of interest is mapped out for all to see in the upper left corner, but the chief object of the photograph happens to be displaced to the opposite corner. Thus a conflict is compositionally present. It follows that an emotional conflict is thus established. Which is fitting to the title of the series from which the illustration comes, Intimations of Disaster.

When we consider the attitude toward reality which these two prints show, the concepts they illustrate become very clear. Movement Studies Number 56 shows several alterations of what

This page: Minor White, *Movement Studies Number 56 (Huntington Hotel)*, 1949.

Caption from White's article, 1950: "This is Number 56 in a series of movement studies by the author. He explains its significance for his thesis in the text on these pages."

any spectator would imagine the original to look like. The figure of a person is blurred by slow shutter speed and has been turned into something faintly resembling the pin-headed people of Henry Moore. Or, better still, the person is caught in the act of becoming someone else. The tonal relations are exaggerated violently; the figure is too black, the wall too white, the zig-zag of the steps thus accentuated. The illusion of substances has been changed; the clothes have become a tone such as is found only in photographs. The walls have been converted to white paper along with the sidewalk. The steps are wood only by implication. Then just to show how far removed from the appearance of reality all these things are, the shadowed wall and steps are as real as the camera will allow. Thus, based on the point of its extensive alteration of visual reality, the print is a strong example of the camera-as-brush concept.

In the *Arrows* nothing has been changed—or so a spectator would agree. It is just as found. The emotional significance lies in this particular geographical location of these particular objects. The symbol of the arrows means direction, danger, or whatever other connotation they ordinarily contain.

When we compare the picture on the last point of our series, attitude toward creative activity, we will have to depend on the maker's word. And since that is myself I can explain accurately. *Movement Studies* was "seen" only as to placement of main objects, the moving figure planned to occur where it does. The printing was a complete exploration of the negative. Many kinds of prints were tried and this one completes the statement as I felt I wanted it at the time.

On the contrary the *Arrows* was printed so as to materialize the print I imagined at the time of exposure. And I wanted a print to look as much like what I saw visually as possible. Alterations were not necessary. Thus the meaning of this print comes from a total respect for the objects as they were. That fact is the very foundation of the implied meaning. The reality of painted arrows and a drip of pigment are transcended into human significance.

I turned to the young man again, "Do you think that you can analyze your own prints now? Think you can find which concept you are following?"

"I can try," he said, eyes dancing.

"Come back when you have. There is more to say about concepts."

This page: Minor White, *Arrows*, 1949.

Caption from White's article, 1950: "*Arrows* is from a series called *Intimations of Disaster.* The significance for the discussion of photography which the author finds in this is discussed in the text on these pages."

The radical educational concepts that White began to introduce and that he experimented with in his own work included a metaphorical approach to photography and the psychological reading of images. White credited several books with influencing his approach to teaching. In his unpublished 1951 manuscript, *Fundamentals of Style in Photography and the Elements of Reading Photographs,* which is excerpted here, White discussed Heinrich Wolfflin's *Principles of Art History,* which "was tossed into my path in 1946, and since I would read anything that could be twisted to have a bearing on Photography I read it. That is the source of the concepts presented here. They have been modified, shamefully, to fit a different need than Wolfflin's."[10] Responding strongly to Wolfflin's writing—which he first encountered while studying with Meyer Schapiro—White reinterpreted many of the concepts to make them more applicable to photography: "Mine was a different need, that of a kind of catalogue of visual occurrences, a quick way of grasping the areas of visual

occurrences which photography can command. I needed something to organize my seeing of visual elements that would match the rapidity of the camera."[11]

White cited two other books as influences—*Principles of Art Appreciation* (1949) by Stephen Pepper, which he describes as a "comprehensive text employing all the recent knowledge that psychology and aesthetics bring to bear on the problems of human response to pictures,"[12] and *The Problem of Aesthetics* (1953) by Eliseo Vivas and Murray Krieger: "This has been most helpful to keep a book that is mainly concerned with the individual response to pictures."[13]

Fundamentals of Style in Photography and the Elements of Reading Photographs[14]

Introduction

When we cheerfully agree that photography is a language more universal than words, we rarely remember that no count has been made of the visual symbols that are universally understood. No accurate table exists of the images that mean the same thing to everybody regardless of nation or culture. There are some safe guesses: a babe at breast, a nude, a tearful child, a woman standing at the door of her shelter, a man with a dead animal at his feet. While we do not know the number of such images, the actual number may be so few that anyone who attempted to communicate exclusively with them would find the message content confined to basics. Beyond that communication between cultures by visual means is as effectively blocked as by two different languages.

Obviously the swelling tide of photographs and the improved means of circulation, and now Television, are making changes. This automatic visual Esperanto is being constantly enlarged; consequently the complexity of messages that may be universally communicative is increasing. Maybe by now the picture of the Tin Lizzy, or its contemporary counterpart, the Jeep, is a universally comprehended symbol.

At the other end of the scale are those who wish to communicate, not the commonplace universals, but something which only a few know or that they alone know. These are the artists who must try to communicate intangibles. These are the ones who inform by causing the audience to participate in an experience, and who, therefore, must have all the craftsmanship of their medium at their command. Such craftsmanship includes symbols, vocabulary, syntax and all the rest. The artists, poets, composers are the first to realize that the scope and depth of their communications is determined largely by the symbols common to audience and themselves. The degree of "literacy," whether of work, image or sound, in the audience sets the boundaries of the artist's messages.

Such "literacy" includes, in addition to a commonly understood body of symbols and vocabulary, the syntax and treatment of subject according to the limitations and assets of the medium. In writing for instance, the order of words, the disposition of the rhythms, the choice of words and the architectonics of the whole contributes materially to the communication of a complex state of mind or an obscure atmosphere of feeling. In the visual arts the parallel exists in how light is treated, how space is used, how surfaces are rendered, how masses are disposed, and all

‹Photography is a language more universal than words.›
—MINOR WHITE, 1951

the other elements of style. If the spectator knows photographic "syntax," photographic "style," he can "read" the overtones by which the photographer is trying to communicate—above and beyond the impact of the raw subject. As in literature, so in visual art, how a statement is made is often just as important as the statement. When we consider the universal themes such as love, or good and evil, treatment is frequently the very means through which the spectator may participate in the experience.

So far it has been implied that the degree of visual literacy in the audience is the limiting factor in communication of complex and subtle states with photographs. Photographers are equally at fault; few of them know the communicative power of the visuals (or graphics) of their medium or the elements of style. I am tempted to say that hundreds of thousands of them knew less about such things than their audiences. Consequently this book is addressed to both the photographer and the spectator—also to the situation when both meet in the same person. It aims to provide the photographer with conceptual tools by which the potential of style can be put to his communicative purposes; it aims at providing the spectator with means of interpreting the messages and feelings that are carried in the overtones and implications, in the visuals and in the style of photographs. As any instructor of photography will tell you, he knows when looking at class assignments, what the students have had for breakfast and how the love affair is going.

We cannot expect this book to revolutionize photographers or spectators, or provide a universally understood body of symbols for photography, vocabulary or syntax for photography, but it can add to the small number of books, such as the *Language of Vision* by Gyorgy Kepes, which address the task.

Of the many who have contributed to this book I shall select only a few to publicly thank: the students in photography at the California School of Fine Arts, who for seven years, explored, expanded and refined the concepts that are outlined; Heinrich Wolfflin's book *The Principles of Art History,* the concepts therein which have been revised, remodeled and revamped for the purposes of the practicing photographer who wants to see, and for the purposes of the spectator of photographs who wants to interpret.

How to Read Photographs

Why Read a Photograph?
- To find out more than a first glance will give.
- There is more in a photograph than first meets the eye.
 A photograph can be compared to a deep drawer—the things on top only *might* let us know what is hidden below.
- At first glance a photograph can inform us.
- At second glance it can reach us.
 As we stare at it, a great deal more can happen to us, we can lose ourselves in it, it can be an experience to us, an engrossing experience; one that may be serious or so deep that we are not sure what it means; or jolly and yet we are not able to say why we laugh.
 And this is why I think we ought to read photographs.

‹At first glance a photograph can inform us. At second glance it can reach us.›
——MINOR WHITE, 1951

Reading Photographs Includes All These—And More

The historical meanings, the meanings we get from our specialist backgrounds such as engineers, farmers, city slickers, the meanings from design, the emotional meanings and more, can be read from photographs.

If so, where do we start? The logical place to start is with whatever can be seen in photographs. There are such visuals as tone, area, edges, and (in photographs) the illusions of surfaces and textures.

Surprisingly enough people respond to these basic visual elements about the same way. We respond to many basic elements about like other people without being particularly conscious of either similarity or difference. We all know about light, how bright sun affects us, how darkness affects us, our feelings on cloudy days. We all know what sandpaper feels like, or skin, or china plates. We all know big things affect us as compared to little ones. Photographers know these things too. If he wants to evoke a sensation of a certain kind of roughness he is reasonably sure that a photograph of sandpaper will evoke about the same sensation in others that it does in him. Not exactly, but close enough for working purposes.

People in general have a good idea of how they respond to such visual occurrences such as texture and tone, or they respond unconsciously, but nevertheless accurately. Many people who are accustomed to looking at paintings or the other graphic arts, are acutely aware of what the visual elements do, but forget to apply it to photographs. Why, I do not know. At any rate we will start reading photographs with the basic visual elements, or visual occurrences as they appear in photographs.

A Visual Vocabulary

The basic visual occurrences in pictures are such things as light, space, texture, surfaces, edges, tones, structure, areas and a few others. These visual occurrences can be compared to words. For instance, a smooth texture is one word, a rough texture is another; or a dark tone is a word, or a middly gray tone. And these things can be used like words to either make statements or modify statements. One can compose a little essay of textures, or one can use textures in a background to say more about a person in the photograph than can be read from his face.

All the visual of shapes, varieties of light, kinds of images together form a kind of visual vocabulary. The vocabulary is extensive. The photographer uses these words in his visual vocabulary very much as a writer does. The writer makes sentences and paragraphs; the photographer makes pictures, sometimes with a few words, sometimes with many.

The photographer can use these "words" but unless his spectator is aware of them he is, in a way, tongue-tied. The latter has to know something about a visual vocabulary if he expects to get all that is going on in a photograph. Fortunately there is this basic response to a great variety of visual elements with which to start. A "visual vocabulary" could become highly specialized, to a point of secret symbolism understood only by the initiates. Nothing of the sort is intended here. The idea of a visual vocabulary will not be pushed beyond its usefulness as a metaphor and the concepts used will stay on the level of common human experience as far as that is possible. We will start to learn to read with the visual elements that are common knowledge of people, for these are the basis of communication with photographs.

First published in April 1952 with Minor White as editor, *Aperture* became a forum for White to articulate his ideas about photography. He continued as editor for the next twenty-three years.

In addition to White, the original founders and supporters of *Aperture* included Ansel Adams, Melton Ferris, Ernst Louie, Dorothea Lange, Barbara Morgan, Beaumont and Nancy Newhall, and Dody Warren.

The founding statement, which they all signed, read in part, "*Aperture* is intended to be a mature journal in which photographers can talk straight to each other, discuss the problems that face photography as profession and art, share their experiences, comment on what goes on, descry the new potentials. We, who have founded this journal, invite others to use *Aperture* as a common ground for the advancement of photography."[15]

Writing three years after his departure from the California School of Fine Arts, White reflected back on his teaching experience at the school in vol. 4, no. 4 of *Aperture* (1956). At the time of this article White was teaching at the Rochester Institute of Technology.

A Unique Experience in Teaching Photography [16]

When seventy-five-year-old California School of Fine Arts in San Francisco introduced a photography department in 1946, the way was opened for a rare teaching experience. This unusual program, which lasted seven years, may be quickly summed up as an experience of teaching photography at graduate level—and as an experience in teaching photography the only way it can be taught effectively, namely by doing, by intensely doing.

Since that time the school has become accredited and the present course now fits undergraduate academic standards. This new regime may also be summed up: in the words of one of the present instructors, "the students no longer have time to make photographs!"

Consequently when I set down some of the most important concepts that we used in teaching camera work I will have to rely on my memory of that fabulous experiment.

Many factors contributed to the uniqueness of that experience. One of them, not necessarily the most important, was the quality of the students themselves. They were G.I.s from the Second World War full of plans after the long futility of no planning; older, most of them experienced in photography, in school because they chose to be. Furthermore there were so many applicants for the 36 places that we screened with lengthy interviews. Their enthusiasm was truly remarkable: an instructor could only ride high on the wave of teeming personalities. Another factor was the location of the school: San Francisco itself is a stimulating experience, cosmopolitan, dramatic, western, and full of verve. Its white buildings sweep across the hills like surf on a reef of rocks. The blue ocean at the city's tip does the same. Then, too, San Francisco is a center of intensive photography. Consider its magnets of photography: Edward Weston, Dorothea Lange, Ansel Adams, Imogen Cunningham. These were the names to conjure with at that time and all of them were so interested in the school that they gladly taught or lectured in their respective fields.

Speaking of guest instructors, Lisette Model taught the second year class in miniature camera for six weeks one year; Homer Page taught miniature camera work for an entire year.

This page: Bill Heick, Minor White teaching, 1947.

Still another factor was the nature of the school policy. The department had been set going by Ansel Adams at the request of the school's wartime president, Eldridge T. Spencer, as part of a plan to up-date an old, comfortably academic private art school. The school went uncomfortably modern practically overnight under the directorship of Douglas MacAgy; the changeover, however, generated a high creative excitement in both students and staff. In this atmosphere of abstract painting, non-objective drawing and experimental sculpture the photography students got a bird's eye view of their own medium such as is rarely accorded students of photography. And because it was done by students as enthusiastic as themselves, they did not cast the abstract approach lightly aside. They came saying, like good G.I.'s "this is for the birds" and stayed to see that when this was superior it had spirit. Once they could see the spirit in modern art, they could usually find it in photography.

The teaching policy of the school contributed greatly. Students were taught by doing. The program was as flexible as possible; each class was three hours duration, and four of the five days a week was spent in photography. This fitted the teaching of photography exactly because lectures, shooting schedules, dark room time, critiques, both individual and class, could be scheduled to fit each project. Projects might be as short as a week or as long as a term, nevertheless we could schedule by the project. This flexibility, this fluidity of programming, was perhaps the one single factor that contributed the most to the uniqueness of the experience for both student and instructor. The students could, and did, live the life of the practicing photographer for days on end: the instructors could maintain the kind of apprentice-tutorial-conservatory method that they felt to be particularly pertinent to teaching photography.

Another factor was the personalities and contributions of the instructors. As was said the department was inaugurated by Ansel Adams. Tutor-taught, musician-trained, he brought the conservatory method of teaching to the department. This method of teaching, stated briefly, encourages the student to work by himself until he reaches his own ceiling and then, and not until then, does he go to the instructor to have that ceiling raised. Adams also brought to the department his famous discipline of technique, what was codified under the name of "the zone system of planned photography." The zone system is a means of linking the science of sensitometry to the art of picture content. This last means that the photographer has a logical and controllable way of interpreting the scene in front of his camera in terms of photography. Simple as this may seem, as the students soon found out, a mastery of the zone system meant the difference between being camera-handled or man-handling the camera. The third Adams contribution was the idea that only the freelance photographer could be a professional in the sense that an architect or a doctor is a professional.

I, on the contrary, was trained in colleges with majors in science and the history of art and photography. Consequently I brought to the department academic teaching methods; thus lectures supplemented the long tutorial individual conference sessions. To parallel the zone system which gave a method of interpreting the scene in terms of the photograph, I introduced an analytical method which allowed interpretation of the photograph itself in terms of the human consumer. This method was called, for teaching purposes, "space analysis." It was found to be useful to future photographers, picture editors and potential critics alike.

When Mr. Adams left the department to become its advisor later in the first year, the technical side was taken over by William Quandt, Jr., who covered everything from the zone system to photograms. I continued, as the non-technical member of the two-instructor team, to approach

‹Students were taught by doing.›
——MINOR WHITE, 1952

the creative side of photography both directly and indirectly. For the direct approach to creativity we borrowed a title from Alfred Stieglitz, namely "equivalent." With that term we deliberately photographed for what photographs can suggest. We consciously and determinedly went after what photographs could suggest above and beyond the subject of the pictures. Much to the surprise of the more conventional students it was found that what photographs obviously convey is often meager compared to what they can convey by suggestion. For the indirect approach to creativity (which is the more successful when coupled with a direct approach) we depended faithfully on osmosis.

To link "creative" photography (and we emphasized the creativeness that happens at the moment of *seeing* over the kind that takes place in the dark room) to professional work and the professional attitude we made a distinction between the words "expressive" and "creative." As artificial as this distinction was it served the purpose of indicating to the professional his responsibilities as a creative photographer. The "expressive" was personal: it stood for the use of the camera to discover the photographer's own inner condition, his own inner self, and during a three year period the student could trace his own inner growth to some extent by "expressive" photography. This knowledge and distinction we considered essential to photographers who might be expected to work as artists, because through such self discovery, they learned what they had to say. The second term, "creative," stood for making photographs so that what one had to say was communicated to another person. And communicate to him by the photograph. The photographer was expected to know what he had to say so well, that he could find the right means, the proper photograph so that another person would understand what he was trying to say. The "creative" photograph was expected to evoke a mood or "create" one in the spectator. Furthermore, this mood to be evoked was to be predetermined by the photographer.

To the would-be "artist" photographer, "expressive" and "creative" were equally important; with one he learned for himself what he had to say; with the other he found the means to say it. Exclusive production of the "expressive" was compared to unplayed music. The professional artist-photographer on the other hand was compared to the concert musician who both composed and played his own work. The long list of factors that contributed to the uniqueness of the department may be terminated with a paradox and a slogan. The paradox: the student was encouraged to see privately and at the same time driven to enact the ideal of professionalism. He was encouraged to see with eyes of a poet; and held to being able to apply his training *appropriately* to the needs of a client. It was constantly held up as an ideal that a trained photographer could apply both his talent and his training appropriately.

The slogan: "I don't want excuses, I want photographs!"

The Capsule Course

In our attempt to fit the aesthetically talented student to a society that holds commerce more dear than spirit we came to several conclusions. The most important of these still seems to be the "capsule course" that was introduced during the third year of the department's existence. The students for this course enrolled for one year only. They had to be college graduates with majors in the humanities—or upon sufficient persuasion, seasoned professional photographers. The capsule course was conducted in an unorthodox manner. Upon entering, a tailor-made outline of study was determined after lengthy interviews for each student. In general these students took the classic view-camera technique, the discipline of "space analysis" and the approaches to "creative selection" with the first year men. Miniature camera technique and its rationale

of creativeness (called "recognition") was practiced with the second year men. With this second year group they also practiced the photography of people as individuals. This last amounted to both portraiture for commerce where the pleasing likeness is the sole demand and portraiture for character revelation, an area in which the camera is an unsurpassed tool of penetration. With the third year men they explored the philosophy of photography, communication and criticism. The third year seminar was properly their class. In it photographs from a very wide variety of sources were discussed both formally and informally, both by rule and intuitively. This class met for one three hour session per week throughout the entire year. The college graduates invariably brought to this class unparalleled maturity and solidity. The result was enthusiastic sessions that occasionally built up to an unforgettable group experiencing of photographs.

The three-hour sessions were especially intense when the photographs of a seminar class member were up for discussion. The member was sure of a disturbing experience; his style was defined, his sins of omission as well as those of commission were listed, his power to communicate was evaluated in terms of "expressive and creative." The man behind the photographs was sought through an analysis of his choice of subjects and treatment thereof—and always found. The inner man could not hide behind the mask of the photograph with class members as it could with strangers. Such an experience might have been nothing short of traumatic, but by some grand good will the afternoon was always creative rather than destructive. Criticism was always sympathetic rather than antagonistic. Consequently the individual under fire saw his own work in a new light and his horizons were widened once again. This time, not by an instructor, but by his own friends. By this method the value of the ideal critic was made apparent. (This critic that has yet to make his appearance in photography; the one whose taste and integrity and background will always be equal to the most uncompromising photographer.)

The tailor-made aspect of the program really took place in the private conferences. These tutorial periods were of untold value to the efficiency of the capsule course. The individual's problems were subjected to frequent discussion; his individual progress related to the photography itself over and over again. And many a time a three-hour session would extend indefinitely over drinks and dinner.

The year of the capsule course was one of total immersion for the student. It was much the same for all the students, but the one-year man had a time limit that led him to steep himself more thoroughly than the three-year men did. The concentration paid off for these one-year men; esthetics blossomed with technique, picture making developed quickly into picture editing, communication grew almost directly out of personal expression, criticism, based on a generous knowledge of photography, developed into a kind of passionate objectivism, and the ideal of professionalism that only the free lance photographer can achieve became a reality—to be able to put at the service of a client a craftsmanlike technique, a craftsmanship of feeling and a craft of communication.

To the surprise of the instructors this course proved basic, not only to photographers, as we had planned, but to potential picture editors, future critics, instructors and a dozen other occupations in the world that depend on picture-mindedness.

Edward Weston and Point Lobos

The climax of every year was the five day, early spring trip to visit Edward Weston and to photograph at Point Lobos State Park, which his pictures had made famous. Full-time concern with

This page: Gerald Ratto, Minor White, c. 1952.

photography was nothing new with us, but on this trip the intensity rose like a thermometer held over a match flame.

Until he became too ill, Weston showed us the beauties of the park itself. He made the students leave their cameras in their cars the first afternoon knowing full well that otherwise they would have all gone to work in the first hundred yards. He annotated one magnificent spot after another, always stopping at the ancient Cypress stump he photographed first in 1929. Under his guidance the years ticked by a picture at a time. It slowly dawned on us that this rich place was a little like a lumber yard to him, stocked with the material for a million pictures. From the depth of his honesty he said that he but scratched the surface and encouraged everyone to do more.

The first contact with the man and the place was rounded off that same evening. After dinner in nearby Carmel or Monterey the group drove to Weston's cottage to see the man and his photographs. The single flood lamp was rounded up, a brighter bulb put in and Weston took out a stack of prints from their cases. He selected carefully, put them, one at a time, on the spotlighted easel. He talked quietly or not at all, answered questions, purred to his cats and kittens vying for the attention of the audience. He never belittled his work, never boasted, but let each picture speak for itself. He obviously handled each print with affection. Here was a man who, all his life, had pursued photography as an art. And we looked. With the sound of the sea pounding in our ears, the smell of a log fire around, many of the seeds, planted during the year, sprouted. All that had been said about integrity, love of medium, self respect combined with humility, the growth of the inner man made manifest by his photographs was suddenly visible. All came to focus in the person of this mature photographer. Man, place and photographs merged into a totality in front of our eyes!

Lobos is a strange place and students reacted violently—for or against. Somehow its outward manifestations of worn beaches, plunging cliffs, twisted Cypresses, a Pacific blue as mid-ocean, succulents that leaned like frosted stars in the forests, often fall into patterns suggestive of a man's inner self. His hopes, fears, hungers, inner drives and hidden corners seemed to be nearer the surface here than anywhere else. The slightest observation revealed it. Consequently, individuality was stamped on all the photographs made on these trips. Personal expression always ran high. Some students returned with pictures of great beauty, others with nothing, they found the place incompatible. These were usually the ones who had a passionate drive towards people and a weak one towards nature. Since we treated the photographs made at Lobos, not as assignments, but as indicators of personality, whatever was turned in to class was evidence. The trip's photographs brought home to most students that the camera really was a means of personal expression. If they doubted that before, they were convinced afterwards. Often how much of them was uncovered with the camera came as a distinct shock. The psychological aspect of camera work was thus touched upon. We explored this capacity of photographs only long enough to convince the interested students that it would take an expert psychologist or psychiatrist to unravel the entire skein revealed by the photographs. We retreated from this exploration, perhaps a little reluctantly, knowing that we had crossed the borders of picture esthetics and picture interpretation into the realm of the therapeutic. But then we always went too far in any direction; technique, esthetics, interpretation; in order to find out what far enough was.

If any single factor can be said to stand out to make this seven-year experience unique in teaching photography, it was the freedom to concentrate on photography. With that concentration we could take a person who thought himself enamored of photography and give him so

much camera work that he discovered for himself that in order to be a photographer he had to know everything else in the world that he could possibly learn. We could teach photography as a way to make a living, and best of all, somehow to get students to experience for themselves photography as a way of life.

Notes

1 Minor White. "Biographical Sketch of Minor White," 1948. SFAIA. Copyright © by the Trustees of Princeton University. Publication here is with permission of the Minor White Archive, Princeton University Art Museum.

2 Ibid.

3 Draft of biography of Minor White, c. 1957, intended for publication in *Masters of Photography*. Compiled by Nancy Newhall with revisions by Beaumont Newhall. Copyright © by the Trustees of Princeton University. Publication here is with permission of the Minor White Archive, Princeton University Art Museum.

4 Minor White to Alfred Stieglitz, 7 July 1947, in Peter C. Bunnell, *Minor White, The Eye that Shapes* (Princeton: The Art Museum, Princeton University, 1986), 24. Copyright © by the Trustees of Princeton University. Publication here is with permission of the Minor White Archive, Princeton University Art Museum.

5 Minor White. "Photography in an Art School," *U.S. Camera* (July 1949): 50–51. Copyright © by the Trustees of Princeton University. Publication here is with permission of the Minor White Archive, Princeton University Art Museum.

6 Minor White to Beaumont and Nancy Newhall, 25 May 1950, in Bunnell, *Minor White*, 26.

7 Minor White, "Photography Is an Art," *Design 49*, no. 4 (December 1947): 6–8, 20. Copyright © by the Trustees of Princeton University. Publication here is with permission of the Minor White Archive, Princeton University Art Museum.

8 Minor White, "Outline of the Photographic Course—California School of Fine Arts, Recommendations for Courses in the Art Department for Photography Students" (1950). Copyright © by the Trustees of Princeton University. Publication here is with permission of the Minor White Archive, Princeton University Art Museum.

9 Minor White, "Your Concepts Are Showing. How to Judge Your Own Photographs." First of a series of six articles, *American Photography*, vol. 45 no. 5 (May 1951). Private collection of Nathan Lyons. Copyright © 1951 by Minor White renewed by the Trustees of Princeton University. Publication here is with permission of the Minor White Archive, Princeton University Art Museum.

10 Minor White, "Fundamentals of Style in Photography and the Elements of Reading Photographs," (unpublished, 1951). Private collection of Nathan Lyons. Copyright © by the Trustees of Princeton University. Publication here is with permission of the Minor White Archive, Princeton University Art Museum.

11 Ibid.

12 Ibid.

13 White, "Photography Is An Art," 8.

14 White, "Fundamentals of Style." Private collection of Nathan Lyons. Copyright © by the Trustees of Princeton University. Publication here is with permission of the Minor White Archive, Princeton University Art Museum.

15 "About Aperture," *Aperture* no. 1 (1952): 3. Copyright © 1952 by Minor White, renewed by the Trustees of Princeton University. Publication here is with permission of the Minor White Archive, Princeton University Art Museum.

16 White, "A Unique Experience in Teaching Photography," *Aperture*, vol. 4 no. 4 (1956): 151. Copyright © 1956 by Minor White renewed by the Trustees of Princeton University. Publication here is with permission of the Minor White Archive, Princeton University Art Museum.

STUDENT PORTFOLIO

IMAGE EXCHANGE

Immersed in an intensive program that included mastering technical skills along with an emphasis on reading and interpreting images, CSFA Department of Photography students combined social activities with discussing their photographs. A monthly image exchange was established early in the program. It gave the students an opportunity to get together outside of school to relax and talk about their photographs in an informal setting. In the beginning about twenty students gathered for these parties, usually at Minor White's house.

This page: Pirkle Jones, *Broken Plaque, San Francisco Dump,* 1947.

This page: Clifford Freehe, *Untitled*, c. 1946. **Opposite page, left:** Donald Ross, *Broken Glass, Berkeley*, 1950. **Right:** Tom Murphy, *Untitled*, c. 1948.

This page: Zoe (Lowenthal) Brown, *Untitled*, 1953. **Opposite page:** Dwain Faubion, *Untitled*, c. 1947.

This page: Walter Stoy, *Untitled*, c. 1947. **Opposite page, left:** Benjamen Chinn, *Untitled*, 1949. **Right:** Richard Reinke, *Untitled*, c. 1947.

This page: James Scoggins, *Untitled*, c. 1948. Opposite page, left: John Rogers, *Untitled*, c. 1948. Right: Patricia Harris Noyes, *Untitled*, c. 1947.

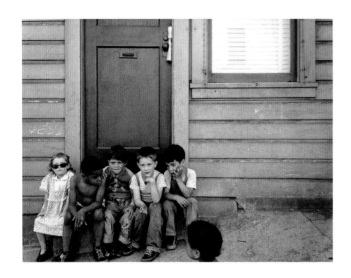

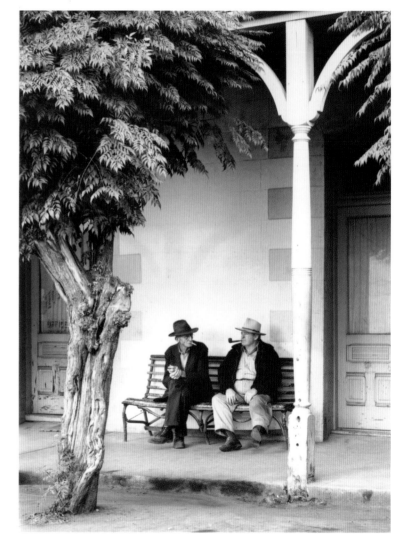

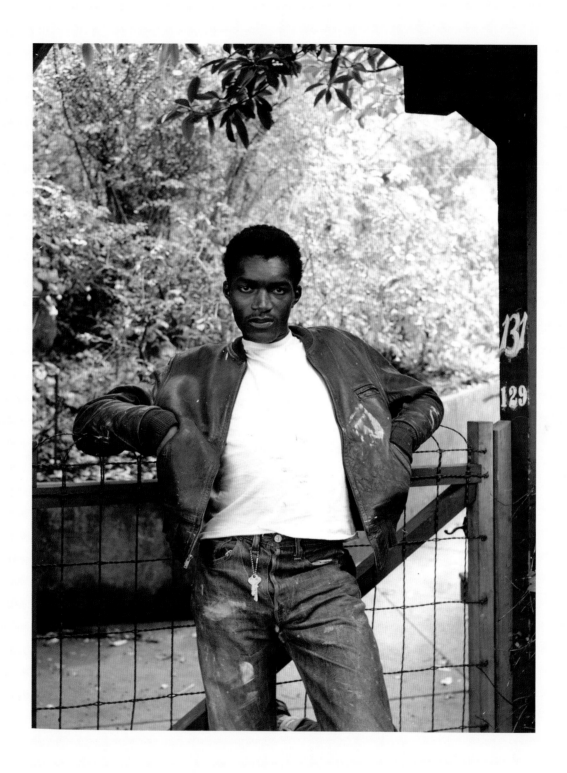

This page: David Johnson, *Ansel Adams' House*, 1946. Opposite page, left: Ira Latour, *Children, San Francisco*, 1945. Right: L. Champagne, *Untitled*, c. 1948.

This page: Bob Hollingsworth, *Untitled*, c. 1948. Opposite page, left: Helen Howell, *Untitled*, c. 1948. Right: Elizabeth Mailliard, *Untitled*, c. 1953.

This page: Nata Piaskowski, *Still Life with Bread,* 1949. **Opposite page, left:** Emily Rogers, *Untitled,* c. 1948. **Right:** Arnold Wheelock, *Untitled,* c. 1948.

This page: Charles Wong, *Untitled,* 1950. **Opposite page, top:** Paul Rundall, *Untitled,* c. 1949. **Bottom:** Leonard Nelson, *Untitled,* c. 1948.

This page: Ramon Vega, *Untitled*, c. 1948. **Opposite page, left:** Lois Willard, *Untitled*, c. 1949. **Right:** Bill Heick, *Mendocino, California*, 1947.

This page: John Bertolino, *Untitled*, 1948. Opposite page, left: Al Gay, *Untitled*, 1947. Right: Ruth-Marion Baruch, *Nun and Chinese Child*, 1948.

This page: Al Richter, *Untitled*, c. 1948. Opposite page, left: Cameron Macauley, *Dew on Paper Sack*, 1949. Right: Harold Zegart, *Untitled*, 1948.

This page: Don Whyte, *Mendocino*, 1948. **Opposite page:** Gene Petersen, *Untitled*, 1953.

FACULTY PORTFOLIOS

ANSEL ADAMS

This page: Ansel Adams, *Alabama Hills, Clouds, Owens Valley, California*, 1950.

This page: Ansel Adams, *Crosses, Trampas, New Mexico*, 1958. Opposite page: Ansel Adams, *Moon and Rocks, Joshua Tree National Monument*, 1948.

This page: Ansel Adams, *Detail, Rainbow Bridge, Rainbow Bridge National Monument*, 1942. **Opposite page:** Ansel Adams, *Sand Fence near Keeler, California*, 1948.

This page: Ansel Adams, *"Homecoming," Hornitos, California,* 1944. **Opposite page:** Ansel Adams, *Rails and Jet Trails, Roseville, California,* 1953.

IMOGEN CUNNINGHAM

This page: Imogen Cunningham, *Morris Graves, Painter,* 1950.

This page: Imogen Cunningham, *Leaves*, 1948. **Opposite page:** Imogen Cunningham, *The Unmade Bed*, 1957.

This page: Imogen Cunningham, *Boy Selling Newspapers, San Francisco*, c. 1950. **Opposite page**: Imogen Cunningham, *Stan with Symbol*, 1953.

This page: Imogen Cunningham, *Watchers of the Evangel Meeting, San Francisco*, 1946. Opposite page: Imogen Cunningham, *Child in San Francisco Chinatown, c.* 1950.

DOROTHEA LANGE

This page: Dorothea Lange, *James Roosevelt Campaign for Governor of California, February 17,* 1950.

This page: Dorothea Lange, *First Braceros*, c. 1942. **Opposite page:** Dorothea Lange, *Braceros*, 1942.

This page: Dorothea Lange, *Street Demonstrations Against Conference,* 1945. **Opposite page:** Dorothea Lange, *Shipyard Worker & Family in Trailer Camp,* 1944.

This page: Dorothea Lange, *Love and Marriage—"They Go Together Like a Horse and Carriage," New York City,* 1954. **Opposite page:** Dorothea Lange, *Consumer Relationships,* 1952.

ROSE MANDEL

This page: Rose Mandel, *Untitled (#20)*, c. 1947.

This page: Rose Mandel, *Untitled (#2)*, c. 1947. Opposite page: Rose Mandel, *Untitled (#1)*, c. 1947.

This page: Rose Mandel, *Untitled (#3)*, c. 1947. Opposite page: Rose Mandel, *Untitled (#15)*, c. 1947.

This page: Rose Mandel, *Untitled (#7)*, c. 1947. **Opposite page:** Rose Mandel, *Untitled (#16)*, c. 1947.

LISETTE MODEL

This page: Lisette Model, *Running Legs, Fifth Avenue, New York*, c. 1940–1941.

This page: Lisette Model, *Reno*, 1949. **Opposite page:** Lisette Model, *Las Vegas*, 1949.

This page: Lisette Model, *Window, San Francisco*, 1949. **Opposite page:** Lisette Model, *Reno*, 1949.

This page: Lisette Model, *Opera, San Francisco*, 1949. Opposite page: Lisette Model, *Opera, San Francisco*, 1949.

HOMER PAGE

This page: Homer Page, *Untitled*, c. 1940.

This page: Homer Page, *Untitled*, c. 1940. Opposite page: Homer Page, *Untitled*, c. 1940.

This page: Homer Page, *Mission*, Fall 1944. Opposite page: Homer Page, *Untitled*, from *Question of the Kids*, 1944.

This page: Homer Page, *Untitled*, c. 1940. Opposite page: Homer Page, *Untitled*, c. 1940.

FREDERICK W. QUANDT

This page: Frederick W. Quandt, *Virginia City*, c. 1952.

This page: Frederick W. Quandt, *San Francisco*, c. 1948. **Opposite page:** Frederick W. Quandt, *Textures*, c. 1948.

This page: Frederick W. Quandt, *Sign*, c. 1949. **Opposite page:** Frederick W. Quandt, *Abalone, Mendocino*, c. 1948.

This page: Frederick W. Quandt, *Leaves*, c. 1950. **Opposite page:** Frederick W. Quandt, *Hands*, c. 1950.

EDWARD WESTON

This page: Edward Weston, *Nautilus Shells*, c. 1947.

This page: Edward Weston, *Negro Church, Louisiana,* 1941. **Opposite page:** Edward Weston, *Broken Walls, Las Truchas, New Mexico,* 1941.

This page: Edward Weston, *Boulder Dam*, 1941. **Opposite page:** Edward Weston, *Gulf Oil, Port Arthur, Texas*, 1941.

This page: Edward Weston, *Hela*, 1946. Opposite page: Edward Weston, *Pelican, Point Lobos*, 1942.

MINOR WHITE

This page: Minor White, *San Francisco*, 1949.

This page: Minor White, *Cedar and Laguna Streets, San Francisco,* 1948. **Opposite page:** Minor White, *Chinese New Year, San Francisco,* 1953.

This page: Minor White, *Movement Studies Number 56 (Huntington Hotel)*, 1949. **Opposite page:** Minor White, *Warehouse Area, San Francisco*, 1949.

This page: Minor White, *Columbus Avenue, San Francisco*, 1949. Opposite page: Minor White, *Arrows*, 1949.

Credits

THE MOMENT OF SEEING

Cover image
Minor White, *Movement Studies Number 56 (Huntington Hotel),* 1949. Reproduction courtesy the Minor White Archive, Princeton University Art Museum. Copyright © by the Trustees of Princeton University.

4–5 Photographs by F. W. Quandt, Courtesy Jonathan Quandt.

6 *Ansel Adams,* 1938. San Francisco History Center, San Francisco Public Library.

8 Two students drawing outside at the California School of Fine Arts, 1928. Sponagel & Herrmann Commercial-Press Photographers. San Francisco History Center, San Francisco Public Library.

Students in a painting class, 1928. San Francisco History Center, San Francisco Public Library.

Students in a sculpture class, 1938. Ibid.

9 California School of Fine Arts, 1930. San Francisco History Center, San Francisco Public Library.

Mark Hopkins Mansion, Nob Hill, c. 1906. SFAIA.

10 CSFA, c. 1930. SFAIA.

Albert M. Bender, 1938. San Francisco History Center, San Francisco Public Library.

11 Students in a painting class, 1934. San Francisco History Center, San Francisco Public Library.

12 Ansel Adams teaching at the Art Center School, Los Angeles, 1941. Collection Center for Creative Photography, The University of Arizona. Copyright © Trustees of The Ansel Adams Publishing Rights Trust.

13 Edward Weston, *Ansel Adams, Wildcat Hill,* 1943. Collection Center for Creative Photography, University of Arizona. Copyright © 1981 Arizona Board of Regents.

CSFA catalogue, 1940–41. SFAIA.

15 Ellen Bransten, *Douglas MacAgy, CSFA Director,* 1945. Courtesy Estate of Ellen Bransten. SFAIA.

16 *Miss Mary Grant, RN and six-time donor Mr. Frank Blackburn, Chairman of the Blood Donor Day for Firemen,* 1944. Copyright © Moulin Archives, San Francisco History Center, San Francisco Public Library.

Article from *San Francisco Chronicle.* Courtesy *San Francisco Chronicle.* SFAIA.

17 From a letter dated, 24 August 1945, written by Beaumont Newhall to Douglas MacAgy. Copyright © 1945, Beaumont Newhall. Copyright © 2005 the Estate of Beaumont Newhall and Nancy Newhall. Permission to reproduce courtesy of Scheinbaum and Russek Ltd., Santa Fe, NM.

18 Western Union Telegram. SFAIA. Columbia Foundation letter. SFAIA.

20 Ira H. Latour, *San Francisco,* 1945. Copyright © Trustees of The Ansel Adams Publishing Rights Trust, Collection of Ira H. Latour.

21 Collection Center for Creative Photography, University of Arizona Copyright © Trustees of The Ansel Adams Publishing Rights Trust; Collection Center for Creative Photography, University of Arizona Copyright © Trustees of The Ansel Adams Publishing Rights Trust, Collection of Ira H. Latour.

22 Pirkle Jones, *Nancy and Beaumont Newhall in Ansel Adams' garden,* 1947. Courtesy Pirkle Jones.

24 Imogen Cunningham, portrait of Alma Lavenson, 1942. Copyright © Imogen Cunningham Trust, Collection of Susan Ehrens.

Students working in the darkroom, c. 1948. SFAIA.

25 Lisette Model, *Imogen Cunningham,* 1946. Copyright © National Gallery of Canada, Gift of the Estate of Lisette Model, 1990, by direction of Joseph G. Blum, New York, through the American Friends of Canada.

26 Ansel Adams demonstrates darkroom technique to students (clockwise from upper left: Philip Hyde, John Bertolino, Pirkle Jones and Muriel Green), 1946. San Francisco History Center, San Francisco Public Library.

27 Al Richter, Minor White teaching, 1949. Courtesy Dale Richter, Collection of the Minor White Archive, Princeton University Art Museum.

28 Al Richter, Minor White, c. 1948. Courtesy Dale Richter, Collection of Peggy Bertolino.

Fritz Henle, *Edward Weston and Charis in their Home,* Carmel, 1941. Fritz Henle, Courtesy Henle Archive Trust, Collection Center for Creative Photography, University of Arizona.

29 Attendance record, summer session, 1946. SFAIA.

30 CSFA catalogue 1947–1948. SFAIA.

31 Beaumont Newhall, *Ansel Adams at Mono Lake, East Side of the Sierra.* Copyright © 1947, Beaumont Newhall. Copyright © 2005 the Estate of Beaumont Newhall and Nancy Newhall. Permission to reproduce courtesy of Scheinbaum and Russek Ltd., Santa Fe, NM. Collection Center for Creative Photography, University of Arizona.

32 Ruth-Marion Baruch, *Untitled,* from the Power and Light project, 1947. Courtesy Estate of Ruth-Marion Baruch, Collection of Pirkle Jones.

Rose Mandel, *Untitled,* from the Power and Light project, 1947. Copyright © Estate of Rose Mandel, Courtesy Susan Ehrens, Collection of Susan Ehrens.

33 Al Gay, *Untitled,* from the Power and Light project, 1947.

34 Lee Blodget, portrait of Rose Mandel, c. 1947. Courtesy Betty Blodget Wentworth, Collection of Susan Ehrens.

Rose Mandel, *Nata Piaskowski,* c. 1946. Copyright © Estate of Rose Mandel, Courtesy Susan Ehrens, Collection of Susan Ehrens.

35 Minor White, *Evil Plants,* 1947. Reproduction courtesy the Minor White Archive, Princeton University Art Museum. Copyright © by the Trustees of Princeton University.

36 Al Richter, portrait of Bill Quandt and David Johnson, c. 1947. Courtesy Dale Richter, Collection Jonathan Quandt.

Bill Heick, view camera class (clockwise from upper left: George Wallace, John Bertolino, unknown student, and Benjamen Chinn), 1948. Courtesy Bill Heick. SFAIA.

Portrait of Al Richter, c. 1948. Collection of Peggy Bertolino.

37 Pirkle Jones, *Court of Arches, Stanford University,* 1947. Courtesy Pirkle Jones.

Al Gay, portrait of David Johnson, 1946.

38 Milton Halberstadt, portrait of Homer Page, 1947. Courtesy Estate of M. Halberstadt, Collection of Christina Gardener.

Rose Mandel, *Portrait of Ruth-Marion Baruch,* 1946. Copyright © Estate of Rose Mandel, Courtesy Susan Ehrens, Collection of Pirkle Jones.

39 Bill Heick, Richard Diebenkorn's painting class at CSFA, 1949. Courtesy Bill Heick. SFAIA.

Acting, The First Six Lessons, by Richard Boleslavsky Copyright © Theater Arts, Inc. New York, New York, Ninth Printing, February 1947.

Eliot Finkels, *Boots,* 1946. Courtesy Eliot Finkels.

40 California School of Fine Arts Admission Survey. SFAIA.

41 Imogen Cunningham, John Bertolino and Benjamen Chinn, c. 1947. Collection of Peggy Bertolino.

F. W. Quandt, Minor White and Pirkle Jones, 1947. Courtesy Jonathan Quandt.

Clyde and Marge Childress, 1945. Collection of Marge Childress.

42 Al Richter, class party, 1948. Courtesy Dale Richter, Collection of Peggy Bertolino.

Al Richter, Minor White, 1948. Ibid. CSFA Catalog 1948–49. SFAIA.

43 F. W. Quandt, CSFA students Pirkle Jones, Pauline Pierce, Al Gay, and Walter Stoy, c. 1948. Courtesy Jonathan Quandt. SFAIA.

44 F. W. Quandt, CSFA students, c. 1950. Courtesy Jonathan Quandt.

Minor White, from the San Francisco Museum of Art exhibition of photographs interpreting the town of Benicia, 1948. Reproduction courtesy the Minor White Archive, Princeton University Art Museum. Copyright © by the Trustees of Princeton University. SFAIA.

45 Richard Rundle, *Edward Weston,* 1948. SFAIA.

46 *The New York Times,* article, Copyright © 1948 The New York Times.

47 F. W. Quandt, Sr., darkroom blueprint (detail), 1948. Courtesy Jonathan Quandt. SFAIA.

48 F. W. Quandt, Edward Weston, c. 1947. Courtesy Jonathan Quandt.

49 F. W. Quandt, Edward Weston demonstrating camera technique with Ruth-Marion Baruch as sitter, c. 1947. Courtesy Jonathan Quandt.

50 CSFA Personnel Data Sheets. SFAIA.

52 Minor White, *Tom Murphy, 1948, Tom Murphy, 1947, Tom Murphy, 1948,* all from the sequence *The Temptation of Saint Anthony Is Mirrors,* 1948. Reproductions courtesy the Minor White Archive, Princeton University Art Museum. Copyright © by the Trustees of Princeton University.

F. W. Quandt, Ansel Adams Presiding over the Wedding of Pirkle Jones and Ruth-Marion Baruch at Yosemite, 1949. Courtesy Jonathan Quandt, Collection Pirkle Jones.

53 Bill Heick, Sidney Peterson's film class, 1948. Courtesy Bill Heick. SFAIA.

54 Clockwise from upper left: Benjamen Chinn, Walter Stoy, Bill Quandt and Philip Hyde, c. 1948. Collection of Jonathan Quandt.

55 *U.S. Camera,* July 1949 (cover; pp. 50–51). Article reproduced courtesy the Minor White Archive, Princeton University Art Museum. Copyright © by the Trustees of Princeton University.

56 Rose Mandel, *Lisette Model,* 1949. Copyright © Estate of Rose Mandel, Courtesy Susan Ehrens, Collection of Susan Ehrens.

57 Bill Heick, Bob McCollister teaching optics, 1947. Courtesy Bill Heick. SFAIA.

58 Stan Zrnich, portrait of Minor White, c. 1952. Courtesy Stan Zrnich. SFAIA.

Stan Zrnich, *Portrait of Bill Quandt,* 1952. Ibid.

59 Gene Petersen, New CSFA director Ernest Mundt, David Park (acting director for the summer session), and outgoing director Douglas MacAgy, 1950. Courtesy Lauren Donnachie. SFAIA.

Gerald Ratto, portrait of Zoe Lowenthal, c. 1952. Courtesy Gerald Ratto.

60 F. W. Quandt, Minor White, c. 1950. Courtesy Jonathan Quandt.

61 F. W. Quandt, Minor White, c. 1952. Courtesy Jonathan Quandt.

62 The play, *A Phoenix Too Frequent,* photographed as a class project, 1950. SFAIA.

Gerald Ratto, San Francisco Museum of Art and CSFA project photographing dance, c. 1952. Courtesy Gerald Ratto.

Stan Zrnich, *Looking at Looking* exhibition, January 1952. Courtesy Stan Zrnich. SFAIA.

63 Gerald Ratto, San Francisco Museum of Art and CSFA project photographing dance, c. 1952. Courtesy Gerald Ratto.

64 Minor White, *Intimations of Disaster,* 1949–53. Reproduction courtesy the Minor White Archive, Princeton University Art Museum. Copyright © by the Trustees of Princeton University, Collection The Museum of Fine Arts, Houston. *The Target Collection of American Photography,* Gift of Target Stores.

Aperture, Vol. 2, No. 1, 1953. Cover image by Ernest Louie. Reproduced courtesy the Minor White Archive, Princeton University Art Museum. Copyright © 1953 by Minor White, renewed by the Trustees of Princeton University.

Aperture, No. 1, 1952. Cover image by Dorothea Lange. Copyright © the Dorothea Lange Collection, Oakland Museum of California, City of Oakland. Gift of Paul S. Taylor, Reproduced courtesy the Minor White Archive, Princeton University Art Museum. Copyright © 1952 by Minor White, renewed by the Trustees of Princeton University.

65 John Cockroft, Ernest Mundt addressing student concerns, 1952. SFAIA.

66 Ansel Adams, *Pirkle Jones, Marin County,* 1948. Copyright © Trustees of The Ansel Adams Publishing Rights Trust. Collection Pirkle Jones.

Perceptions catalogue. Reproduced courtesy the Minor White Archive, Princeton University Art Museum. Copyright © 1954 by Minor White, renewed by the Trustees of Princeton University.

Cover image by Edward Weston, *Zomah and Jean Charlot,* 1933. Copyright © 1981 Center for Creative Photography, Arizona Board of Regents. SFAIA.

Gerald Ratto, portrait of Stan Zrnich, c. 1952. Courtesy Gerald Ratto.

67 Al Richter, Minor White's going-away party, 1953. Courtesy Dale Richter, Collection of the Minor White Archive, Princeton University Art Museum.

68 *Let's Go to Art School,* film clip, 1953. SFAIA.

Stan Zrnich, Visitors viewing work during an opening at The Photographers Gallery, 1954. Courtesy Stan Zrnich. SFAIA.

Stan Zrnich, Janet Graham outside The Photographers Gallery, May 1954. Courtesy Stan Zrnich. SFAIA.

69 Larry Cowell, portrait of Minor White, c. 1951. Collection of the Minor White Archive, Princeton University Art Museum.

70 Stan Zrnich, contact sheet, 1952. Courtesy Stan Zrnich. SFAIA.

72 Western Union Telegram, Minor White to Roy Ascott, 6 May 1976. SFAIA. Copyright © by the Trustees of Princeton University. Publication here is with the permission of the Minor White Archive, Princeton University Art Museum.

73 Minor White, *Forty-Second Ave. and Pacheco, San Francisco, 18 August 1949.* Reproduction courtesy the Minor White Archive, Princeton University Art Museum. Copyright © by the Trustees of Princeton University, Minor White Collection (1946–1953), California Historical Society.

Minor White, *"Old Spanish Prison," Filbert Street, San Francisco, 20 July 1949.* Ibid.

Minor White, *"Claremont Rooms, 15 October 1948," First and Harrison, San Francisco.* Ibid.

A VISUAL VOCABULARY

78 Gerald Ratto, Minor White, c. 1952. Courtesy Gerald Ratto.

80 F. W. Quandt, Minor White and students, c. 1950. Courtesy Jonathan Quandt.

82 Stan Zrnich, photo critique, 1952. Courtesy Stan Zrnich. SFAIA.

85 Benjamen Chinn, Minor White teaching, c. 1948. Courtesy Benjamen Chinn, Collection of the Minor White Archive, Princeton University Art Museum.

86 Al Richter, Minor White teaching, 1949. Courtesy Dale Richter, Collection of the Minor White Archive, Princeton University Art Museum.

88 Stan Zrnich, Minor White critiquing photographs, 1952. Courtesy Stan Zrnich. SFAIA.

93 Minor White, *Movement Studies Number 56 (Huntington Hotel),* 1949. Reproduction courtesy the Minor White Archive, Princeton University Art Museum. Copyright © by the Trustees of Princeton University, Minor White Collection.

94 Minor White, *Arrows,* 1949. Reproduction courtesy the Minor White Archive, Princeton University Art Museum. Copyright © by the Trustees of Princeton University, Minor White Collection.

98 Bill Heick, Minor White teaching, 1947. Courtesy Bill Heick. SFAIA.

101 Gerald Ratto, Minor White, c. 1952. Courtesy Gerald Ratto.

STUDENT PORTFOLIO

105 Pirkle Jones, *Broken Plaque, San Francisco Dump*, 1947. Courtesy Pirkle Jones.

106 Donald Ross, *Broken Glass, Berkeley*, 1950. Courtesy Merg Ross. From the collection of Paul Hertzmann and Susan Herzig, Paul M. Hertzmann, Inc., San Francisco, CA.

Tom Murphy, *Untitled*, c.1948. Collection of Jonathan Quandt.

107 Clifford Freehe, *Untitled*, c.1946. Collection of Dennis Reed.

108 Dwain Faubion, *Untitled*, c.1947. Courtesy Patricia Faubion. From the collection of Paul Hertzmann and Susan Herzig, Paul M. Hertzmann, Inc., San Francisco, CA.

109 Zoe (Lowenthal) Brown, *Untitled*, 1953. Courtesy Zoe (Lowenthal) Brown. From the collection of Paul Hertzmann and Susan Herzig, Paul M. Hertzmann, Inc., San Francisco, CA.

110 Benjamen Chinn, *Untitled*, 1949. Courtesy Benjamen Chinn, Collection of Jonathan Quandt.

Richard Reinke, *Untitled*, c.1947. Courtesy Richard Reinke. Collection of Jonathan Quandt.

111 Walter Stoy, *Untitled*, c.1947. Courtesy Walter Stoy. From the collection of Paul Hertzmann and Susan Herzig, Paul M. Hertzmann, Inc., San Francisco, CA.

112 John Rogers, *Untitled*, c.1948. Courtesy John Rogers. Collection of Jonathan Quandt.

Patricia Harris Noyes, *Untitled*, c.1947. Courtesy Patricia Harris Noyes. Collection of Jonathan Quandt.

113 James Scoggins, *Untitled*, c.1948. From the collection of Paul Hertzmann and Susan Herzig, Paul M. Hertzmann, Inc., San Francisco, CA.

114 Ira Latour, *Children, San Francisco*, 1945. Courtesy Ira H. Latour.

L. Champagne, *Untitled*, c.1948. From the collection of Paul Hertzmann and Susan Herzig, Paul M. Hertzmann, Inc., San Francisco, CA.

115 David Johnson, *Ansel Adams' House*, 1946. Courtesy David Johnson.

116 Helen Howell, *Untitled*, c.1948. Courtesy Helen Howell. Collection of Jonathan Quandt.

Elizabeth Mailliard, *Untitled*, c.1953. Collection Jonathan Quandt.

117 Bob Hollingsworth, *Untitled*, c.1948. Courtesy Bob Hollingsworth. Collection of Jonathan Quandt.

118 Emily Rogers, *Untitled*, c.1948. Collection of Peggy Bertolino.

Arnold Wheelock, *Untitled*, c.1948. Courtesy Mary Wheelock. Collection of Jonathan Quandt.

119 Nata Piaskowski, *Still Life with Bread*, 1949. Courtesy of Paul Hertzmann and Susan Herzig, Paul M. Hertzmann, Inc., San Francisco, CA.

120 Paul Rundall, *Untitled*, c.1949. Collection of the Minor White Archive, Princeton University Art Museum.

Leonard Nelson, *Untitled*, c.1948. Collection of the Minor White Archive, Princeton University Art Museum.

121 Charles Wong, *Untitled*, 1950. Courtesy Charles Wong. Collection of Jonathan Quandt.

122 Lois Willard, *Untitled*, c.1949. Collection of Jonathan Quandt.

Bill Heick, *Mendocino, California*, 1947. Courtesy Bill Heick. From the collection of Paul Hertzmann and Susan Herzig, Paul M. Hertzmann, Inc., San Francisco, CA.

123 Ramon Vega, *Untitled*, c.1948. Collection of Jonathan Quandt.

124 Al Gay, *Untitled*, 1947. Collection of Pirkle Jones.

Ruth-Marion Baruch, *Nun and Chinese Child*, 1948. Courtesy Estate of Ruth-Marion Baruch, Collection of Pirkle Jones.

125 John Bertolino, *Untitled*, 1948. Courtesy Peggy Bertolino. From the collection of Paul Hertzmann and Susan Herzig, Paul M. Hertzmann, Inc., San Francisco, CA.

126 Harold Zegart, *Untitled*, 1948. Courtesy Harold Zegart. From the collection of Paul Hertzmann and Susan Herzig, Paul M. Hertzmann, Inc., San Francisco, CA.

Cameron Macauley, *Dew on Paper Sack*, 1949. Courtesy C. Cameron Macauley Copyright © 2005.

127 Al Richter, *Untitled*, c.1948. Courtesy Dale Richter. Collection of Jonathan Quandt.

128 Gene Petersen, *Untitled*, 1953. Courtesy Lauren Donnachie. Collection of the Minor White Archive, Princeton University Art Museum.

129 Don Whyte, *Mendocino*, 1948. Courtesy Ken Ball and Victoria (Whyte) Ball.

FACULTY PORTFOLIOS

131 Ansel Adams, *Alabama Hills, Clouds, Owens Valley, California*, 1950. Collection Center for Creative Photography, University of Arizona Copyright © Trustees of The Ansel Adams Publishing Rights Trust.

132 Ansel Adams, *Moon and Rocks, Joshua Tree National Monument*, 1948. Collection Center for Creative Photography, University of Arizona Copyright © Trustees of The Ansel Adams Publishing Rights Trust.

133 Ansel Adams, *Crosses, Trampas, New Mexico*, 1958. Collection Center for Creative Photography, University of Arizona Copyright © Trustees of The Ansel Adams Publishing Rights Trust.

134 Ansel Adams, *Sand Fence near Keeler, California*, 1948. Collection Center for Creative Photography, University of Arizona Copyright © Trustees of The Ansel Adams Publishing Rights Trust.

135 Ansel Adams, *Detail, Rainbow Bridge, Rainbow Bridge National Monument*, 1942. Collection Center for Creative Photography, University of Arizona Copyright © Trustees of The Ansel Adams Publishing Rights Trust.

136 Ansel Adams, *Rails and Jet Trails, Roseville, California*, 1953. Collection Center for Creative Photography, University of Arizona Copyright © Trustees of The Ansel Adams Publishing Rights Trust.

137 Ansel Adams, *"Homecoming," Hornitos, California*, 1944. Collection Center for Creative Photography, University of Arizona Copyright © Trustees of The Ansel Adams Publishing Rights Trust.

139 Imogen Cunningham, *Morris Graves, Painter*, 1950. Copyright © Imogen Cunningham Trust.

140 Imogen Cunningham, *The Unmade Bed*, 1957. Copyright © Imogen Cunningham Trust.

141 Imogen Cunningham, *Leaves*, 1948. Copyright © Imogen Cunningham Trust.

142 Imogen Cunningham, *Stan with Symbol*, 1953. Copyright © Imogen Cunningham Trust.

143 Imogen Cunningham, *Boy Selling Newspapers, San Francisco*, c.1950. Copyright © Imogen Cunningham Trust.

144 Imogen Cunningham, *Child in San Francisco Chinatown*, c.1950. Copyright © Imogen Cunningham Trust.

145 Imogen Cunningham, *Watchers of the Evangel Meeting, San Francisco*, 1946. Copyright © Imogen Cunningham Trust.

147 Dorothea Lange, *James Roosevelt Campaign for Governor of California*, February 17, 1950. Copyright © the Dorothea Lange Collection, Oakland Museum of California, City of Oakland, Gift of Paul S. Taylor.

148 Dorothea Lange, *Braceros*, 1942. Copyright © the Dorothea Lange Collection, Oakland Museum of California, City of Oakland, Gift of Paul S. Taylor.

149 Dorothea Lange, *First Braceros*, c.1942. Copyright © the Dorothea Lange Collection, Oakland Museum of California, City of Oakland, Gift of Paul S. Taylor.

150 Dorothea Lange, *Shipyard Worker & Family in Trailer Camp*, 1944. Copyright © the Dorothea Lange Collection, Oakland Museum of California, City of Oakland, Gift of Paul S. Taylor.

151 Dorothea Lange, *Street Demonstrations Against Conference*, 1945. Copyright © the Dorothea Lange Collection, Oakland Museum of California, City of Oakland, Gift of Paul S. Taylor.

152 Dorothea Lange, *Consumer Relationships*, 1952. Copyright © the Dorothea Lange Collection, Oakland Museum of California, City of Oakland, Gift of Paul S. Taylor.

153 Dorothea Lange, *Love and Marriage—"They Go Together Like a Horse and Carriage," New York City*, 1954. Copyright © the Dorothea Lange Collection, Oakland Museum of California, City of Oakland, Gift of Paul S. Taylor.

155 Rose Mandel, *Untitled (#20)*, c. 1947, from the series *On Walls and Behind Glass*. Copyright © Estate of Rose Mandel, Courtesy Susan Ehrens, Collection The Art Institute of Chicago, Restricted gift of Lucia Woods Lindley and Daniel A. Lindley, Jr.

156 Rose Mandel, *Untitled (#1)*, c. 1947, from the series *On Walls and Behind Glass*. Copyright © Estate of Rose Mandel, Courtesy Susan Ehrens, Collection The Art Institute of Chicago, Restricted gift of Lucia Woods Lindley and Daniel A. Lindley, Jr.

157 Rose Mandel, *Untitled (#2)*, c. 1947, from the series *On Walls and Behind Glass*. Copyright © Estate of Rose Mandel, Courtesy Susan Ehrens, Collection The Art Institute of Chicago, Restricted gift of Lucia Woods Lindley and Daniel A. Lindley, Jr.

158 Rose Mandel, *Untitled (#15)*, c. 1947, from the series *On Walls and Behind Glass*. Copyright © Estate of Rose Mandel, Courtesy Susan Ehrens, Collection The Art Institute of Chicago, Restricted gift of Lucia Woods Lindley and Daniel A. Lindley, Jr.

159 Rose Mandel, *Untitled (#3)*, c. 1947, from the series *On Walls and Behind Glass*. Copyright © Estate of Rose Mandel, Courtesy Susan Ehrens, Collection The Art Institute of Chicago, Restricted gift of Lucia Woods Lindley and Daniel A. Lindley, Jr.

160 Rose Mandel, *Untitled (#16)*, c. 1947, from the series *On Walls and Behind Glass*. Copyright © Estate of Rose Mandel, Courtesy Susan Ehrens, Collection The Art Institute of Chicago, Restricted gift of Lucia Woods Lindley and Daniel A. Lindley, Jr.

161 Rose Mandel, *Untitled (#7)*, c. 1947, from the series *On Walls and Behind Glass*. Copyright © Estate of Rose Mandel, Courtesy Susan Ehrens, Collection The Art Institute of Chicago, Restricted gift of Lucia Woods Lindley and Daniel A. Lindley, Jr.

163 Lisette Model, *Running Legs, Fifth Avenue, New York*, c. 1940–1941. Copyright © National Gallery of Canada, Gift of the Estate of Lisette Model, 1990, by direction of Joseph G. Blum, New York, through the American Friends of Canada.

164 Lisette Model, *Las Vegas*, 1949. Courtesy Estate of Lisette Model, Collection Galerie Baudoin Lebon/ Galerie Maurice Keitelman.

165 Lisette Model, *Reno*, 1949. Courtesy Estate of Lisette Model, Collection Galerie Baudoin Lebon/Galerie Maurice Keitelman.

166 Lisette Model, *Reno*, 1949. Copyright © National Gallery of Canada, Gift of the Estate of Lisette Model, 1990, by direction of Joseph G. Blum, New York, through the American Friends of Canada.

167 Lisette Model, *Window, San Francisco*, 1949. Copyright © National Gallery of Canada, Gift of the Estate of Lisette Model, 1990, by direction of Joseph G. Blum, New York, through the American Friends of Canada.

168 Lisette Model, *Opera, San Francisco*, 1949. Copyright © National Gallery of Canada, Gift of the Estate of Lisette Model, 1990, by direction of Joseph G. Blum, New York, through the American Friends of Canada.

169 Lisette Model, *Opera, San Francisco*, 1949. Copyright © National Gallery of Canada, Gift of the Estate of Lisette Model, 1990, by direction of Joseph G. Blum, New York, through the American Friends of Canada.

171 Homer Page, *Untitled*, c. 1940. Courtesy Christina Gardner.

172 Homer Page, *Untitled*, c. 1940. Courtesy Christina Gardner.

173 Homer Page, *Untitled*, c. 1940. Courtesy Christina Gardner.

174 Homer Page, *Untitled*, from *Question of the Kids*, 1944. Courtesy Christina Gardner.

175 Homer Page, Homer Page, *Mission*, Fall 1944. Courtesy Christina Gardner.

176 Homer Page, *Untitled*, c. 1940. Courtesy Christina Gardner.

177 Homer Page, *Untitled*, c. 1940. Courtesy Christina Gardner.

179 Frederick W. Quandt, *Virginia City*, c. 1952. Courtesy of Jonathan Quandt.

180 Frederick W. Quandt, *Textures*, c. 1948. Courtesy of Jonathan Quandt.

181 Frederick W. Quandt, *San Francisco*, c. 1948. Courtesy of Jonathan Quandt.

182 Frederick W. Quandt, *Abalone, Mendocino*, c. 1948. Courtesy of Jonathan Quandt.

183 Frederick W. Quandt, *Sign*, c. 1948. Courtesy of Jonathan Quandt.

184 Frederick W. Quandt, *Hands*, c. 1950. Courtesy of Jonathan Quandt.

185 Frederick W. Quandt, *Leaves*, c. 1950. Courtesy of Jonathan Quandt.

187 Edward Weston, *Nautilus Shells*, c. 1947. Collection Center for Creative Photography, University of Arizona Copyright © 1981 Arizona Board of Regents.

188 Edward Weston, *Broken Walls, Las Truchas, New Mexico*, 1941. Collection Center for Creative Photography, University of Arizona Copyright © 1981 Arizona Board of Regents.

189 Edward Weston, *Negro Church, Louisiana*, 1941. Collection Center for Creative Photography, University of Arizona Copyright © 1981 Arizona Board of Regents.

190 Edward Weston, *Gulf Oil, Port Arthur, Texas*, 1941. Collection Center for Creative Photography, University of Arizona Copyright © 1981 Arizona Board of Regents.

191 Edward Weston, *Boulder Dam*, 1941. Collection Center for Creative Photography, University of Arizona Copyright © 1981 Arizona Board of Regents.

192 Edward Weston, *Pelican, Point Lobos*, 1942. Collection Center for Creative Photography, University of Arizona Copyright © 1981 Arizona Board of Regents.

193 Edward Weston, *Hela*, 1946. Collection Center for Creative Photography, University of Arizona Copyright © 1981 Arizona Board of Regents.

195 Minor White, *San Francisco*, 1949. Reproduction courtesy the Minor White Archive, Princeton University Art Museum. Copyright © by the Trustees of Princeton University.

196 Minor White, *Chinese New Year, San Francisco*, 1953. Reproduction courtesy the Minor White Archive, Princeton University Art Museum. Copyright © by the Trustees of Princeton University.

197 Minor White, *Cedar and Laguna Streets, San Francisco*, 1948. Reproduction courtesy the Minor White Archive, Princeton University Art Museum. Copyright © by the Trustees of Princeton University.

198 Minor White, *Warehouse Area, San Francisco*, 1949. Reproduction courtesy the Minor White Archive, Princeton University Art Museum. Copyright © by the Trustees of Princeton University.

199 Minor White, *Movement Studies Number 56 (Huntington Hotel)*, 1949. Reproduction courtesy the Minor White Archive, Princeton University Art Museum. Copyright © by the Trustees of Princeton University.

200 Minor White, *Arrows*, 1949. Reproduction courtesy the Minor White Archive, Princeton University Art Museum. Copyright © by the Trustees of Princeton University.

201 Minor White, *Columbus Avenue, San Francisco*, 1949. Reproduction courtesy the Minor White Archive, Princeton University Art Museum. Copyright © by the Trustees of Princeton University.

INTIMATIONS OF DISASTER

206–07

Minor White, *Intimations of Disaster*, 1949–53. Reproduction courtesy the Minor White Archive, Princeton University Art Museum. Copyright © by the Trustees of Princeton University, Collection The Museum of Fine Arts, Houston. *The Target Collection of American Photography*, Gift of Target Stores.

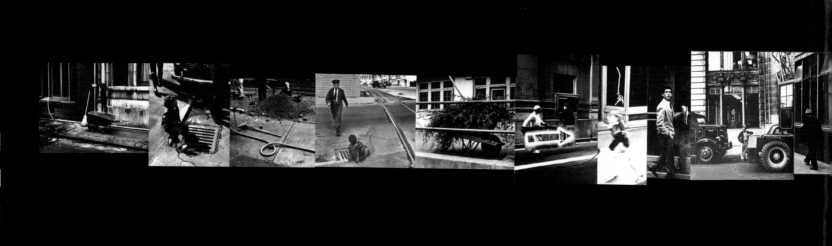

Minor White, *Intimations of Disaster,*
1949–1953.

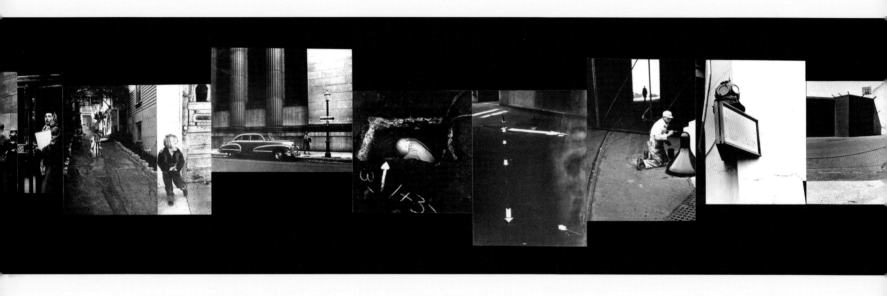

Acknowledgments

The authors would like to recognize the following individuals and institutions for their interest and support of *The Moment of Seeing*:

Ansel Adams Publishing Rights Trust, Ken Ball, Victoria Whyte Ball, Peggy Bertolino, David Bransten, Chris Bratton, Zoe Brown, Peter Bunnell, California Historical Society, Leslie Calmes, Center for Creative Photography, Marge Childress, Benjamen Chinn, Imogen Cunningham Trust, Lauren Donnachie, Susan Ehrens, Patricia Faubion, Eliot Finkels, Galerie Baudoin Lebon, Christina Gardner, Denise Gosé, Hans Halberstadt, Bill Heick, Maria Henle, Paul Hertzmann, Susan Herzig, Bob Hollingsworth, Helen Howell, David Hyde, Philip Hyde, David Johnson, Pirkle Jones, Ira Latour, Nathan Lyons, Cameron Macauley, Jennifer McFarland, Dan Meinwald, Estate of Lisette Model, Moulin Studios, The Museum of Fine Arts, Houston, National Gallery of Canada, The New York Times Company, Dianne Nilsen, Patricia Harris Noyes, Oakland Museum of California, Rebecca Palmer, Irene Poon Andersen, Minor White Archives at Princeton University Art Museum, Jonathan Quandt, Alan Rapp, Gerald Ratto, Dennis Reed, Richard Reinke, Dale Richter, John Rogers, Merg Ross, Amy Rule, The San Francisco Chronicle, San Francisco History Center, San Francisco Public Library, San Francisco Art Institute, Tara Schaurer, David Scheinbaum, Michael Shapiro, Rita Stapp, Walter Stoy, Marcia Tiede, David Travis, Betty Blodget Wentworth, Jean L. Weston, Mary Wheelock, Charles Wong, Harold Zegart and Stan Zrnich.

Additional support provided by the Joseph Bellows Gallery, La Jolla, California.

Special thanks to Jeff Gunderson, Michael Read, and Irene Rietschel.